Desire
by Design

Desire
by Design

Body, Territories and New Technologies

edited by

Cutting Edge
The Women's Research Group

I.B.Tauris *Publishers*
LONDON • NEW YORK

Published in 1999 by I.B.Tauris & Co Ltd
Victoria House, Bloomsbury Square, London WC1B 4DZ
175 Fifth Avenue, New York NY 10010

In the United States and Canada distributed by St. Martin's Press
175 Fifth Avenue, New York NY 10010

ISBN 1 86064 280 2

A full CIP record for this book is available from the British Library
A full CIP record for this book is available from the Library of Congress

Library of Congress catalog card: available

Typeset in Nimrod by Karen Stafford
Printed and bound in Great Britain by WBC Ltd, Bridgend

CONTENTS

LIST OF COLOUR PLATES

SYLVIA BELANGER
Watch – Sylvia Belanger

NICKY WEST
Performing Daily 1994 – Nicky West – Installation photograph by Terry Dennet
Love Con 1 1995 – Nicky West
Celestial 1997 – Nicky West

CHRISTINE TAMBLYN
Mistaken Identities – Christine Tamblyn 1996

RITA KEEGAN
Hands 1996 – Images from video Installation – Rita Keegan
Trophies of Empire, Self Portrait 1992 – Images from Video Installation – Rita Keegan
Time Machine 1995 – Images from video Installation – Rita Keegan

JANE PROPHET
Love Pump – Jane Prophet
Exit – Jane Prophet
Mask – Jane Prophet

ALEXA WRIGHT
Left *RD1* and above *GN2* – Alexa Wright

JACKIE HATFIELD
Stills from Installation *Scar* – Jackie Hatfield
Stills from 'Camera Suit' Performances – Jackie Hatfield
Stills from *Walk in the Glens Wearing a Camera Suit and Tartan Boots* – Jackie Hatfield

GAIL PEARCE
Mirror, Mirror: interactive installation, the user's response – Gail Pearce
Mirror, Mirror: behind the mirror, what makes it work – Gail Pearce

FOREWORD

About the Cutting Edge Research Group

The idea of establishing a group to concentrate on design and gender came from work in the early 1980s of two of the original Cutting Edge group, Philippa Goodall and myself. We co-edited a special issue of *Feminist Arts News* which focused specifically on Women and Design, at that time a relatively underdeveloped sphere. Our editorial for that issue noted that we would like to continue and develop the debates and to that end we initiated a conference.

The conference 'Design: Women at the Cutting Edge' was held at the Institute of Contemporary Arts in May 1988 with the kind help of Erica Carter, then director of conferences at the ICA and the addition of Jos Boys from Matrix, the feminist architectural group. The ICA conference was a success and acted as a platform to invite other women to join the nascent group. Its composition has changed over time but from the beginning the intention was to engage in a cross disciplinary approach to design, which was largely regarded as discrete specialist territories, professionally and conceptually, in which theory, 'women's studies' and women's presence in the design professions were largely absent. By the mid-1980s 'design' was one of the Thatcher government's flagships to deliver added value for British industry and the country's export drive, design had become popularized and a sought-after commodity. In part this was the backdrop against which the Cutting Edge group decided to work on an exhibition on the politics of consumption at the Design Museum in London. Unfortunately, lack of funding and change of policy at the Design Museum meant this exhibition was never realized.

Jos Boys, Philippa Goodall, Janice Winship and I were keen to continue as a research group with an intention to publish. As I was on the staff at the University of Westminster in the School of Design and Media I approached the School on their behalf to recognize 'Cutting Edge' as a research group within the research policy framework of the University and to allocate it appropriate development resources. We describe ourselves as a 'feminist' group and recognize diverse theoretical and creative objectives. We are all familiar with the margin-

alization that accompanies any discussion around issues of gender too often considered to be 'girls' stuff'.The perspectives the group seek to explore do not fit comfortably within the definitions of what constitutes appropriate research or the funding remits of the Art and Design research committee. 'Cutting Edge' has led to category confusion.

Our intellectual concerns cross many of the subject boundaries within our faculty; we are a cross-institutional and nationally based group. 'Cutting Edge' includes women who work in and across art, design, media, architecture, museum studies, photography, literature and cultural theory. The editorial group of 11 who have contributed time and work on this book are: Stevie Bezencenet, Jos Boys, Helen Coxall, Philippa Goodall, Jackie Hatfield, Roberta McGrath, Marion Roberts, Gail Pearce, Jane Prophet, Alex Warwick and myself.

The theme for the conference and this publication arose from series of discussions with invited speakers. We explored the discourses of gender and technology that formed a core of common interest for the whole group, aware that the new technologies were changing day-to-day experience and categories we used to make sense of the world. We wanted to know how the technologies and concepts like genetic engineering, digital media and cyberspace were shifting the boundaries and reshaping the categories of gender and class, body and space. Also how technologies were transforming our understanding of nature in all its various complex forms and repositioning us in different ways to our understanding of culture and cultural identity.

Some women have joined us halfway through the editing process, other women have left at its finish and I would like this opportunity to thank all the women who have worked so hard to make this publication possible.

<div align="right">

Erica Matlow

COORDINATOR FOR THE 'CUTTING EDGE' WOMEN'S RESEARCH GROUP

AT THE UNIVERSITY OF WESTMINSTER

FEBRUARY 1998

</div>

INTRODUCTION

> . . . first, the production of a universal totalizing theory
> is a major mistake that misses most of reality probably
> always, but certainly now; and second, taking responsi-
> bility for the social relations of science and technology
> means refusing an anti-science metaphysics, a demon-
> ology of technology, and so means embracing the skilful
> task of reconstructing the boundaries of everyday life, in
> partial communication with others, in communication
> with all of our parts . . . science and technology are a
> possible means of great human satisfaction, as well as a
> matrix of complex dominations.
>
> (Donna Haraway, 'A Manifesto for Cyborgs')

Since this was written in the mid-eighties, on the first wave of con-
sideration of the impact of new technologies on our lives, there has
been a great deal of critical, creative and popular interest in areas
such as the relationship between the body and technology, the po-
tential of digital information, identity and the virtual world, and the
particular place of women in this new environment.

The urgency of the need to consider these issues is clear; new tech-
nologies are transforming every aspect of life and this is apparent in
women's day-to-day experience, as well as in our work as artists,
teachers and theorists in visual and textual media. Such technologies
have enabled change in the production, distribution and consumption
of work and ideas, widening access and involvement through the
availability of different kinds of media and the processes of interac-
tivity. Technology retains its ambivalence however; the industrial
revolutions of the eighteenth and nineteenth centuries produced a
range of effects on populations, many of them far from positive, and
the information revolutions of the twentieth and twenty-first cen-
turies promise a similar range. In this there is a danger that existing
inequalities, global, national and individual, may simply be main-
tained through the reinscription of dominant ideologies in new
media. This collection is designed both as a celebration and an in-
terrogation of the possibilities offered by new technologies. It seeks

to consider new concepts and practices which challenge preconceived ideas about gender, identity, the body, subjectivity, space and technology, and to avoid the reinscription of culturally dominant notions of difference.

Haraway's vision is of women's intervention in the discourses of science and technology, an intervention based in refusal of binary oppositions and resistance to anti-technology positions. This offers the possibility of interrogation and reaffirmation of science and technology in a variety of forms, and it is a challenge which is taken up in this book. Through such interventions women can take the opportunity of expressing and exploring and moving forward new ways of understanding gender by opening up spaces in which difference can be articulated. These spaces, virtual, actual, fictional or conceptual, need not remain separate from each other or from lived experience, and in their articulation begin to break down the artificial boundaries constructed to contain them. Just as the boundaries of practice can be dissolved, so too can the notions of fixed identity and subject position, and this collection represents a rethinking of feminism and the question of gender identity. The chapters in this volume do not proceed from a single position, and while all take gender and/or women's experience as a starting point, the multiplicity of perspectives reflects the multiplicity of possible identities of contemporary women. The contributors to this collection work in a number of different fields inside and outside academia, from graphic design, architecture, and cultural studies to photography, video and multimedia practice. While drawing on these different backgrounds they also show the ways in which it is possible to move beyond the constriction of any single discipline.

In her chapter Katy Deepwell provides a clear illustration of both the constricting and illusory nature of the boundaries that have been thought to exist between different disciplines of art practice. Taking a wide-ranging cross-cultural perspective, which explicitly sets aside the for/against arguments around new technology she looks at the uses of such technology in feminist art practice. Using work from a variety of media, she illustrates ways in which the work of the women artists discussed goes beyond the institutional demarcations of these media. Janice Cheddie's chapter also seeks to break down

and blur the borders between creative forms, drawing comparisons between the history of improvisation and innovation in Black music and the production of work by contemporary Black artists. She sees cyberspace and diaspora as related models of imaginative territory that have great potential for both the creation and reading of work by Black artists seeking to make interventions into debates on digital technology and cultural production.

An effect of the artificial construction of boundaries has been that the kind of interventions envisaged by Haraway have been inconsistent across the disciplines. In areas like reproductive technology there is already a strong and complex critique that proceeds at least partially from earlier feminist concerns about reproductive rights and the control of women's bodies. Using Mary Shelley's *Frankenstein* as a framework, Sarah Kember investigates medical imaging and reproductive technologies in the light of the masculine desire for medicine to 'father itself'. This fantasy of autonomous reproduction, she argues, is premised on a dual conception of the female body as both maternal and faulty, and the wish to exclude women from the process of reproduction. The Visible Human Project and the Human Genome Project are read as recent examples of the fantasy of mapping and mastery, and she argues for a feminist intervention in which responsibility is taken for the products of scientific creation.

In the field of imaging and representation the ground-breaking work of Mulvey and others on the gaze and the politics of vision has allowed the possibility of further expansion and divergence of debate on the meanings of the body and its representation, through the introduction of new visual media. In her essay 'Partial Bodies', Alexa Wright brings together a number of concerns that inform her practice as an artist who uses digital media and photography to make pieces which often employ imagery from surgical procedures. In particular Wright problematizes the emphasis on vision in virtual reality and calls for a reintegration of the body and the 'self'. Her exploration of the complex relationship between body and mind takes the transplant patient and the amputee as subjects for exploring issues such as perception, neural mapping and body memory. People with atypical bodies and/or distorted perceptions of their bodies are used as a model for developing a new approach to virtual reality

13

which moves beyond the pictorial. Similarly, Jackie Hatfield's piece investigates the experiential body and the body/self relation in space and time, specifically using video and film in an installation context. She also explores the question of subjectivity in relation to the representation of the subject.

Two other digital media artists in this collection are concerned with issues around the representation of the body, and particularly with the changing relationships between producer, artifact and audience. Nicky West examines ways in which new technology enables a reconceptualizing of the body, especially in categories of gender identity. By using two of her own works as case studies in which she takes the photographic image of a real person and transforms it in order to re-narrate that person's life, she argues for the positive potential of cyberspace as a domain in which re-imagining of the body is possible. Jane Prophet demonstrates through the creation and discussion of the imaginary organs of a cyborg the fluidity of our sense of self, and the ways in which the cyborg that transgresses boundaries of gender, species and substance speaks of our ambivalent attraction to a subjectivity which is not contained within the 'universal body'.

While the kinds of debate that these chapters engage with are already rich and dense, in other fields, such as architecture for example, the critique of gendered positions and assumptions has been less extensive. Arguably, the entrenched masculine practices of the profession have constricted the development of work by women, both as practitioners and theorists, though there have been some important recent contributions. As Jos Boys points out, the feminist tradition which analyses the mapping of gender divisions onto the material landscape through a series of binary oppositions has been challenged by questioning the validity of such binaries and exploring instead spatial metaphors like the margin and the edge to open up more fluid and experiential positions. In her piece 'Positions in the Landscape' she argues that contestation of space by marginalized groups is undermined by an inadequate conceptualization of space, that the notion of it as a fixable entity needs to be replaced by one of process and that we must differentiate more explicitly between social and spatial concepts and between spaces of engagement and subject positions. By

taking examples from specific physical and virtual spaces she analyses the relation of gender identities to particular processes of production and consumption. Proceeding in a similar fashion from concrete examples, Marion Roberts examines four proposals for the form that towns and cities should take in the light of contemporary feminist concerns. In parallel to the need to resist anti-technological positions she argues for a resistance to discourses of nostalgic ruralism that reject urban possibilities. She advocates instead an understanding of social relations such as the feminization of the work force which would give rise to different forms of public and private space.

In other areas, such as graphic design and museum exhibition the extent of feminist intervention is also limited, focusing primarily on the object and its history. In some fields, as we have suggested, it is possible to move very far beyond traditional concepts of gender and identity and practice, while in others where little discourse exists to draw upon, this movement 'beyond' is more difficult to accomplish. Critiques in these areas are beginning to establish the particular questions that are relevant and their relation to theoretical perspectives from other areas of inquiry. Erica Matlow, for example, argues here the importance of the recognition that there has been a paradigm shift from traditional modernist graphic design towards a fragmented postmodern approach. She suggests that this is manifested in the introduction of new technologies, the consequent movement away from rigid structures and principles to the transparent and ephemeral which exist for the most part within virtual dimensions. She also proposes that the consideration of this movement in relation to issues of gender can illuminate professional and individual practice.

In a related area, and in conversation with a graphic designer, Uma Patel considers her work in a heavily male dominated profession as a human/computer interface designer, discussing issues of cognition and perception and the need for a shared perspective between the practitioners of graphic and interface design to develop this field further. Her concerns strongly support the desire for the breakdown of professional barriers to change, evidenced throughout this collection, and also bear witness to ways in which new technologies are already developing in a manner that does not take difference into account. By contrast, Helen Coxall's chapter elucidates

the potential of interactivity and human/computer interface in the specific context of museum exhibition and the possibilities of offering, through interactive technologies, personal pathways through information which allow meaningful perceptions for visitors of the exhibits in relation to their own experiences. She argues and demonstrates by reference to recent exhibitions that interaction can open up a plural narrative for marginalized groups, allowing a fluidity of readings that empower the user by movement away from an object-based viewpoint.

Interactivity has been identified by many as a positive means by which a personal intervention can be effected, and as a method of constructing an individually relevant narrative from the material available. This foregrounds and lays bare the more usually concealed processes of narration by permitting and encouraging the user to become conscious of her own arrangement and interpretation of information in ways that are frequently submerged in traditional narrative formats. This is clear in the chapter by Gail Pearce, which is an artist's description of a piece of her recent work, an installation that by subverting and disguising the technology produces an environment that allows interactive construction of a narrative dealing with gender and violence.

In this book we have attempted to give a space for women to articulate in greater detail some of the debates outlined and to explore the possibilities of new spaces, imaginative and actual, theoretical and creative. This is reflected in the disparate formats of the contributions, which range from fictional through art practice and performance to the theoretical, though in the spirit of transgression of boundaries promised by new technologies none is limited to a single subject discipline, being interdisciplinary in form and content. Alex Warwick's essay 'Bodies of Glass' ranges across architecture, modernism, theories of representation and models of the body and, by taking glass both as a metaphor and a substance, explores the meanings and uses of this product of technology. She argues that although glass has ambivalent meanings for women in terms of its practical use in the twentieth century, its theoretical construction offers ways of rethinking space and gender. Danielle Eubank's piece is in the tradition of feminist science fiction which explores the implications of

virtual communications systems for the self-presentation of gendered identity, and the Technowhores' piece enacts and theorises the trace of a Technowhores engagement on the Internet. It projects a cyberfeminist consciousness through a questioning of essentialism and embraces technology as a site of female pleasure.

Perhaps this last point is the appropriate one on which to end this introduction. For some women trained in older and more rigid methods and practices the confrontation with new technologies and their possibilities has been a difficult one; we hope that the kind of work elaborated here is both a testimony to the process of coming to terms in the twentieth century and a manifesto for the project of liberatory intervention into the twenty-first.

Alex Warwick

Section 1
Designing Bodies

PARTIAL BODIES
Re-establishing boundaries, medical and virtual

Alexa Wright

In the Christian West we have an inherited abhorrence of the fleshy body which conveniently permits a reduction of the complex and problematic notion of self. Cleansed by the orderly division between mind and matter, the self is perceived to be the cerebral owner of a body which it is constantly striving to normalize, or to transcend, in an attempt to avoid abjection. It is, though, the body which locates us in the world. As Merleau Ponty wrote in 1962: 'far from my body's being for me no more than a fragment of space, there would be no space at all for me if I had no body.'[1] Before cyberspace, before the instantaneity of the interface where shape, size, location and even Euclidian notions of space itself seemingly lost their significance, the self could not exist without a body. But in this space without continuity, where all bodies are no bodies, what happens to that blind spot which was the corporeal body? Have we finally found fulfilment of the desire for transcendence?

Since the early nineteenth century the body has been represented in Western culture as increasingly fragmented: it has been further and further divided into specific organic and mechanical systems, each to be treated in isolation. As the unexplored space of the body is reduced and we develop the means to visualize, and therefore objectify, every minute surface of ourselves, the mind/body split is extended. As powerful optical devices are developed, the ability to see, understand, and therefore seemingly to control evermore inaccessible spaces, has allowed vision to become the all-powerful sense; enabling a detached 'point of view' from which the commanding eye of the viewer can dominate its subject. This provides a perfect frame-

work for virtual reality, where the disembodied gaze alone can move the user through space. The desire to leave the 'heavy machinery' of the body behind and move into virtual space does seem very logical when considered in relation to a history in which intelligence and memory have become almost exclusively located in the brain, with vision perceived as the primary means of inputting knowledge. However, to quote Merleau Ponty again: 'the body is a natural self'. The Nature/Culture argument does not go away and, even if the importance of 'the body' is acknowledged, we are faced with the enduring question of which body it is that we are referring to. As the desire for transcendence of the flesh is the basis of most religious doctrine, so also is a sense of the body as a sacred enclosure, and despite a gradual shift of power to the individual we are slow to lose respect for the boundary rules laid down by Christianity. The already difficult notion of a natural, and therefore pure or authentic, form for the self is further problematized by an acceleration of the means of hybridizing the body. As 'foreign bodies' are incorporated into the system and parts are removed, replaced and reorganized, the organism begins to disintegrate. Increasingly the physical self may be tailored to 'fit', both functionally and aesthetically, so that the position of the 'real me' is rendered ambiguous by the speed of the process of transformation.

In theory, then, the territory owned by the self can open to incorporate the implants, transplants and prostheses which internally defend its integrity. In functional terms, though, the fact that the body may be more reluctant to map its new form is evidenced by some of the effects of transplant and of amputation. People with amputations speak of the instant of surprise they feel when, often for some years after their operation, they reach down to scratch a missing limb and encounter only empty space. The integration of a transplanted organ can be equally problematic:

> In one sense a transplant is a chronic disease because the body is constantly fighting it. For the body it always remains something strange; something that doesn't belong, that needs to be destroyed. Even with family donors or twins the patient still has to take medication

to prevent rejection. The body remains a closed system: if the patient stops taking medication the body immediately starts to reject the organ. This complicates the adaptation of the patient because they are reminded every day that the organ is not theirs.[2]

To prevent emotional complications transplant patients are usually protected by the medical profession from knowing the source of their new organ. Likewise, surgical patients are generally spared knowledge of the process of their operation: the medical body is treated as a sacred machine, anaesthetized to the pain of transformation and therefore blind to itself. In surgery the flow and disorder inherent in the state of transition are restrained by the sterile field and, as the patient wakes, only the closure at the surface of the body is visible: the controlled environment of the hospital provides a shield against the abject fear engendered by the chaotic nature of an accidental wound. To see beyond the acceptable surface of the skin into the body is almost always undesirable; suggesting that detachment from, and objectification of, the body is not quite as advanced as we would like to imagine. Despite the plethora of available imaging devices; many of which offer dry, clean, digitized representations of the interior, in the medical context 'my body' is still a subjective, felt experience bounded by its capacity for pain and by fear of dissolution, with responsibility for analysis and repair controlled by professional 'others'.

There are many medical conditions such as, for example, perceptual disorders which call into question the meaning of the self and the unity of conscious experience. There are problems of (re)definition associated with many types of surgery. Even in the case of cosmetic intervention, when alterations are elected by the patient, there may be a blurring of the self/nonself boundary:

The changes in embodiment . . . which accompany all types of cosmetic surgery . . . can lead to a dissociation from the body. A 'loss of identity' has been associated with both cosmetic and corrective plastic surgery which may be short or long term.[3]

There are many cultures in which people have long been dreaming of a virtual, free-floating subject; sought via such means as meditation, religious ritual and drug use. But we have not yet seen the day when consciousness is truly divorced from the body and its functions. In cyberspace 'I' may become text, seemingly free of gender or racial identity, but both text and fluid identity remain prosthetic. Although they may prove useful in liberating concealed aspects of the self in a variety of contexts, the personas we invent on the Net are pure theatre: we may achieve the illusion of a concealed or effaced body but, for now at least, the 'real me' remains firmly attached to its own flesh (and blood). The body in virtual reality (VR) is pure representation, becoming real only to the extent that disbelief may be suspended. As the virtual body takes its place in a long tradition of representation it provides a far less problematic image for the self than, for example, the cosmetically altered appearance of the fleshy body, or the steroid-enhanced form of the body-builder. The virtual body is a simple and malleable representation; its symbolism divorced from its functionality by virtue of the fact that it is 'added on' to the self as an external prosthesis.

> One does not take one's body into VR, one leaves it at the door. VR reinforces the Cartesian duality, replacing the body with a body image, a creation of mind, as all objects in VR are a product of mind . . . But the term 'body' should be clarified. When we discuss the body it seems to be as two quite different perceptual roles. We can discuss the body as a thing which is perceived, (and understood to be the physical manifestation attached to the observing mind), and we can also discuss the body as the thing which does the perceiving of other things outside the body. This distinction applies to the corporeal body and it also applies to the body representation in VR.[4]

Although we have an abundance of new models for possible virtual selves, the production of the body as a metaphor or representation is nothing new: from the earliest gods to the most recent cyborgs (conjunctions of body and machine) the body has been used to represent the

beliefs and aspirations particular to every age and society. As Jennifer Gonzalez points out: 'the cyborg thus becomes the historical record of changes in human perception.'[5] What is, perhaps, new is the potential offered by medical technologies to internalize this dream: to make the cyborg 'real' to itself; to codify or normalize the body from the inside out. In VR applications much attention has previously been paid to the believability of the virtual experience, achieved principally through fidelity of pictorial representation; with parts of the user's own body appearing as visual prostheses.

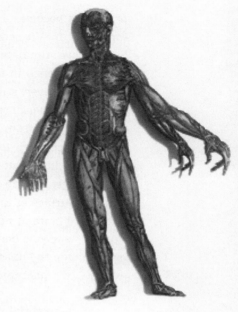

In the medical world there is rapid technological development in respect of the body, but in practical terms this is still mostly restricted to a delicately balanced replacement of mechanical body parts. There is minimal disruption to body image with, for example, operations such as joint replacement and the insertion of a pacemaker: both of which are now common procedures. Things could, however, change as the role of the nervous system in providing a monitoring device for the self and its parameters is investigated. We could then see a redefinition of human boundaries in perceptual, rather than representational, terms. According to Dr Ramachandran, Professor of Neuroscience at the University of California and at the Salk Institute, La Jolla, California, the surface of the brain supports a neural 'map' of the body, where motor information is received and monitored. After modifications to the body the neural map may take time to update; to the extent that phantoms remaining after amputation haunt the body's new form. As in more complex and emotional disorders such as anorexia nervosa, the body's internal representation is rendered at odds with its representation to the rest of the world. Investigation of this experience of a split between the physical and visual boundaries of the self provides a point at which medical and virtual bodies may begin to intersect. The reluctance of the 'natural' body to relinquish its integrity is currently used medically in the fitting of prosthetic limbs, when the

prosthesis becomes a visible and tangible manifestation of the phantom limb. In VR sensory links are already exploited as vision and hearing are stimulated to override the other senses, simulating a convincing presence in the virtual environment. The sense of a Virtual Body is, however, still a prosthetic one: the interface is external; the 'added on' experience convincing only insofar as the technology is made to recede from consciousness. But how would things change if the interface were to become internalized; the body representation once again inseparable from the meat body?

Seemingly we are born with this map of the body already etched onto the surface of the brain, each map serving as a blueprint for an individual state of normality. For a person with congenital amputation (i.e. someone born differently configured to the 'norm'), the map may include the missing body part, so that it is possible for them to experience a phantom of a limb missing since birth:

> A substantial number of children who are born without a limb feel a phantom of the missing part, suggesting that the neural network, or 'neuromatrix', that subserves body sensation has a genetically determined substrate that is modified by sensory experience.[6]

New medical research has revealed a complexity of neural connections in this map which, when the body is functioning as a 'complete' organism, are masked by inhibitory mechanisms: in the same way, perhaps, as awareness of one's own being is masked until there is a disruption to the body's normal functions. 'After reconfiguration of the body (such as amputation) these mechanisms may be disabled, and underlying connections unmasked. In practice this means that when a limb is amputated the corresponding area of the cortex loses its sensory input, allowing the relevant area of the brain to receive input from another part of the body, so that touch stimuli on the face may then be felt on the phantom limb.'[7] Scientists consider that it may be possible for these 'unconscious' connections to be manipulated so that, by controlling sensory input, a different representation of the body is made on the brain – one that has little to do with physical morphology. This research is currently directed towards the treat-

ment of painful phantoms and other neurological disorders, but, given the metaphorical nature of most virtual experiences, the information could also provide material from which a truly virtual self may be constructed: one whose sense of itself is experienced rather than visualized:

> The mind/body split concept is a key component of the enlightenment world view and structures the way we think about ourselves and the world. Computer discourse is a direct descendant of that world view, made more extreme by the pragmatism of engineering. The reification of the mind/body split within computer systems and computer discourse has lent the idea new force. But contemporary thinking in many fields is bringing many basic premises of computer science into question. A concerted effort is now necessary to denaturalise the mind/body split and to re-learn that subjectivity is not subject to reductive analysis. Subjecthood is anchored in the body. What we call 'the mind' permeates the body and is not located in any organ. To believe otherwise is to deny traditional intelligences of the arts.[8]

If subjecthood really is anchored in the body then it would make sense for that body to become a part of the virtual experience. The new challenge of representation in VR seems to be that of representing the self to itself; the representation or simulation of a space being a far more familiar problem, located within a long tradition of pictorial representation. Merleau Ponty's assertion that space can only be experienced through the medium of the body must also apply in virtual space if we are to move beyond the frame of pictorial representation into a virtual reality. Medical technologies, and study of the experiences of people with atypical bodies or with distorted perceptions of their bodies, have much to offer the development of virtual reality. Once we are able to alter (self) perception at source the sense of a loss of boundary of the 'natural' architecture of the self may no longer be metaphorical; the malleable virtual body could become inseparable from, rather than additional to, the 'real' body.

NITS AND NRTS
Medical science and the Frankenstein factor

Sarah Kember

This chapter brings together debates on new imaging and reproductive technologies (NITs and NRTs), and views them jointly in the light of medicine's desire to father itself. Sarah Franklin points out that 'visualising and imaging technologies are critical to the theoretical and discursive apparatus of assisted reproduction'.[1] Ultrasound scans, laparoscopy and microscopy are some of the technologies she cites as being essential in reproductive medicine, and as being the most effective means of generating ideas and imagery about reproduction in the media. I would add to this by suggesting that the use of new imaging technologies in medicine generally (and not necessarily reproductive medicine) is currently creating a sense of reproductive autonomy. Not only do we have scanned images of foetuses 'which effectively eliminate the mother's body from view'[2] and present reproduction as an interaction between the foetus and the doctor, but we have a whole array of imaging processes such as Computed Axial Tomography (CT), Magnetic Resonance Imaging (MRI) and Positron Emission Tomography (PET) scans which can render the whole or any part of the human body newly visible and newly present to the medical gaze. Medicine can now simulate, capture and seemingly re-create the human body in cyberspace, and this, for me, is another facet of autonomous reproduction.

In a recent television programme entitled *The Cyborg Cometh*,[3] a doctor discusses the technical abilities of CT and MRI scanners and looks forward to a future in which body scanners would be able to incorporate a complete human being in a computer. In November 1994 the United States National Library of Medicine launched the Visible

Human Project by putting 'Adam' on the internet. Adam is the name given by the organizers of the project to a complete electronically scanned and archived male body. About a year later, Adam was joined by Eve.

In 'Adam and Eve in Cyberspace' I will discuss the Visible Human Project in detail, but first I will be focusing more closely on the connections between new reproductive technologies, the Visible Human Project and the story of *Frankenstein*. This is partly due to the mechanics of the Visible Human Project. Adam and Eve were created from cut up and reassembled bodies. Like Dr Frankenstein's creation, they are monsters – only this time, cyborg monsters. For me, the Visible Human Project, like *Frankenstein*, is a story of autonomous creation and of medicine's attempt to father itself. What is more, *Frankenstein* is a cautionary tale, written by a woman, Mary Shelley. Like the best of current feminist writing on science and technology, *Frankenstein* combines a critique of science and its current or potential abilities with an imaginary tale – or political fiction – which has, at its heart, a sympathy with and care for the monstrous other.

Mary Shelley's tale, which has been described as 'the masterpiece of the [Gothic] genre' or 'the cornerstone of another, science fiction'[4] is dystopian. It emerged from her discussions with Byron and others about galvanism and the reanimation of corpses, and its origins in a dream arising from the storytelling competition between Mary and Percy Shelley, Byron and his doctor, Polidori, are well-known. According to Diane Johnson it is 'one of the most complete accounts of the emergence of a literary work from the unconscious into the conscious mind.'[5] The preface, written by Percy Shelley in 1871, asserts that the story 'affords a point of view to the imagination for the delineating of human passions more comprehensive and commanding than any which the ordinary relations of existing events can yield.'[6] So this semi-dream text hovers between two worlds – the social world of human relations and scientific progress, and the world of the author's unconscious fears and desires:

> As much as it comments on the inner life of and education of its author, it seems also to touch upon modern archetypal anxieties – family conflicts, our mistrust of

science, and our sympathy for mankind abandoned by
its creator.[7]

Frankenstein is resonantly intertextual and has biographical as well
as literary touchstones, and these concern childbirth and loss. Mary
Shelley's mother, Mary Wollstonecraft, died giving birth to her and
Shelley's own experience was one of successive pregnancies, miscar-
riages and deaths of her children.

In this way, Mary Shelley's dream work, her political fiction is em-
bodied; it is rooted in her own experience and expresses her uncon-
scious and conscious fears and desires. I am inclined to ascribe to it
a certain affinity with current feminist political fictions, especially
Donna Haraway's dream text 'A Manifesto for Cyborgs'. Both are
works of the imagination as well as being critiques of science and so-
cial relations. Both embody a feminist standpoint on knowledge and
power, and both have issues of creation and responsibility at their
core. They tell of the emergence of a monstrous creation into a world
of hierarchies and social division, and are clear about the moral and
political consequences of abdicating responsibility for its fate. What
Shelley doesn't imagine, and Haraway does, is a more utopian sce-
nario in which responsibility for the monster is taken and a shift or
transformation in the terms of scientific knowledge and human rela-
tions is signalled.

Conversely, what Shelley demonstrates more effectively than
Haraway is the unconscious dynamic behind the creation of a mon-
strous other. *Frankenstein*, like other Gothic novels,[8] deals with is-
sues of repression, splitting and projection. As Diane Johnson
suggests: 'The main characters are the allegorical figures of the
human psyche, and a way of dramatising concepts which had no of-
ficial description, although today the language of psychoanalysis
would seem appropriate language for discussing them'.[9]

Repressed desires and unconscious conflicts are explored and
played/acted out in alien places. One of the key tropes of the gothic
novel and certainly of *Frankenstein* is the creation of a double who is
the repository of the repressed or undesirable elements of the self.
The monster is therefore a split off part of ourselves: 'We send our
monster to do our work – that which we wish or fear to wish to do

ourselves.'[10] The monster in *Frankenstein* may therefore be seen as Victor's other – a split and projected part of himself. It is no coincidence, perhaps, that in the many reworkings of the story in popular culture, he acquires his maker's name but has no name of his own. Frankenstein's sense of responsibility for his creation vacillates but he never assimilates the monster as part of himself. What Mary Shelley seems to do in the story, partly through her sympathy with the monster and her sense of injustice done to him, is to approximate an assimilation whereby Frankenstein and the monster seem during the course of the narrative to exchange places. Frankenstein as the embodiment of reason and knowledge becomes increasingly deranged and experiences something like a breakdown. On the other hand, for all his outbursts of destruction the monster's actions appear to be based on reason and 'fine sensations'.[11]

Another way in which Shelley comments on Frankenstein's actions is to demonstrate through the course of the narrative how his failure to take responsibility for his monstrous other leads to tragedy and destruction and is the main cause of his downfall. Certainly, as Johnson suggests,[12] Shelley's sympathy with the devil stems from her Romantic stance on the human condition in nineteenth-century society. Shelley's monster originally possesses a child-like innocence, he is unlearned, pure, 'natural'. He is corrupted by a society which rejects and casts him out for no good reason, and only because he is different. The monster comes to embody Frankenstein's inner 'monstrosity' – aspects of himself which he finds dangerous or unacceptable. The monster, like Dorian Gray's picture, is ugly so that Frankenstein appears beautiful: 'my form is a filthy type of yours, more horrid even from the very resemblance.'[13] Shelley shows that it is on account of his appearance, his physical difference, that the monster originally appears monstrous and is rejected by society. He approaches a blind cottager and is received with warmth and sympathy, but when he is seen by the blind man's family he is attacked and driven out. So Shelley's sympathy with the monster is at least in part a sympathy with difference which is normally received in negative terms as monstrosity.

In her chapter 'Mothers, Monsters and Machines', Rosi Braidotti comments on the negative status of difference within Western

thought and society: 'It can be argued that Western thought has a logic of binary oppositions that treats difference as that which is other-than the accepted norm.'[14] The monster, she says, 'is the bodily incarnation of difference from the basic human norm; it is deviant, an a-nomaly; it is abnormal'.[15] She also argues that there is an historical association between women (understood in biological or essentialist terms as mothers) and monsters, which she traces back to Aristotle. In 'The Generation of Animals' Aristotle argues that the human norm is male:

> Thus, in reproduction, when everything goes according to the norm a boy is produced: the female only happens when something goes wrong or fails to occur in the reproductive process. The female is there-fore an anomaly, a variation on the theme of man-kind.[16]

Women are different and therefore deviant, monstrous, other. Their monstrosity is located in the body and in the biological function of reproduction and childbirth:

> The woman's body can change shape in pregnancy and childbearing; it is therefore capable of defeating the notion of fixed bodily form, of visible, recognisable, clear and distinct shapes as that which marks the contours of the body. She is morphologically dubious.[17]

Braidotti goes on to argue that 'the female body shares with the monster the privilege of bringing out a unique blend of fascination and horror' which 'psychoanalytic theory takes . . . as the fundamental structure of the mechanism of desire'.[18] Here she refers to the work of Julia Kristeva and the concept of the maternal body as 'the site of the origin of life and consequently also of the insertion into mortality and death'.[19] In psychoanalytic terms the mother is the original love object and her body represents 'the threshold of existence'. It is an ambiguous and, in Kristeva's terms, 'abject' site of unclear boundaries and bodily fluids, associated with both interior and exterior worlds, unity and separation, life and death. The state of unity with

the mother's body gives it the connotations of death, of returning to the womb, of going back to a condition prior to separation and birth into individuality. Freud's Oedipus complex describes 'the psychic and cultural imperative to separate from the mother and accept the law of the father'[20] but anxiety about the female body as the site of origin is compounded for the male subject through the terms of castration.

Freud connected this logic of attraction and repulsion to the sight of female genitalia; because there is nothing to see in that dark and mysterious region, the imagination goes haywire. Short of losing his head, the male gazer is certainly struck with castration anxiety.[21] In this way, the difference of the female body signifies monstrosity. The connection between women, monsters and machines is made obvious for Braidotti in the context of new reproductive technologies:

> The possibility of mechanising the maternal function is by now well within our reach; the manipulation of life through different combinations of genetic engineering has allowed for the creation of new artificial monsters in the high-tech labs of our biochemists.[22]

Like Treichler, Franklin and others, Braidotti views the relationship between women and these technologies with a political urgency, and regards contemporary biotechnology as a conclusive sign of the power of science over women's bodies and as an instance of autonomous reproduction within the masculine scientific community.

In response she instigates a strategic feminist rethinking of the configuration, mothers, monsters and machines and of the concept of difference. Difference has negative connotations within Western culture and epistemology. In attempting to rethink the status of difference and therefore of women in Western society, 'feminists are attempting to redefine the very meaning of thought'. In order to do this effectively, Braidotti advocates a style of 'epistemic nomadism' which is 'securely anchored in the "inbetween" zones'[23] of existing disciplines and academic discourses, and which is also rooted in experience. She insists on retaining a view of new reproductive technologies as politically contestable, but contestable in a society with strongly marked gender hierarchies. The contest is made doubly ur-

gent by this imbalance of power and by the 'implosive peak' already attained in science's quest to father itself.

NEW IMAGING AND REPRODUCTIVE TECHNOLOGIES AND WOMEN'S BODIES

Braidotti makes it clear that her concern with epistemology and epistemological transformations is grounded in a historical materialism:

> The kind of feminism I want to defend rests on the presence and the experience of real-life women whose political consciousness is bent on changing the institution of power in our society.[24]

Feminist epistemology has Marxist roots and grew out of the need to rethink foundational but essentialist categories such as 'woman'. The category of woman needed to be divorced from its universalist and biological essence in order to represent adequately the diversity of women's lives and experiences. This of course renders the term inherently unstable and problematic within feminist discourse, and poses problems for the notion of feminism itself. Nevertheless, theorists such as Braidotti retain a commitment to social change for women understood as a range of existing and potential subjectivities.

To the feminist epistemologist social change is inseparable from, and indeed premised on a grass roots shift in the way in which categories such as woman, monster and machine are thought. If we continue to think of women as others and of others as threatening, intolerable or monstrous, then what difference does a development in machinery, for example, make? Will women not be represented and treated in the same way?

If there is no consensus of opinion over the state of the contest over new imaging and reproductive technologies in contemporary feminist research, then there seems to be a current of opinion that the nature of the contest is not strictly technological. But where there is a welcome shortage of technological determinism there would seem to me to be a tendency towards a kind of techno-historical totalism where technology is part of a scenario in which either everything or nothing has changed. Martha Rosler informs us that: 'in medicine, digitised imagery, particularly in conjunction with CAT scans and ultrasound,

is producing a new type of representation of bodily innards'.[25]

It seems appropriate at this point to consider what this new type of representation signifies. What is the connection between medical representation and structures of knowledge and power? Are these new too? Barbara Maria Stafford argues that they are, or at least could be, and that 'the marvels of non-invasive body scans are but one small instance in our culture of an undeniable pictorial power for the good'.[26] She suggests that they contribute to a shift in Enlightenment epistemology away from an intrusive dualistic and anatomical model of knowing and towards 'a new and non-reductive model of knowing'[27] which I have argued is analogical. Stafford connects Enlightenment epistemology with patriarchal power but maintains that in the new unified world of electronic imaging:

> the opportunity exists not only to free the image from patriarchal rule, but to liberate other, supposedly lesser orders of being from domination and a false sense of superiority. These 'inferior' forms of nature include any sex other than male, races other than white, creatures other than man, and environments other than industrial or corporative.[28]

Against this, Mary Jacobus, Sally Shuttleworth and Evelyn Fox Keller maintain that advances in technology contribute to the perpetuation and indeed fulfilment of Enlightenment structures of domination in modern medicine, as they note:

> The last two centuries have witnessed an increasing literalization of one of the dominant metaphors which guided the development of early modern science.[29]

The metaphor which has been literalized through technological change and the professionalization of science is, they suggest, Bacon's metaphor of scientific knowledge 'as the domination of the female body of nature'. Domination has developed into an explicit material and ideological practice not least in the context of new reproductive technologies:

Viewed as medical events, pregnancy and childbirth can be monitored and controlled by the latest technology, while in the laboratory, women's role in reproduction is increasingly open to question; IVF and the burgeoning of genetic engineering offer to fulfil, with undreamt of specificity, earlier visions of science as the virile domination of the female body of nature.[30]

The authors point out that the reproductive autonomy of science is based on its construction of the female body as an inefficient mechanism of both production and reproduction. Science legitimizes its practices on the basis that technology is merely helping or correcting for deficiencies in nature. Technology therefore acquires 'the agency and [re]productive powers previously assigned only to human life'.[31]

But, at the point where technology appears to be taking over the reproductive role of women, a new anxiety seems to arise within both medical and popular discourse and representation. If the desire for technological autonomy is already based on a fear of the maternal body and a construction of it as faulty, then, according to Mary Ann Doane this fearful and faulty body may appear to infect the technology which is there to correct and control it:

Technology promises more strictly to control, supervise, regulate the maternal – to put limits upon it. But somehow the fear lingers – perhaps the maternal will contaminate the technological.[32]

Alternatively, Sarah Franklin argues that if the female body is regarded as being finally and fully delimited and controlled, then science and technology lack what she calls the 'foundational authority' of nature – the status of being absolute, certain or real. Rather, 'the absolute provided by the belief in technological enablement, or scientific progress, is the promise of unbounded possibilities.'[33] Either way, the authority of science and its epistemological categories (subject/object, nature/culture) is threatened, and the result according to both Doane and Franklin is a proliferation of anxiety-ridden images of bodies and machines in popular culture and particularly (for Doane)

science fiction films such as the clutch of *Alien* films where we are presented with the almost archetypal monstrous mother machine.

For me, Constance Penley most accurately identifies the current status of bodies and machines in institutional and popular discourse by suggesting that there is a 'frequent conflation of women-out-of-control with technology-out-of-control'.[34] She argues that the proliferation of stories and jokes about Christa McAuliffe and the Challenger explosion is a key case in point. According to Penley, the story of Christa McAuliffe (partly because of what is not known about the disaster) 'has become densely inscribed in science fictional, mythical, folkloric and ideological narratives about women, space and catastrophe'. But at the same time she asks: 'How might some of these narratives be rewritten to shift or reshape their figuration of the woman as the embodiment of technological disaster, as someone who has no place in space?'[35] In answer to this she suggests that science, in this case NASA, ends its secrecy and allows all mourners to have empirical knowledge of the disaster so that a process of re-narrativization might take place. Penley points out that she is not opposing fantasy to fact but:

> Rather the issue is to demand better science while acknowledging the work of fantasy in everyday life, popular culture, and scientific practice, and recognising that one can get at the empirical only through understanding the omnipresence of fantasmatic thought.[36]

SCIENCE, FANTASY AND MYTH

The presence of the unconscious, of fantasy and particularly of anxiety, I suggest, undermines the totality of scientific achievement in Enlightenment terms. Anxiety is precisely about subjects (not objects) being or feeling uncontained and out of control. I would maintain that the construction of ideas and images about women and/or technology being out of control is a projection from the subject's unconscious and there is no place for the unconscious, irrational subject in Enlightenment discourse. Where the presence of the unconscious acts as a form of resistance or at least sabotage, there is also the presence of conscious acts of resistance to scientific author-

ity and inscription – acted out invariably by those who consider themselves to be at the receiving end of it. In two issues of *Camera Obscura*[37] the editors Paula A. Treichler and Lisa Cartwright incorporate work on various forms of political and representational activism against dominant medical inscriptions. Contributors look at how imaging and reproductive technologies 'are internally critiqued and retooled to produce technological innovations, to cultivate counterpractices, or to interrogate and disrupt institutional discourses of science and medicine.'[38] A notable example is that of AIDS activism which incorporates practices of self-representation.

With these two forms of resistance in mind I propose that the prospect of a fully autonomous reproductive science and technology is a patriarchal fantasy which is enacted or acted out to an inevitably limited degree in the face of women's persistent ability to have children and in response to an ongoing and ever present fear of the female body read in the essentialist terms of its maternal function. The fantasy of fathering offspring without women is a defence against the anxiety provoked by the ultimate limitation placed on this desire.

In the same way I suggest that the re-creation of Adam and Eve in cyberspace is also an omnipotence fantasy enacted in the face of medicine's generative limitations and by means of a fetishistic use of technology. New imaging and reproductive technologies may be seen to compensate as much for a paternal lack (the inability to produce children) as for a maternal threat, but as Mary Ann Doane makes clear, the link between technological fetishism and the female body is a crucial one:

> Technological fetishism, through its alliance of technology
> with a process of concealing and revealing lack, is
> theoretically returned to the body of the mother.[39]

Paradoxically, where the maternal body is feared it is also desired because it is 'the one site of uncertain origin'[40] and offers 'a certain amount of epistemological comfort.'[41] The mother 'guarantees, at one level, the possibility of certitude in historical knowledge. Without her, the story of origins vacillates, narrative vacillates.'[42] As Braidotti points out 'psychoanalysts like Lacan and Irigaray argue the epis-

tem(ophil)ic question of the origin lies at the heart of all scientific investigation.'[43]

So the mother's body will never be finally erased from the material, ideological or epistemological practices of contemporary science and (bio)technology because they cannot properly exist without it. It might, however, be argued that science has so far problematized and sought to erase the function of the maternal body that fears and desires which originally belong to it are experienced through forms of technophobia and technophilia respectively.

Fears and desires, technophobia and technophilia are effectively the two sides of the same coin. The Visible Human Project and the Human Genome Project seem to me to be driven by an intensely ambitious desire to know, which combines a mixture of fear and fascination because: 'The desire to know is, like all desires, related to the problem of representing one's origin, of answering the most childish and consequently fundamental of questions: "Where did I come from?"'[44] What is more, according to Braidotti:

> Scientific knowledge becomes, in this perspective, an extremely perverted version of that original question. The desire to go and see how things work is related to primitive sadistic drives, so that, somewhere along the line, the scientist is like the anxious little child who pulls apart his favourite toy to see how it's made inside. Knowing in this mode is the result of the scopophilic drive – to go and see, and the sadistic one – to rip it apart physically so as to master it intellectually.[45]

ADAM AND EVE IN CYBERSPACE

The Visible Human Project uses state of the art imaging technologies in a pioneering scheme to obtain a complete visual archive of the male and female body for medical research and training. In order to obtain the archive, the male body, nicknamed Adam, was scanned, sliced up and photographed at one millimetre intervals and then recreated in cyberspace. For the purpose of better image resolution, Eve was subsequently put through the same process at one third of a millimetre intervals.

40

The project originated in the National Library of Medicine's 1986 Long Range Plan which recommended that the library should 'thoroughly and systematically investigate the technical requirements for and feasibility of instituting a biomedical images library.'[46] The image library would complement the library's stock of medical textbooks and would consist of digital images which could be distributed over high speed computer networks. In 1989 a planning panel on electronic image libraries was formed and this recommended that: 'NLM should undertake a first project building a digital image library of volumetric data representing a complete, normal adult male and female.'[47] The Visible Human Project should 'include digitised photographic images for cryosectioning, digital images derived from computerised tomographic and digital magnetic resonance images of cadavers.'[48]

The candidates for the project were chosen with care, or as one journalist put it, they 'had to meet some pretty stiff requirements'.[49] The criteria for 'normality' were set at being between twenty and sixty years of age, average weight for height, under six feet tall and without any visible abnormalities or significant surgery. They had to have died a 'non-violent' death so that the appearance of their bodies was not affected, and it was intended that they should remain anonymous.[50]

> The contract for Adam and Eve was awarded to Dr Victor Spitzer and Dr David Whitlock at the University of Colorado. Dr Spitzer outlined Adam and Eve's principal role and the aptness of their nicknames: 'the bodies chosen for this project will become the archetypes for the human form. They'll be used for research and study for years to come.'[51]

Adam was scanned at cross-sectional intervals, first as a fresh and then as a frozen corpse by computed tomography. The magnetic resonance imaging scans were longitudinal. In order to obtain photographs at the same interval, he was frozen to -70 °C, immersed in gelatin, cut into four sections and put through an industrial planer. Photographs were taken as each new surface was exposed: 'We want to be as thorough as possible', Dr Spitzer said during the course of

the project.[52] The 1878 computed tomography scans and congruent colour photographs 'can be restacked to define the human body at every location in space with 1mm voxels'.[53]

So Adam and Eve are now available on the Internet and on digital audio tape as vast amounts (approximately 21 gigabytes or the equivalent of 35 CD-ROMS for Adam alone) of raw data. It would take around two weeks to download Adam in his entirety (and presumably three times longer for Eve), and unless you were already trained in anatomy it would be hard to know what you were looking at. The Visible Human data set is as yet an unclassified, unlabelled archive, and the National Library of Medicine is seeking a computer programme which can outline and annotate Adam and Eve's organs. Recalling for a moment Bertillon's experience of classification and photography, it seems that once again (but now in the context of digital imaging) we have 'the fundamental problem of the archive, the problem of volume'.[54]

The current state of the project entails the process of anatomical classification and annotation of the data. From there, the aim 'is to produce a system of knowledge structures that will transparently link the visual knowledge forms to symbolic knowledge formats'.[55] A method is needed for linking images to names and other textual information, and the project is considering the use of hypermedia 'where words can be used to find pictures, and pictures can be used as an index into relevant text'.[56] There is as yet no method for linking image and text based anatomical information or for linking structural/anatomical to functional/physiological knowledge, but the goal of the project 'is to make the print library and the image library a single unified resource for medical information'.[57]

The applications of the Visible Human Data Set begin to sound futuristic, if not apocalyptic, quite quickly. They range from identifying anatomical structures on the cross-sections to ending the need for the practice of pathological anatomy and achieving 'interactive total body control and simulation (including simultaneous modelling of all the synergistic and antagonistic muscle motions)'.[58] The project therefore points the way towards virtual medicine and has started investigating ways of simulating realistic muscle movement and resistance using Adam as a 'unique source of real human anatomy'.[59] It is like-

ly to be in the area of surgical simulation and three-dimensional re-
construction that Adam and Eve will come into their own, and where
virtual medicine will emerge. Though research is ongoing, virtual
medicine is still a step or two away:

> For one thing, the three-dimensional images are nowhere
> near sharp enough. For another, though impressive, the
> speed with which they can be manipulated – turned, sec-
> tioned, coloured, made transparent or stripped away – still
> leaves a lot to be desired.[60]

As an exercise in advanced imaging, the Visible Human Project pre-
figures an era of virtual medicine which will undoubtedly arrive, and
in doing so marks another milestone in scientific progress. But the
project does not leave all of the old technologies (or values) behind.
Photography still has a key role to play in the establishment of this
archive, and the archive has been and is being constructed using
many of the values that informed the earliest attempts at visually
documenting and classifying the human form.

Dr Michael Ackerman, project organizer at the National Library of
Medicine, pointed out that all of the digital data is transferred onto
photographic film because film provides the greater image resolution
and storage capacity even though it is less effective at retrieval and
distribution. For him, film is the 'ultimate archival unit'[61] and as such
all film for the project is kept in a vault.

As a computer imaging and archiving project, the Visible Human
Project demonstrates that photography is far from dead. Neither are
the ideologies of the earliest photographic projects aimed at archiv-
ing the human body. It is clear that the selection of Adam and Eve
was typographical and subject to a process of normalization. Where
Adam represents the average man, Eve represents the average
woman. They are therefore (again) fictional archetypes against which
(real) others will be measured and defined.

As Richard C. Lewontin points out in 'The dream of the human
genome', the Human Genome Project is also premised on a concept of
the average man and sets standards for normalization. This project
aims to map 'the complete ordered sequence of As Ts Cs and Gs – the

four nucleotides – that make up all the genes in the human genome', and like the Visible Human Project will generate a huge archive of information or 'a string of letters that will be three billion elements long'.[62]

Information about the human genome is intended for use in isolating and eliminating defective genes and gene disorders such as cystic fibrosis. But Lewontin suggests that a knowledge of DNA sequence doesn't necessarily help in tracing the cause of a disorder and therefore generating a cure. Beyond the limitations of a diagnostic approach at this level, he points to the wider problem of biological determinism which surrounds the project:

> The medical model that begins, for example, with a genetic explanation of the extensive and irreversible degeneration of the central nervous system characteristic of Huntingdon's Chorea, may end with an explanation of human intelligence, of how much people drink, how intolerable they find the social condition of their lives, whom they choose as sexual partners, and whether they get sick on the job. A medical model of all human variation makes a medical model of normality, including social normality, and dictates that we pre-emptively or through subsequent corrective therapy bring into line anyone who deviates from that norm.[63]

The Human Genome Project may become continuous with the ideology of eugenics and may also be said to be in keeping with a wider manifestation of biological determinism in contemporary technoscientific culture.[64] But if DNA sequences do not determine the cause of physical or social ills, then what else might this huge quest for knowledge be about? It might be argued that the project is cloaked in metaphysics and 'the conviction that DNA contains the secret of human life'.[65]

A successful attempt to map the human genome and 'compute the organism'[66] would therefore lead scientists to enlightenment and beyond. Rather like re-creating Adam and Eve in cyberspace, discovering the human genome is something of a god-like act. In literary

terms (and from Satan to Faustus to Frankenstein), when men act like gods they are called overreachers and, as Lewontin suggests, those who have sought to know the secret of life 'have exchanged something a good deal more precious' than time and effort or power and money.

'PREPARE TO HEAR OF OCCURRENCES WHICH ARE USUALLY DEEMED MARVELLOUS'

Rather like the story of *Frankenstein*, the Visible Human Project and the Human Genome Project illustrate the 'omnipresence of fantasmatic thought' in science, or rather, they demonstrate that the realms of fact and fantasy are co-existent. A piece of Gothic fiction, a state of the art medical imaging project and a pioneering exercise in biotechnology would appear to be driven by a similar metaphysics and to exist in the perhaps not so separate worlds of science and the supernatural, the social and the psychic. Where the Visible Human Project clearly represents progress in medical research and will undoubtedly benefit human life, it is also, I would suggest, the epitome of what Donna Haraway refers to as the 'god-trick'.[67] It would seem to be a product of infinite vision and can be said to express an unconscious desire for omnipotence, immortality and transcendence. In terms of the relationship between medical science and the human body, the project represents everything seen from nowhere. It is the product of a disembodied knowledge and power. The organizers of the project have re-created Adam and Eve in cyberspace without a trace of self-consciousness or irony, but with a rather contagious and uneasy fascination with the more macabre aspects of the process and an obvious sense of technological achievement. Adam and Eve are freely and widely available (at least parts of them are) on the Internet. Given the right technology anyone can download the sample data set, and it is necessary only to sign a licence agreement with the National Library of Medicine in order to publish or reproduce the images. Given the level of excitement and expectation concerning the Internet within medicine and elsewhere, there is a sense in which Adam and Eve will be set loose in a technological Eden. Who or what is responsible for their fate has yet to be determined as the library's primary objective has been fulfilled and they are now set to be parcelled

45

off into various commercial ventures which can further develop and promote their potential. Adam and Eve may signal the start of a new race in cyberspace as there have been suggestions of cyborg offspring.

So in the Visible Human Project medical science would seem to have pulled off the god-trick of infinite vision, and simulated autonomous creation. I want now to return to *Frankenstein* in order to develop the notion of autonomous creation as a fantasy enacted in the face of generative limitations and a fear of the female body. As a fantasy which is also enacted by means of technological fetishism however, I want to suggest that Frankensteins everywhere are inevitably returned to the point of origin and that their fears and fascinations always concern the mother's body even if they come to be expressed as fears and fascinations about science and technology itself.

Frankenstein tells his story in order to prevent the downfall of another potential overreacher who is on a mission of discovery to the North Pole and will stop at nothing in order to boldly go where no man has gone before, to confer 'inestimable benefit' on mankind and to 'accomplish some great purpose'.[68] Frankenstein tells Walton that 'knowledge and wisdom' can be 'a serpent to sting you' and begins his story at the beginning – with his origins and his mother (a 'virtuous woman'). He describes his early quest for knowledge in terms that are both sadistic and sexual. His interest in the world was of the rip it apart and see how it works variety which is contrasted with Elizabeth, his 'more than sister' and soon to be wife's gentle contemplations. He describes it as a channel for his anger which elevates him to the realms of metaphysics:

> My temper was sometimes violent, and my passions vehement; but by some law in my temperament they were turned not towards childish pursuits but to an eager desire to learn, and not to learn all things indiscriminately . . . It was the secrets of heaven and earth that I desired to learn . . . my inquiries were directed to the metaphysical, or in the highest sense, the physical secrets of the world.[69]

He also tells of the birth of a passion which arose 'from ignoble and almost forgotten sources . . . swelling as it proceeded' until it 'became the torment which, in its course, has swept away all my hopes and joys'.[70] Knowledge and desire are presented as being linked at the point of his origin. He is specific about the nature of scientific knowledge which engages him, describing it ultimately as a bringing together of pre-modern (alchemical) science and its lofty metaphysical leanings with the mechanical and instrumental science of the Enlightenment. Frankenstein completes his education away from home and after his mother's death. He resolves to 'pioneer a new way' and while training himself in anatomy and observing 'the natural decay and corruption of the human body' he succeeds in 'discovering the cause of generation and life' and moreover finds himself 'capable of bestowing animation upon lifeless matter'.[71] Frankenstein performs his god-trick in an attic but is clearly optimistic about the outcome at this stage: 'A new species would bless me as its creator and source; many happy and excellent natures would owe their being to me. No father could claim the gratitude of his child so completely as I should deserve theirs.'[72] But he rather changes his mind once his ambition has been achieved and desire gives way to disgust: 'I had desired it with an ardour that far exceeded moderation; but now that I had finished, the beauty of the dream vanished, and breathless horror and disgust filled my heart.'[73] Frankenstein shuts himself in his bedroom, dreams of embracing his lover who turns into his dead mother, and wakes to find his very own monstrous creation at the side of his bed. He flees but the monster returns with reasonable demands and criticisms and gives him another opportunity to take responsibility for his creation:

> I ought to be thy Adam, but I am rather the fallen angel,
> whom thou drivest from joy for no misdeed. Everywhere
> I see bliss, from which I alone am irrevocably excluded.
> I was benevolent and good; misery made me a fiend.
> make me happy, and I shall again be virtuous.[74]

When the satanic monster that should be Adam demands his Eve, Frankenstein agrees to create her. He delays his own wedding until

he has done so, but having put her together he tears her apart again in front of the monster, without ever having given her life. The monster, not well-pleased, warns him that 'I shall be with you on your wedding-night' and when that 'dreadful, very dreadful' night arrives, so does the monster who kills Elizabeth before the marriage is consummated. From here, Victor pursues his monster to the death. He dies on completion of his account to Walton and with a final admonition to: 'seek happiness in tranquillity and avoid ambition, even if it be only the apparently innocent one of distinguishing yourself in science and discoveries'.[75] Science and knowledge in themselves appear to be what Frankenstein desires then fears. They are the source of his sexual passion and his lesson to Walton. But the movement between fear and desire can be traced in the narrative by the love and loss of his mother and his lover (who are interchangeable in his dream). The loss of his beloved mother prefigures his act of scientific creation and the loss of Elizabeth signals his/its final destruction. As his double, the monster embodies not merely Victor's scientific ambitions but his unconscious relation to the two central women characters – his wish to restore his mother to life and to prevent sexual contact with Elizabeth. It is Elizabeth who represents the maternal function of the female body in the narrative. It is she who could conceive. Victor's mother, having raised him, adopts an orphan – Elizabeth – and provides him with a substitute m/other in this way. The monster's destruction of Elizabeth on their wedding night is mirrored and prefigured by Frankenstein's destruction of Eve – the monster's bride to be. Frankenstein's act of autonomous fathering, his creation of the monster, is therefore accounted for in part by his wish to avoid involving a woman in the process of reproduction.

It is the monster, as Victor's other, who most clearly expresses and exposes the nature of scientific obsession and its connection to the question of origins. The monster is able to answer the question 'who am I, where did I come from?' by reading the papers in Frankenstein's journal:

> Everything is related in them which bears reference to
> my accursed origin; the whole detail of that series of dis-
> gusting circumstances which produced it is set in view;

the minutest description of my odious and loathsome person is given, in language which painted your own horrors and rendered mine indelible. I sickened as I read. 'Hateful day when I received life!' I exclaimed in agony. 'Accursed creator! Why did you form a monster so hideous that even you turned from me in disgust?'[76]

But the monster can answer the question of origins because he is a product of scientific creation – because he was fathered by men. In this sense he speaks the voice of difference, he speaks as the monstrous (feminine) other, and questions why he was constructed as such. Shelley's sympathy with the monster is most evident at this point, and it is from here that she imagines but is forced to reject a scenario in which Frankenstein accepts his monster as himself, and in which difference might be tolerated in society.

By using the story of *Frankenstein* in my analysis of NITs and NRTs, I have attempted to underline the interaction between science and myth, fact and fantasy and to raise the issues of creation and responsibility which surround the relationship between self and other in this context. The Gothic novel offers the useful trope of the double, the other or monster who is clearly related to the central character (or self) of the novel. When faced with dominant configuration of the monstrous mother machine, and with feminist attempts to reconfigure the relationship between women and technology, it seems to me to be important to remember and acknowledge that what we construct as monstrous and other refers directly to a split off and projected part of ourselves. The enduring tale of Frankenstein's monster leads us reliably back from a preoccupation with the fascinating and fearsome creations of science to the masculine scientific subject that made them so.

IMAG(IN)ING THE CYBORG

Jane Prophet

This image and text piece presents some of the issues which preoccupy me in my role as an artist working with video and digital media. Most of my works are concerned with ways in which new media technologies are changing relationships between audience, artefact and gallery. Representations of the body and its virtual and/or remote presence are central to a number of these projects, and build on my early background in installation and performance work.

The Imaginary Internal Organs of a Cyborg[1] is a CD-ROM which takes the physical form of the cyborg as a vehicle for exploring philosophical and cultural spaces. The piece employs digital techniques to build up layers of images and sounds – these range from the use of low resolution QuickCam video sequences to 3D computer modelling, from interviews with surgeons and medical researchers to the use of ready-made images from the Wellcome Photo Library and from PhotoDisc. While on the one hand the images appear to represent a body, or a series of bodies, my intention has been to create a transfigurative work which investigates ways in which our sense of self has a fluidity that defies a spatial containment within the 'universal' body. The focus of the work is the impermanence and dissolution of boundaries between the human and machine, the inside and outside and the natural and the artificial. The sense of self that this cyborg has is based upon an awareness of unbounded territories. Christine Battersby contrasts the cognitive semantic view of the body as 'a container for the inner self, all bodies basically the same, over which cultural differences are laid, with the body as an open permeable and fissuring space'.[2] Battersby states that:

> feminists need – for political ends – to exploit the difficulties of containing female identity within the

schemata provided by classical science and meta-physics, and use the resources provided by contempo-rary science and the history of philosophy to think selves, bodies and boundaries in more revolutionary terms. In this respect I agree with Donna Haraway in the alliance with the cyborg. It is time to turn our backs on those forms of feminist theory that castigate all sci-ence and all Western philosophy as rationalist, mas-culinist and weapons of the enemy. It is time to investigate the imaginative schemata that old philoso-phies and new sciences offer us for re-visioning the fe-male self.[3]

An attempt to re-vision and imagine the female self underlies *The Imaginary Internal Organs of a Cyborg*. The first stage of the project, completed in Spring 1996, involved exploring the heart, a rich and contested site, and one which offered up a turbulent eddy of associ-ations. The heart is simultaneously considered as a Cartesian pump-ing machine contained within the body and as the seat of Romantic love, which seeps out of the confines of the body, merging fantasy with flesh. The ability to feel and express emotion, especially love, is commonly held as that which sets the human aside from the ma-chine. In science fiction writing it is more often the brain that be-comes the focus for exploring cyborg identities, this is epitomized by the recurring theme of a human personality – the contents of a per-son's brain – being transferred onto a computer chip. As the project developed I turned my attention to the brain which is treated as the site for exploring distributed memory, neural networks and artificial intelligence. I then concentrated on the stomach which embodies ideas of the digestion and assimilation of data and becomes the cen-tre of the cyborg as a flow of information. Here too are references to everyday associations of the body with emotional states, and its at-tendant focus on nausea and appetite.

The images and sounds that make up *The Imaginary Internal Organs of a Cyborg* together form a figuration of the cyborg – paro-dying the world of advertising and the culture of medicine. Sarah Kember has argued that figuration (as opposed to representation)

has a self-conscious relationship to epistemological structures. Figuration is representation plus. It offers a partial and situated knowledge and tends towards shifting subject positions, it:

> is an alternative verbal or visual language which embodies a transformation in the terms of knowledge, power and subjectivity. It strategically resists and competes with the structures of patriarchy and the Enlightenment – specifically a gendered and hierarchical dualism which privileges culture over nature, mind over body, male over female. Its usual mode of operation is parody.[4]

The body has long been used by women artists as a site for intervention[5] and the cyborg body, or bodies, provides a rich philosophical and cultural locus. This territory is unfixed and constantly shifting, more like duned desert than solid ground, with cyborg identities appearing like mirages, shimmering and difficult to make out, disappearing and then re-emerging changed elsewhere. I have found the metaphor of the mirage particularly useful as I try to imagine the cyborg body: the mirage is an optical illusion in which images of distant objects, hidden or beyond the horizon, become visible by the refraction of light. New medical imagining technologies have brought images of the interior of our corporeal 'landscape' to us which are invisible to our unassisted vision. The cyborg has occupied a space somewhere just beyond our event horizon and images of the augmented body appear before us in science fiction films, medical journals and popular science TV programmes like images from a place just beyond our reach. Each of the cyborg identities is a refraction of our earth-bound desires and fantasies about our bodies, of our drive to improve our longevity, to extend our physical and mental capabilities or to circumvent social and cultural restrictions.

Issues of gender permeate the piece, though I deliberately chose to work with internal organs which were not sex-specific in an attempt to move away from a biologically determinist reading of femininity. However I am mindful of the problems of adopting a liberal theory stance on the body, as Donna Haraway argues:

53

Liberal theory was a resource for feminists, but only at the expense of renouncing anything specific about women's voice and position, and carefully avoiding difference, for example race, among women. The 'neutral' body was always unmarked, white and masculine.[6]

Rather than trying to visualise a non-specific or universal body by focussing on its potential for neutrality, it may be more useful to shift the emphasis to the position and identity of the eye that looks at it. Baxandall's[7] idea of the 'period eye' provides a useful framework for looking at images of the body. Simply put, the 'period eye' refers to the skills of interpretation and the cultural context that viewers in a particular chronological and geographical location bring with them when they look at images. The eye with which we view representations of the contemporary body is located in a period where we have become familiar with images of simulacra and our late twentieth century beau ideal frequently turns out to be surgically altered or digitally enhanced. The contemporary notion of ideal beauty incorporates a post-modern philosophy of transience – a belief that the nature of being is subject to change, that our physical states need not be fixed by nature, but can be altered utilizing new technologies such as genetic engineering, surgery and pharmaceuticals to produce a cyborg which might embody excellence.

If the cyborg can act as a philosophical space, then it is a territory criss-crossed with tracks left by malevolent super-machismo man-machine hybrids from sci-fi films and books – these are the emotionless killing machines that figured strongly in the popular culture of the 1980s, whose bodies were high tech, high performance weapons. Overlaying these are other traces: the cyborg as a chimera, a blend of human and animal organs, the embodiment of wild fancy and imagined horror.[8] The chimera is chemically 'fixed', rather like a photograph, its hybrid form is held together with pharmaceuticals which prevent the

human body rejecting donor organs, and the relationship between the host and foreign bodies, once established is monitored by imaging technologies. Here also is the mark of the analogue cyborg, the woman with the mechanical heart valves or the artificial hips, the child with the metal plate in its head or the steel pins in its shins.

The cyborg occupies spaces between flesh and information, straddling the boundaries between the natural and artificial. We have become used to the notion of the body as 'meat' and while many cultural theorists emphasise that this view is not a continuation of the Enlightenment 'Flight from the Body' they pay little attention to the hardships and pain that a journey of physical augmentation or alteration entails. The transformative journey from human to post-

human invokes a keen awareness of the physicality of the flesh through the experience of surgical and pharmaceutical intervention. The body is meat and we need cleavers, knives and saws to open it, clamps and braces to hold it open while it is worked upon, staples and stitches to close it up. Its meatiness is prone to rotting and degeneration, and renders the corpus in need of preservation.

Stored in formaldehyde and held frozen in cryogenic tanks, opened butterfly-like, brains are a sign of the mysterious flowering of our intellect. Imaging technologies are used to expose the inner workings typified by the vast and uncharted territory of the synapses. Rows of jars in museums: the brain of a serial killer, Einstein's brain, so

many uncontextualized and unexplained disembodied brains free-floating, held as the measure of criminality or genius. We have become used to the idea that our intellect, somehow seated in our brain, is what separates us from other animals. The development of our brain, in particular its larger size, is used as an indicator of our superiority and elevated position in relation to other primates. Medical imaging systems expose the formerly invisible processes and recesses of the body to a technocratic gaze, drawing out our innermost functions from the private to the public sphere of visual culture. Here again is a confusion of boundary, a subsidence of the private into the public and an eruption of the public into the private, as ultrasound images of the foetus and magnetic resonance imaging (MRI) scans of the brain are tucked into family albums, passed round at parties alongside snapshots of the exterior body.

The heart of the cyborg beats in time to the metronomic pacemaker. Airbags are inserted along collapsing arteries by surgeons trained on virtual reality simulations. Metal valves click like old clocks. Animals are bio-engineered for human transplant compatibility. The meat-market economy of 'Third World' organ donation is wiped out

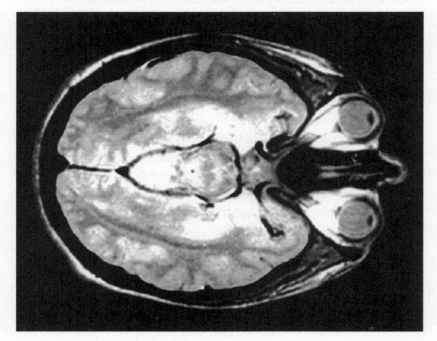

by the increased use of pigs from medical farms which are owned and controlled by the 'First World' medical infrastructure. Thus each operation and transplant forms an integral part of the financial structure of the architecture of medicine.

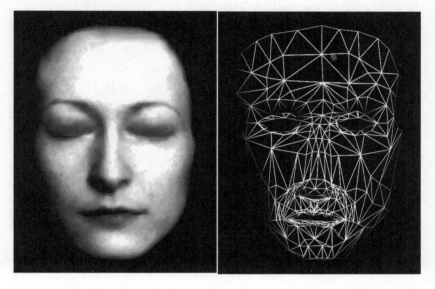

The Imaginary Internal Organs of a Cyborg returns us to the malleable architecture of the imagined cyborg body, to the cyborg stomach where there are remnants and semi-digested fragments of many a cyborgian fantasy. These include traces of the digital cyborg which has become immaterial – a pure information space – with a digital body of algorithms, which ingests zeros and ones of 'pure' information like an expensive drug. Virtual cakes and sweets lie next to real ones, eye-candy and cake to fuel and fatten the meat. Performance enhancing vitamins, steroids, antibiotics, artificial hormones create a soup of biotechnology navigated by self-propelling pills containing bite sized nano-surgeons. This cyborg has devoured medical science, pulled the surgeon in through the wound and kept 'him' prisoner within walls of flesh. Like the woman who swallowed the spider, augmentation wriggles and wriggles inside her. The fairy cakes, lamb chops and fresh vegetables all hold within them the traces of a drive to improve performance and longevity: faint tastes of pesticide, the feel of waxy skin and the endlessly fresh bloom of irradiation. The

stomach contents of this cyborg are held in a small space, the stomach tucked to create a flatter outer appearance and the intestine shortened to make room for a Hi NRG Carbohydrate Converter and more information technology.

The cyborg body as a subject for philosophical enquiry is, like all bodies, inscribed with the values and beliefs of the culture from which it emerges. Biotechnical advances and cybernetic developments embed the cyborg within military and industrial commodity[9], but its identity splits and fissures as we import ideas of Artificial Intelligence and neural networks which challenge our notions of what it is to be human. There are two linked concepts, interpolation and interpellation, which may help explain our fascination with the notion of the cyborg. They both contain the sense of interruption – the first in relation to tampering with matter by the insertion of new or strange material; the second in relation to the grabbing of attention. Mathematicians and computer programmers commonly use the term iterative interpolation to mean a series of digitally defined, sequential alterations to a model or image, which cause it to change from one structure to another. The cyborg bodies discussed previ-

ously are the first iterations in our journey from the human to the post-human and offer us the opportunity to fantasize about the process of continual transformation and the power this implies. In Cultural Studies, interpellation is used to describe the process by which a subject feels they are being hailed and considers how we recognize ourselves in the representations and messages offered to us. As the cyborg in all its manifestations becomes ever present in popular culture, so does our fascination with cyborg bodies. This begs the question: why do we embrace these new forms with such vigour and what does this recognition imply for our sense of self?

IMAGING THE UNSEEABLE

Jackie Hatfield

How is it possible to make visible what is unseen about the body beyond the surface of its representation? Relative to the real body its representation brings with it a sense of loss. It is a phantom of the original. What concerns me is the contradiction between the real fleshy body and its simulation through technology (digital, video and film). In my work I present the real body as an active 'becoming' rather than a passive given, the body as subject in relation to the object; the technology. I use my own body in a performance or ritual to make moving images (digital, video, or film) that foreground the corporeal body. These images are the 'voice' of the artist's body and are the basis for installations where they are often multi-projected, large scale, using the context and surroundings as a spatial element in the work. The pieces are interactive, multi-sensory and tactile; the viewer has an active physical presence and becomes immersed in an environment and a subject in the work. I authenticate the represented body and acknowledge the subject using film and digital images as tactile expressionistic tools.

The existential body, with the experience of its own weight and the dimension of physical space around it, is the material of dancers and performers who acknowledge movement and the presence of other bodies as part of their perception. Live events take place in the present, and as a site of representation the real body takes precedence. An artwork that is a component of the self, the performing body in real time, is the embodiment of the history of its flesh and blood, evidence of identity and being, and of death. As in death, the real body in performance is transient, it disappears and leaves an empty space. The performer's body is actually present – breathing, perspiring, moving the air – part of the physical reality of the audi-

ence at that moment. The performing body as site of representation is not mediated by technology – the camera – when the performance is over that moment is finished and is present only in memory – it is a unique event. However, as an artist using film/electronic image I am interested in the disunion between the real body and the represented body, defining a space where performance and the body itself are not the only authentic embodiments of subjective reality.

The body on film is actually a trace of the real body, a ghost. In film the subject exists physically but apart from the real body, and what is left is a signified body which has a different authenticity from the corporeal body in performance. More than the performing body, both film and video can be used to disclose the internal imaginative realities and dreams of a subject that cannot be seen via the real body. The material of film/video and the digital image can make the unseen visible, showing the internal workings of the psyche and imagination to be as much a part of the real body as its apparent physicality. These media can disclose publicly what lies underneath the surface and can be used to record and reveal aspects of subjectivity that are private.

The questions my work raises around the representation of the body in relation to its reality can be illustrated by looking at the status of the body in medicine. In surgery, as in performance, the real body takes central place, the subject is present. The corporeal body that experiences disease, pain, pleasure and death is the central chthonic element of the drama in the operating theatre. Surgery is a live event where the subjective body is given central status, even when imaging is used as an augmentation to enhance the surgeon's work. Surgery is a catharsis and similar to the temporality of performance, invites the contemplation of death.

In contrast, the medically imaged body outside of the live context particularly the Visible Human Project[1] is analogous to the dislocation of the subject from the body that is visible through other mainstream forms of its representation for entertainment. Although the fracturing and transposition of physicality through cyber spaces and blurring of private and public spaces enable the viewer to experience expanded perceptual space, the subjective body is not present. The medium takes central place.

In the Visible Human Project, the US National Library of Medicine, and the Center for Human Simulation located at the University of Colorado Health Sciences Center, have used magnetic resonance imaging (MRI) to create female and male datasets from the real bodies of a deceased man and woman. This technique has been used by various medical centres to develop interactive programs for use in medical research. Information about these research activities is widely available across the Internet, and there are varied choices of visible humans to browse, such as, 'frozen cadaver' or 'fresh cadaver' slices, or a 'march through the visible human woman'. In the 'Interactive Knee Program', the University of Pennsylvania Medical Center have used CAT scanned and deconvolved[2] body images, to create 'electronically standardised virtual patients' with 'simulated physiological conditions',[3] as educational tools for medical students to dissect and develop diagnostic procedures. Again it is possible to browse this program, to download the virtual body parts from the net, and to interact with them, to view the virtual scalpel cutting into virtual flesh.

It is interesting to see parts of the body that are normally obscured, so graphically represented and freely available, but it is difficult to divorce the fact of origin from these body objects – they are after all, dead subjects, and like the body parts in early nineteenth century cabinets of curiosity, they are fascinating because of this, because their history is invisible. These virtual bodies have not disappeared, or decomposed as in real death, nor left behind an empty space. Resurrected as digital cadavers, these are humans that are more invisible than visible. They embody the presence of absence signifying the loss of the live physical body. These reconstituted bodies are an escape from the fearful fluids of the real body. In dissecting the digital dead, it is easy to forget the sentient physiological condition of the organic body. Waxworks of real parts, the whole stories of these bodies are unacknowledged. Subjectivity cannot be read from the surface which has no meaning on its own – although the inside is visible, it is not visible enough. This is the body programmed as a life and death object, patented as commodity.

What I am interested in as an artist is to define the body as subject, not just a commodified unit, or a representation. These themat-

ic concerns have culminated in the following pieces of work: 'Scar' – an installation with video projections and sound, and 'Walk in the Glens Wearing a Camera Suit and Tartan Boots' – a single screen work that originates from a performance.

SCAR INSTALLATION – SEPTEMBER 1995
Exhibited at Zone Multimedia Event – UK

This work is an experimental narrative, a three channel installation, video projected onto three large transparent hanging screens positioned in the centre and which fill a large dark space, with four audio speakers at each corner. It is originated on film and video, and inspired by my own experience of invasive surgery. The work plays continually on a twelve-minute loop.

A scar is a visible reminder of invasion from both disease and healer. It is a representation of the loss of the whole body. In *Scar* I present myself as both subject and object, playing with iconographic meaning and symbolism, and a relative – within the screen space – not absolute, objective reality, in relation to my imaginary or subjective reality. The work is multi-narrative in content, the symbolic meanings within the projections are juxtaposed and vary at any given time. Each single screen image structure conveys a specific meaning in itself and in relation to the whole three screen structure.

The images are a representation of my internal reality. Memories represented by super8 film footage of childhood and subsequently remembered like this, and dreams of conventional beauty and the desire to be desirable, are juxtaposed in relation to acts of catharsis that symbolize a feeling of physical struggle. The object body is projected onto the central screen, shot as if observed, a single take on a twelve minute loop. This is the female icon performing relentlessly as 'feminine' ironic and artificial, the feminine as drag and facade. In relation to the central image, the content of the right screen represents another subjective reality – recognizably the same woman as in the central screen – but in this screen she performs rituals that denote symbolic meaning that relates to the body's physicality. In this screen I have taken control of the technology – the camera – and used it to record an enactment. I am the performer on both sides of the camera that is no longer pointed at me but is a prosthesis to my body,

part of the performance. On these two screens both bodies are a representation but I have tried to create a dichotomy between the two screen spaces. In the third screen space the images dissolve between clouds and hospital scenes, this content integrates and anchors the meaning of the other two screen spaces to relate to a specific experience. For the audience, looking at the female body is both indulged and denied by the juxtaposition of the screen's content structure. The work has a particular rhythm and pace, and the build up and resolution to the content is achieved in an experimental narrative sense.

WALK IN THE GLENS WEARING A CAMERA SUIT AND TARTAN BOOTS
Performance and single screen – December 1994
The performance element of this single screen work was based around my 'camera suit' which enabled me to wear four camcorders. I wore the suit as prosthetic sculptural extensions to both my arms and legs. The cameras were each linked via an audio and video umbilical to four monitors – each camera had a corresponding monitor. The performance consisted of me composing tonal structures of feedback sound from the monitor sound cones with the cameras and playing them as instruments with the choreography of body. As performer my real body was visible in the performance space but absent from the monitor space – the represented space. I was defining my physicality in relation to the recorded movement on the monitors and to the audience. The viewer was included in the space and represented in the four monitors. The performance was a site-related event at the London Film makers Co-op in 'Women on the Verge of Technology', Festival July 1994. The performance was relayed via a video phone to Perth and reprojected onto a large screen as a live event.

Walk in the Glens Wearing a Camera Suit and Tartan Boots as a single screen work followed on from the performance and made reference to a tradition of mapping the landscape by walking across it – the body in relation to territory. The cameras recorded the points where body and land intersected, what the eye did not see – the furthest points where my body reached out. I wore the camera suit and used the technology to record an intuitive process of a walk in the Glens. I edited the material into a rhythmic structured single screen

work that became something other than the walk. The body is present in the work but in its absence – it is withheld from view – what is left is a trace of presence in space.

In my work I include the body in the process of making images and use film or digital image to create an active context where the real body and the represented body connect. The visible human bodies are displayed minus the traces of their experience, they appear to have no history – deathful relics of the loss of life. Both *Scar* and *Walk in the Glens . . .* are works that embody a fascination with being alive. *Scar* is a subjective imaginative record of survival, and *Walk in the Glens . . .* is a trace of physical presence. I use my body in these works as unique evidence of my physicality, as a mark of the experience of living. I have set out to represent the narrativity of the real body and to develop a conceptual practice to celebrate its corporeality. I am marking out territory for the existential body within the technological architecture of the digital space, either involving myself as performer or the audience as participants in my artworks. Questioning the status of the image, its means of production and dissemination, is part of the conceptual process I use when I image my body and the figments of my imagination that are usually unseen. With digital and semi-immersive technologies I can create a place where the audience can interact with human scale moving images – where their real bodies can interact with the representation of my own.

THE BODY AND THE MACHINE

Nicky West

> We [women] require regeneration, not rebirth, and the
> possibilities for our reconstitution include the utopian
> dream of the hope for a monstrous world without gender.
>
> Donna Haraway[1]

I am used to being on the fringe of society – as a lesbian I am contin-
ually challenging social orthodoxies. As an early convert among pho-
tographic artists to digital imaging in my art practice, it felt very
accessible to me, and very threatening to some others, particularly to
male photographers, who had a big investment in their traditional
methods and equipment. Currently I use mainly traditional light sen-
sitive film in a camera; this is either processed and the images placed
onto a photo CD, or printed and the images turned into digital infor-
mation on the computer screen by scanning them in. Once there, the
image, or rather the digital information that constitutes the image, can
be moved about (montaged) or uniformly changed by applying effects
to all or part of the image. This is the process I used for the first two
series reproduced here. Since its inception photography has been en-
trenched in debates regarding its suitability as an art medium. It has
been argued that it is simply a mechanical device for the accurate re-
production of whatever occurs within the field of vision of the lens,
rather than a creative tool when employed by artists. Just as artists
have worked with photography in new and unforeseen ways, they have
similarly reacted to the introduction of digital imaging. The software
used to manipulate images was originally intended as a design tool for
graphic designers working with images for design layouts such as
magazine work, to aid the sizing, cropping and so on. It was quickly
appropriated by photographic artists. Now digital cameras are being
developed and marketed that will soon replace the camera as we now

know it. Even today, some of my nineteen-year-old students do not believe me when I tell them that by employing some of the digital processes, particularly in printing, an image can be produced at even greater heights of definition than traditional darkroom printing. Disturbing the illusions of others concerning new technology is not what really interests me; upsetting gender expectations through appearance is much more fascinating.

In particular I am interested in how new technology enables us to reconceptualize the body. It is difficult to imagine the body, it becomes easier once it is imbued with the category of a sex. The body then becomes more easily definable and enters the realm of the social. The body has its place, its role, its function. It also has a gender. As Simone de Beauvoir said, 'One is not born a woman;'[2] gender is ascribed to the body. Society is so completely locked into the assumption that there are two sexes and two genders and each sex naturally implies a given gender identity. It is all so simple and all so damaging. We know these two gender identities so well, we are introduced to them from birth in the clothes we are given and the name we are called. We are taught them, we practise them, we sometimes become very good at them. They are lifetime performances. Gender has been described as 'an impersonation dressed up as the real.'[3] If we are successful at it we are adorned with a heterosexual partnership and possibly children.

I am interested, through my practice, in anything which, as Marjorie Garber has written, 'denaturalises, destabilises and de-familiarizes sex and gender signs'.[4]

I have been concerned with questions of gender since I began to work with traditional darkroom photography. Indeed, it was my personal experience as a young dyke which led me to use the medium to question sexual norms. I quickly realized that when the audience looks at a body the first thing they look for is clues as to the sex/gender of images of bodies. Why is this? It is because we need to know if the subject we are viewing is either the same as us or different. Could it be because it is as Pacteau suggests, 'the very difference which constructs me as a subject'?[5] It is by upsetting expectations and disorientating the viewer with such uncertainty that we can begin to recognise how socially entrenched we have become. Soon traditional (darkroom-based) single image photography felt too limiting. I began to understand that

by using traditional photography, by being true to the medium, that is maintaining the supposedly objective and descriptive capacity of the camera, I was upholding the status quo of photography. The history of photography is imbued with notions of realism and verisimilitude. Yet at the same time I was wanting to encourage the viewer to challenge the supposed 'truth' of the rather fixed representation of the social body. I am not interested in a 'realism' which merely seeks to replicate the existing order.

I want to be able to imagine through photography, not always reproduce through photography.

Computer images are not seen as essentially true to what they represent. Rather, viewers tend to suspect the opposite – that computer generated images have undergone a degree of manipulation and reinvention. I am interested in using to my advantage any and all of these expectations in order to challenge the viewer's expectations of gender representations and relationships alongside their perceptions of old and new technology. I am concerned with the borderland between the physical self, the ethical and social self and where these connect and collide with new forms of electronic representation.

My first major series using Adobe Photoshop, *Performing Daily* is about playing out gender performance. I was inspired by the story of Billy Tipton, an American jazz musician of the 1950s and 1960s. It is documented that the undertaker discovered on his death in 1989 that Billy was in fact a woman, having passed as a man for most of her life. My starting point in making this series is the last of the four large black and white images, the photo of the Billy Tipton Trio. Billy was the band leader – the photographer has arranged the three band members in the classic triptych, with the most important person in the centre and above the other two. I wanted to work backwards from this point; this image was created for and existed within the public domain, I wanted to invent the images of his private family life, based on the knowledge that Billy was married and had three adopted sons. I wanted to adopt and adapt the composition of the last image, keeping the placing of Billy intact and simply replacing the two band members with his family. It did not matter to me who these other people were, as long as they had a presence. So I invented his family by scanning into the computer a very 50s looking American woman, I added a baby

in her arms and found an image of a young boy. Billy constructed his male appearance and his family as a conventional union of man and wife. I have simply done the same.

Billy's wife has on many occasions, since his death, stated that she had no idea that she was in fact married to a woman. She has said that Billy had a skin condition which required his torso and abdomen to be bandaged regularly and that she bought these bandages. It seems hard to believe that she did not know her 'husband' was a woman after about fifteen years of marriage. Her assertion that she did not know, if it intended to prove her 'normality', would seem to do the opposite – prompting the question: what normal woman would not have discovered the 'true' sex of her husband during intercourse? If she did know, then was she sufficiently uninterested in 'normal' marital relations to find her 'husband's' lack of maleness no obstacle to continuing their union? Either way, Mrs Tipton herself must have been pretty queer. *Performing Daily* plays on the idea of Billy's maleness as a fiction which we choose to believe or not to believe. For the Tiptons, this fiction was both convenient and necessary, and possibly even a private source of erotic pleasure (as the sensuality of the figure binding itself behind the main panels suggests). We do not know the 'truth' of their relationship and the fascination of their story lies in the way that it confounds conventional perceptions of sexuality, and of the connection between body and gender.

Some of the audience reacted to *Performing Daily* by assuming that the family images and the image of Billy as a woman were documentary portraits rather than constructed, just as people assumed Billy was really a man. The work tries to interrogate viewers' notions both of photography and of gender. My intention was to not make seamless manipulations or montages, but rather retain a feeling of awkwardness in the characters in the first three black and white images, showing them uneasy with themselves, their clothes, appearance or family group.

There were particular 'determining factors' in the jazz scene of 1950s America. Jazz playing was seen as, almost entirely, a male preserve. Through her queerness, Billy went against convention and proved, if posthumously, that a woman could succeed and achieve considerable success in the jazz world. At this juncture at the end of one millennium and the beginning of a new one, we understand that identities are

not necessarily fixed. This knowledge has emerged from the fusion of discourses of politics, cultural values and the new value system of cyberspace and its possibilities for a fluidity of representation. Theories of sexuality have a long history of confronting and challenging perceptions of the 'limits and boundaries of what constitutes the representable'.[6] Cross-dressing challenges society's written and unwritten regulatory principles. Similarly there was an unwritten regulatory system in the jazz world of 1950s America. Although Billy Tipton was personally challenging the social order and the morality of American society, at the same time 'he' was publicly conforming to it by reinventing 'himself' to fit its rigid structures. Was Billy actually attempting to be a man, or rather a construction of masculinity? Nietzsche's comment, 'appearance is not the opposite of truth, but rather includes truth as one of its varieties'[7] helps us to understand the rhetoric of Billy's body. This could also apply to our understanding of the constructed nature of new technology. Billy's experience of a personal and public reconstruction was hard fought, probably at great personal sacrifice as well as the personal fulfilment of a need. Perhaps because of the stress of keeping her secret for most of her life, Wilhemina (her 'real' name) developed a stomach ulcer that finally killed her. She refused to attend hospital. The institution of the hospital would have revealed the 'truth', or at least uncovered the secret.

Through her transformation, Wilhemina did achieve at least some of her dreams and desires. The rhetoric of cyber-visionaries is all about transcending the rigidity of our every day existence where we have to 'submit to the dictates of its constraining and frustrating reality' and 'we are forced to live inside the physical world, we are made of it and we are powerless in it'.[8] Cyberspace has been described as the third area of human living, 'neither inside the individual nor outside in the world of shared reality, the space of creative playing and cultural experience'. Like the cyborg as described by Donna Haraway, 'Billy' is a condensed image of 'both imagination and material reality' and lives in worlds 'ambiguously natural and crafted'.[9]

Following the *Performing Daily* series I became interested in how the use of technology affected viewers reading of the work. For the next series *Love Con 1*, I deliberately refrained from using direct manipulation. But working with the photographs on the computer I con-

trolled the texture and the colour saturation of the images. I then purposefully printed the exhibition prints using an electrostatic plotter, which produces a screen effect in the image, reminiscent of mass-produced, large-scale advertising posters. Only the colour saturation will be detectable in the reproductions within this book. The large scale gives a monumental quality to the work and distances the viewer. The colour saturation is reminiscent of educational posters or films warning children of road safety in the 1950s and 1960s, but more recently such posters warn children to not trust strangers, in particular not to accept sweets from them. All of this gives the images the feel that they are contrived in some way. Knowing my work, some viewers presumed that elements of some of the images had been pieced together. Because the three photos together compose an ambiguous narrative about the girl's relationship with the man, viewers assume that the individual pictures are also montages. In fact in this case the original images depicts a dramatised set of events, but these have not been digitally manipulated.

The final work reproduced in this book is *Celestial 1997*. Here I wanted to play further with notions of what is or is not 'photography'. Here I have excluded the use of both the darkroom and any form of camera. All the elements of the image are created by placing parts of my body on the 'flat-bed' scanner. Using myself as both the object and the subject breaks down the voyeurism of the image, a device often employed by women photographers and film makers. Using the scanner I can easily take 'photos' of myself. I wanted to explore ways of imagining the body differently. We are so familiar with the female body being domesticated, represented within the confines of the home and the family. I wanted to re-imagine it for ourselves, however fantastically. One space yet to be occupied completely is outer space; how could we take up its vastness for ourselves?

Inspired by the writing of Donna Haraway, I wanted to imagine how I might actually inhabit this domain called cyberspace, aware that not only do men have the knack of occupying all spaces, especially new ones (including outer space) but they seem to take up so much room when they get there! The space I have created is non-specific, it may be outer space or cyberspace, it has the connotations of other worldliness outside the existing order. Gazing into this space I appear like

some goddess or cyborg gazing down on my own creation. As in an earlier work where I humorously transposed the body of myself and my girlfriend onto the figures of God and Adam in Michelangelo's *God created Adam*. *Celestial* is similarly playful as I observe my anatomical parts swirling around in the cosmos. There is a play on distance here, considering the close proximity of my body to the scanner, these strange objects in the firmament appear sometimes distant and unrecognizable, disorientating people's usual perceptions of the body.

Many thanks, as ever, to Lizzie Thynne for helping me to develop the ideas in this article.

Section 2
Territories of Information

DIGITAL SAMPLING
Ideas suggested by some women's art practices from Europe, Australia, Canada and America

Katy Deepwell

THE VERY LAST FAMILY IN THE 21ST CENTURY

'A woman, two dogs and another woman sit like a family which, however, no longer is one and will also never become one because they are the end of the family = single sex lovers who no longer want to reproduce as television sets on the sofa and stare motionlessly into a television set which is hollow inside.'[1]

In Pezoldo's bold and ironic artwork, *The Very Last Family in the 21st Century*, four video screens – with the faces of a woman, two dogs, and another woman – nestle together on a sofa facing a TV screen. Person-to-person contact is reduced to virtual or remote communication by video link because the screens do not face each other as humans do in conversation. These individuals do not contemplate anything. The TV is empty. Sealed in hermetic worlds, can one even suggest that there is communication amongst this peer group of 'single sex lovers', perhaps it is all pose and style-consciousness in the pursuit of individualism? Pezoldo's vision is an ironic contrast to Nam June Paik's *Bhudda*, praised as an innovative video work, in which a china figure of Bhudda sits contemplating a video projection of himself into infinity. Pezoldo's designs for an electronic counterworld also stand in opposition to the insane, hectic rush of imagery in Paik's *TV Robots*, symptomatic of Baudrillard's descriptions of the hyperreal[2] and mimicking the image overloads of MTV.[3] Pezoldo's intervention is premised on her stated desire to offer an oppositional set of imagery: 'extremely slow, fluid, Tai-Chi-like images of the newest electronic goddesses' to fill the spiritual void in Western society.[4] Since the late 1960s she has explored through different projects the contradictions of women's position in the world in representation

and in the cultural industries: from early photo pieces like *Against Penis Envy* (early 1970s) where a woman removes her masculine dress and deliberately detaches a prosthetic penis from her body to reveal her sex; to her video-derived drawings coding the body in *The New Embodied Sign Language* or her performance-based creation *Radio Free Utopia* which she promoted as 'the first truly completely private tele- or 'near-vision' station of the world' (Munich, 1977).

Pezoldo is a powerful example to me of the contradictions and innovative leaps necessary to reconceive any discussion of women artists' work with new media which usually falls under the rubric of technology. Her work is premised on establishing a critical relation to popular assumptions about men and women and playing with the languages and mythologies of popular culture. Her work attempts to capture, or rather negotiate, pressing contemporary issues and ideas but it is not medium-specific. She does not follow the modernist credo of exploring the limits of the medium, instead she moves from one medium to another concentrating on communication and language; context and message. She seeks to intervene by disrupting pre-existing meanings in the world and offering a counter-vision. This is not simply reactive gesturing, it is an agonistic politics, defined through critique and opposition, realized through particular concrete artworks and the establishment of events/exhibitions, situations and publications.

I want here to explore how a number of other women are pursuing, though with very different media and aims and objectives, strategies in their work which, in a feminist sense, are agonistic to the dominant culture. As Kass Banning argued in her analysis of the Canadian artist and film-maker, Joyce Wieland, this represents 'a vigilant analytic dissidence'.[5] Through discussion of a range of very different works, I want to offer some observations about art and technology beyond its limitation to particular media or a 'for' or 'against' position and draw attention to what some women artists have been doing. Carol Stabile has argued that feminism's reaction to technology is divided into two camps: technophobes and technomaniacs.[6] This neat distinction has the unfortunate effect of reproducing the essentialist/anti-essentialist debate which dominated discussion in the 1980s in terms of dystopian/utopian visions of technology. On the one

side is the technomaniac Donna Haraway, and on the other, techno-phobes calling for regulation like Catherine Mackinnon.[7] Most of the examples of women's art practice which follow fall somewhere in between these polarizing and simplistic definitions.

Technology in the visual arts is generally only identified with the (relatively speaking) new technologies of communication – 'new media' – video projections, works using electronic equipment and surveillance technologies, hi-tech photography, computer manipulated imageries and printing techniques, art projects on the Internet, CD-ROM projects or holography. Animation is regularly excluded from these definitions no matter how hi-tech the production basis may be for the actual film-making: a decision made primarily because of the distinct markets for animation in terms of their screening and distribution networks. This raises the important point that such ready-to-hand definitions are always institutionally produced and reproduced through departments in educational establishments and the ways types of media are frequently located within specific markets, audiences, places of exhibition, publication and professional networks which maintain such separations. The boundaries in terms of the uses of such technology in specific works are far more fluid than the institutions which fund, market, distribute, consume or sell the work.

Martha Rosler has made this point very well in arguing about the difference between documentary photography and photography's limited acceptance in the art world if it fulfils the author function and can be sold as a limited set of editions.[8] It is worth remembering that in terms of the (economic and material) resources to employ the latest technological developments in image manipulation, resolution and quality, it is the governments and multi-national corporations who are leaders in these fields. Artists whose work is exhibited in museums and galleries are marginalized, even with vital and experimental centres like The Xerox Palo Alto Research Centre, the Massachusetts Institute of Technology or Zentrum für Kunst und Medientechnologie[9] in existence. This is not to say that artists' ideas are not valuable to corporations, as any cursory glance at contemporary film-making or advertising reveals the use of images and ideas appropriated from elsewhere. Gillian Wearing's *Confessions*, for ex-

ample, was quickly adopted in the format of an advertising campaign in Canada by a commercial bank to promote its products. The relationship between art and popular culture is increasingly a two-way street, but most of the more technologically innovative projects in recent times come from artists who have gained access to the technological resources of larger state or corporate institutions, including universities and their research facilities. The Internet, as is well-known, began as a defence communications system for the military in the Cold War, no matter how subversive its potential may appear today in terms of alternative systems of information or academic exchange[10]. Its use by guerrillas, pornographers, tourist agencies, suppliers of commercial goods and services, as well as women's groups, is neither specific to the media nor, given the structure of the Net, subject to any one government's regulation or censorship. 'Internet art', for example, may be an emerging new media category but what is meant by this term in art and technology conferences (a specialist network) is primarily interactive, innovative experimental work, not the thousands of artworks, scanned photographs of paintings or computer generated works which one can find on the internet.

Feminist projects do exist on the Internet. The Womenhouse project on the Internet is indebted to its feminist predecessor – a disused house converted into a women artists' installation and performance space in 1972 in California.[11] Some of the site's participants took part in the original Womenhouse project and the site references their contributions and the context, for example, Lynn Speigel's *Kitchen* and Faith Wilding's *Crocheted Room* – 'a liminal space' in the hallway. Womenhouse profiles a collective of women artists, largely based in New York, but the works created function as art and not documentation of works outside the computer. Linked, somewhat ironically, by a Hymen page – since presumably virginity must be broken to gain maturity as a woman – the piece opens with a scan of a foetus from Amelia Jones. It has been argued that this 'monitoring' of foetal development through sonorscan, used in many Western societies, renders the mother's body invisible as all attention is focused on the foetus. In this context, it could read as celebrating biological reproduction as a creative act – and as the perfect marriage of a woman's body and technology – in so far as the machine penetrates the most

mysterious and unique aspect of woman's body, the womb. Such bio-
logical origins, however, might mislead you as to the scope of the
Womenhouse project which ranges from fluxus-type word poems, to
discussions of teen sex, a feminist analysis of vanity based on a cri-
tique of Kant, and explorations of the security/defence mechanisms
of territories defined in gardens and by childhood memories.

Biotechnology and biology has, until recently in the work of out-
standing feminist scholars like Donna Haraway, N. Katherine Hayles
and Nelly Oudshoorn, generally played a second fiddle to discussions
of communications theory in debates about the impact of new and po-
tential mass media products.[12] Kathleen Woodward attributes this to
a concentration in research on communication theory and cybernet-
ics as opposed to the narratives of biotechnology in the work of the
'post-industrial' prophets, Marshall McLuhan, Norbert Weiner,
Buckminster Fuller and notes the same (masculinist) emphasis in the
writings of Jean Baudrillard and Paul Virilio.[13] In the interfaces be-
tween human and machine proposed by the technocritics, the ma-
chine acts as a prosthesis, an extension of human capabilities and the
mind, 'displacing the material body, transmitting instead its image
around the globe and preserving that image over time'.[14] The seduc-
tion of such technologies, Woodward argues, arises in their ability to
permit as if 'unseen', an ever increasing access to sights/sites both
inside the living body (medical imaging) or as a link between differ-
ent geographical spaces in real time (in global communications sys-
tems). Simulation through computer imaging creates a new
perception of 'realities' in Baudrillard's discussion of the hyperreal,
this new form of imaging (from CAT scans to the kind of missile sur-
veillance used in the Gulf War to relay video footage from bombs as
they descend to target) are re/presentations of representations (i.e. a
double-coding of images) rather than representations or presenta-
tions of the real.[15]

A MATTER OF ROUTINE SURVEILLANCE

If information technologies remain the defining feature of the com-
puter age, one is still left with the basic questions about who has ac-
cess to modern technologies, who authorizes their use or grants
permission to access databases and at what level and in whose inter-

ests is access available to particular kinds of information about the citizen/subject. Given the dispersion and lack of interconnection between databases (for example hospital, police, tax and social security are still separate from corporate accounts of banks and businesses) and registers (of voters, dog owners, missing persons or child molesters), the genuine problems of information circulating which is out-of-date, inaccurate or bogus, the vision of a supremely technologically mapped civilian population under the guise of big brother is still a long way off. Witness discussion, verging on paranoia, about the possible introduction of ID cards in the UK during 1996 which would seek to link for the first time on a mandatory document a person's name, address and national insurance number with a photograph – pieces of information which a driver's licence or a passport still does not show in the UK – or the discussions around the 1997 'Crime Bill' which may undermine the Copyright and Data Protection Acts' provisions by allowing government departments to share databases. Threats to democratically secured rights to privacy and confidentiality through increased surveillance power over consumers, no longer citizens, are for many the downside of the access and availability which the processing power of huge databases run by government agencies and corporations seems to promise.

Canadian artist Sylvie Belanger's work highlights the level of surveillance under which so much of modern twentieth-century life is conducted – street cameras used in police surveillance, shop and business security systems, satellite spy cameras used globally to track the movements of troops and populations, the effects of natural or nuclear disasters. On three video screens, whose wiring and internal workings are dismantled, viewers see themselves on a time loop entering the gallery, aerial surveillance is echoed in the aerial landscape of suburbs on the large photowork panels behind. Viewing through the central screen where 'WATCH' has been etched onto the glass, the audience watch themselves being watched.

THE MEDIA GAMBIT

If the time has come finally to set aside the modernist gambit to insist on the specificity of the qualities unique to the media being explored[16] – be it the media of the Internet, film or painting – as the only

ground in which the avantgarde can operate and forms of technolog-
ical determinism in which every new media will transform our vi-
sion of the world, then what, in terms of critical analysis, should
replace these methods? The principal alternative strategy developed
in cultural studies is to consider the inter-media character of the
works themselves, the languages they use, the strategies of represen-
tation they borrow, the mixing of codes and knowledges employed
and how these produce particular viewpoints on the world.[17] Thus one
has to consider the more complex relationships which go into the pro-
duction of particular works and think through more thoroughly the
cross-overs between painting/photography/film/uses of quick-time
VR on the Net/languages of corporate advertising. Hopefully such ap-
proaches may also demolish on the one hand the hyperbole sur-
rounding new media and some of the equally euphoric rhetoric which
reproduces the deepest held mythologies about art-making and artists
on the other. For example, when contemporary artists produce works
through commission in order to exploit, negotiate or seek to resolve
certain technical problems, these artworks are not simply manufac-
tured but often developed and transformed by not just the technolo-
gy employed but the actual technical skills of the person(s) with
whom the artist works. Such processes have been going on for many
centuries, if one considers the relationships between artists and
printers; or sculptors and casting techniques; the relationship of ar-
chitect to mastercraftsman or the studio system of producing paint-
ings. Where the distinction is drawn between artist's conception and
technological or material support remains an interesting question,
given the teamwork in films, Internet site, CD-ROM design or the
construction of an installation sculpture, and the continued market
and intellectual investment in the name of the artist.[18]

The limited identification of technology with only 'new' technolo-
gies is also a strange identification if one adheres to the use of the
term technology to signify any means through which humanity mod-
ifies its relationship to nature. Conventions regarding viewpoint and
perspective in painting's ability since the 1500s to render a three-
dimensional illusion on a 2-D surface have not been abandoned com-
pletely in the pixilated world of 3-D modelling.[19] Technologies may
transform the tools we use to operate within the world but the im-

plications of this are far from neutral and have many historical precedents. The question of ideology (in terms of whose interests do certain kinds of imagery serve; whose view of the world is represented) tends to get lost in discussions of the hyperbolic possibilities of the new media. Ideology, and therefore any examination of the impact of technology, has always to be seen as thoroughly embedded in social processes. Theresa de Lauretis's useful analysis in 'Technologies of Gender'[20] reminds us to distinguish more clearly between two uses related to considering questions of gender operating as a technology, producing and reproducing different meanings for men and women. The first considers technology in the discursive sense Foucault has developed as a self-regulating system for the subjection and production of subjects through practices, discourses and institutions.[21] In the second, ideology in the Althusserian sense of appellation (i.e. the way a subject is called to attend a pre-existing ideology as if called by someone) can only be analysed and exposed through 'ideologiekritik' as a form of false consciousness.[22]

If, as I have tried to show above, technologies can only be thought of like ideologies if they are seen as embedded in institutions, discourses, and practices, then it is necessary to attend to their specificity. Statements about the benefits of technology also need to be thought in relation to the question of whose interests are being served by new rearticulations in the form of statements, practices (actions, works or texts), institutional frameworks or networks. What are the implications of the existing system for the position of women artists and where lie the possibilities for change and recognition of transformation or resistance?

WOMEN TECHNOCRATS

Women artists have not been absent from work in the new technologies defined above, indeed under the rubric of postmodernism feminist work has been recognized as central to some of postmodernism's anti-aesthetic positions. Feminist analysis of the women's art movement since the 1970s, and as some have argued a form of avant-gardism within it, has defined itself in terms of the rejection of painting and sculpture and the turn towards 'new media'.[23] New media include performance, film and video work and photo-text

pieces in this case. The large number of contemporary women artists working in installation, performance and using video and computer manipulated imagery whose careers span twenty or more years is impressive, even when any analysis of one-person shows in mainstream galleries reveals depressingly low statistics on the representation of any women.[24] To look at any field of work and declare women's absence runs a terrible risk of either failing to see what is already there but insufficiently researched or of reinforcing the premise that women's limited presence has to be explained in terms of what women (rather than social prejudice or societies) lack: be it education, access, brains, the necessary equipment, any good ideas and so on.[25] This kind of logic has to be overcome if we are to examine both positively and creatively the possibilities and projects initiated by women's work in the visual arts in the last three decades. This is not to downplay that discrimination exists, nor naively to accentuate the positive, but it is to advocate a greater critical engagement with what women have actually done.

The intense activities of women using new technologies in the last twenty years are regularly overlooked by a technocratic culture within the electronic arts which is more interested in 'gismos' and swapping technical notes than in critically examining theories of the visual or raising questions of interpretation and ethics or challenging whose interests are represented. There remains a real danger that all the institutional practices which reinforce the marginalization of women are still in place and continuing very effectively to erase women from the historical cultural memory banks of the visual arts. Commentaries on women artists' work have not been written in the generally heroic style of commentaries on male artists' ground-breaking experiments with either new technologies or as the cutting edge (i.e. most fashionable trend) in the contemporary art market. The literature that has been produced on women artists is as a result generally far more critical, analytical and attentive to the play of signs, language and use of media which have been adopted. Vera Frenkel's early interventions with interactive video through telecommunications in *Canada String Games: Improvisations for Inter-City Video*;[26] (9 hours simultaneous transmission, 1974); Nell Tenhaaf's computer work *Us and/or Them* (1983) a chilling play on Boolean logic and Cold

War politics was a pioneering computer work in an on-line form and the result of her participation in a Canadian Government's Communications project;[27] or Margaret Benyon's work in holography over two decades[28] are but three examples of women artists' desire since the 1970s to make great use of opportunities to explore the implications of the latest technologies as they arrive in the world through the commercial marketplace and government or corporate sponsored research centres.

Amongst artists working in electronic media, women artists tend to remain their own advocates, giving papers and presentations of their works at the national/international electronic arts festivals, initiating dialogues about the possibilities and limitations of the media, running workshops to introduce people to new technologies and forming groups to advocate women's involvement in developments in new technologies with an awareness of developments in science. VNS MATRIX, for example, a four-woman team from Australia are a good example in this respect. The Internet publication of their witty and punning *Bitch Mutant Manifesto*, which formed a prelude to presentations at Ars Electronica, Linz & ISEA,[29] or their ironic ideas for a new feminist computer game which would generate new life forms, cyberheroines and stake out bold new biological missions, *All New Gen*,[30] – now under construction – are as sassy and transgressive as anything floated under the 'Bad Girls' banner a few years ago. The presentational style represents a gambit at visibility for an irreverent feminist position, evident in one of their numbers establishment of *Gash-Girl*[31] a web site of pornographic writing for women.

IDENTIFICATION MECHANISMS

Christine Tamblyn's second and most recent CD-ROM *Mistaken Identities* (1996)[32] takes as its subject the imaginary relationship one has to 'famous women' in history, using simultaneous open screens to create a collage of personal and appropriated imagery, theory, history and fiction. Of her first CD-ROM *She Loves It, She Loves It Not*,[33] which explored the relationship between 'women, art and technology', Tamblyn wrote that the piece allowed her to elide 'the boundaries between art and theory (or fiction), but also the boundaries between the body and the machine'. This sense of new possibilities which can

intervene to question the historical position of women, present a view, even if ambivalent, of one's identification with technologies in the home and workplace and against 'famous' women in history is central to the feminist project as defined by historical recovery and rewriting of women's position.[34]

Jill Scott's interactive installation *Frontiers of Utopia* (1995–1996), presented also as a CD-ROM, highlights the complexities of past and present feminist visions of activism.[35] *Frontiers of Utopia* presents narrratives of eight women in the twentieth century in a computerised sound and video installation which viewers explore at four 'interactive' stations. Through the computer screen and interactively triggered film clips, aspects of their lives, aspirations and political credo are presented. At selected moments in the scenario, by touching items in

Frontiers of Utopia
1995–1996 Jill Scott

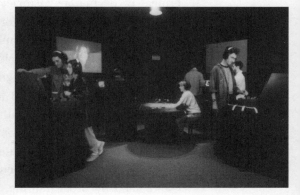

a suitcase (with an electronic key) or prompts on the touch-sensitive screen, viewers may ask the character questions and in return are offered brief reflections from the character in video clips. These fragments of autobiography allow the viewer to gain an understanding of what has happened to them, the development of their political views and different aspects of their personality. *Frontiers of Utopia* is a critique of idealism in women's social and political struggles. The eight characters in *Frontiers of Utopia* represent different ideals and aspirations in women's political struggles: from 1960s student activism; the hippy movement; struggle of and for the proletariat; to 'technocracy'. The combinations of characters range from revolutionary to utopian as a challenge to essentialist views of women's history or 'utopian' liberal/progressive models by demonstrating the pitfalls of such positions as well as their hopes and fears. These eight characters are linked in a central table where the viewer may initiate dialogue between any two of the characters at the same dinner party as another means of assessing the potential interaction between personalities who hold such different beliefs. Drawing upon Brecht's work in the theatre as a model, Jill Scott's characters are drawn as stereotypical of particular histories and positions. The contrast between them offers an opportunity for increased conscious awareness in the viewer because of their complex motivations and the fact that they are drawn from different periods in time.

Margaret Morse has intriguingly suggested that oral logic, rather than the cinematic model of identification, is a better means to understand the immersive realities presented by new technologies in her essay 'What do cyborgs eat?'.[36] A CD-ROM or interactive installation relies on you to navigate through its images and information, clicking, stopping and exploring the different avenues and pathways established by programming. Unlike the experience of watching an unfolding linear narrative of a film in a darkened auditorium, interactivity offers freedom of movement and the fluidity of choice in taking different directions through the CD's material. Morse argues that in film the mechanisms of identification rely on distance, on how we identify with the dilemmas, likeness, similarity of the character revealed to us in the film's editing and point-of-view shots where the film potentially becomes a `mirror in order to mistake the other as

self'.[37] Scott usefully exploits this idea by inviting the viewer across the range of characters to consider points of identification and distance but she retains the function of choice – as always within parameters set by the artist – in terms of the viewer's experience of navigating the project. Morse's concept of oral logic, derived from Melanie Klein's psychoanalytic object-relations theory, functions quite differently through introjection and incorporation, 'a more-than-closeness' which offers the viewer the chance both to assimilate and transform the host. Morse's suggestions usefully encourage us to think of the interaction as dominated by a form of 'oral logic' but one which nevertheless still co-exists with symbolization, identification and immersive illusion. Absorption in oral logic, Morse argues, becomes complete when the 'obsolescent body's immersion with the machine leads to an inorganic rebirth' in contrast to 'disembodied, artificial intelligence'[38] of the nineteenth-century Romantic imagination, where immersion in nature was the ultimate fantasy.

MEDIATIONS BETWEEN THE ORGANIC AND ELECTRONIC

In the French artist Orlan's body art with surgery, her 'natural' body is the ground upon which it is possible to act, to be; but the artifice of this regeneration is the key to understanding her position. The employment of her own body as subject for her artworks using cosmetic surgery, in a form of 'woman-to-woman transsexualism', takes place in highly staged operations, ritualized and choreographed in terms of a cutural performance, and generally transmitted live to a remote audience. The resulting artefacts of videos, films and photo-stills are then edited into CD-ROM, catalogues and videos which are not just documents but extensions of the art embodied in each of her operations. In contrast to the (male) Australian body artist, Stellarc, who rhetorically celebrates the notion that the body has been rendered obsolescent by technology (an ironic statement given his performances which rely on his body's interaction with a robotic arm and a random generation of electronic currents), Orlan's work treads a difficult line between control of or surrender to transformation by technology in her critique of standards of beauty and a woman's right to self-determination.[39] She has described her recognition of self – in so far as there is a necessity for continuity, given that the human

body daily and continually renews itself in cell regeneration – as present in an interior life – her voice – her breath one could say, rather than in an exterior continuity. In Orlan's work, the viewer is forced to confront – and for many it is an all too painful experience – the processes of surgical transformation to achieve not an ego ideal but a representation which modifies codes of beauty by combining distinct features in one surgically-transformed human subject. The struggle is mediated by audience reaction to the artist's endeavour unlike, for example, Nancy Burson's *Anatomy Machine*[40] which allows the viewer to morph her own face in a video projection transformed by medically known diseases, malformations or spatial distortions, thereby allowing the viewer to see herself otherwise. Orlan's work, therefore, tests the notion of acceptability within aesthetic judgement in a culture dominated by the almost-routine advocacy of cosmetic surgery found in today's fashion and beauty magazines and the notions of perfection upon which this privatized industry styles itself.

In the problematic definitions of nature as opposed to culture and the mediating role of technological transformation, the figure of the cyborg is frequently presented as a useful construction to question both the drawing and blurring of boundaries. The cyborg operates simultaneously as an entity and a metaphor for how we understand ourselves and carries with it, as Haraway usefully suggests, 'a way out of the maze of dualisms . . . a powerful infidel heteroglossia'.[41] Morse's idea of oral logic highlights ways in which both corporeal negation or 'abjection' (drawn from Kristeva's *Powers of Horror*) function in a technologically driven economy of oral disgust and machinic desire.[42] Jane Prophet's work *The Imaginary Organs of a Cyborg* (1996–7),[43] as a play on metaphors and modes of representation of the brain, stomach and heart, identifies Morse's more optimistic thesis that a cyborg's construction might challenge the relationship between the organic and the electronic. In moving around the space of the CD-ROM, identification would merge with oral logic and 'the eater (electronic culture) becomes the eaten, in a symbolic initiation of the cyborg into the human condition'.[44]

Species Life 1989
Petronella Tenhaaf

Nell Tenhaaf's work *Species Life* (1989), offers another version of cyborg heteroglossia derived from the merging (hybridizing) two distinct species of thought. Tenhaaf's piece questions the received idea of, as Kim Sawchuk describes, 'a programmable genetic code as scientifically erroneous and politically dangerous'[45] because of the way it excludes or ignores environmental, chemical or societal factors in the development of humans and other organisms. Pitting computer generated imagery of the DNA helix against quotations from Nietzsche and Irigaray in works constructed as photographic lightboxes, Tenhaaf's work questions the discursive construction of evolutionary thought or theories of 'origin' in human development as a species. In this context, Helen Chadwick's last series of works on reproduction,[46] photographing cells rejected from the process of *in vitro* fertilization, although it might initially be seen as running the risk of aestheticizing conception is actually a challenge to the eugenicist rhetoric in science of seeking to breed the most perfect. In the installations of this work, she began to explore critically the evolutionary tales of the origin of the species by focusing on an imagery derived from primarily dysfunctional specimens.

Central to the works discussed above is how the female body, rather than 'the body', and a gendered spectator position, can be represented. Such a focus does not limit the variety of strategies adopted nor the range of media used, from appropriation of both familiar and unfamiliar imagery from film, TV, pornography or science to challenge our perceptions of representation, history/memory, space and time. Three final and very distinctive examples may suggest how women continue to look for new strategies to both reposition the audience and the representation of women's bodies through presence and absence.

In Pipilotti Rist's installations every attempt is made to change and alter the habits of viewing. Videos are screened hanging in swimsuits, projected onto walls lined with bras, screens are hidden in a wall of handbags, or made visible only through chandeliers of glass. Viewers are invited to poke their heads through holes cut into large prism-like viewing structures projecting from the wall or sit on plush red sofas expanded so dramatically in size that the viewer becomes infantilized by the experience of sitting on them, or to push a control panel to watch a tiny TV on which Rist's videos occupy all the channels.[47] Can one hail this as the democratization of culture or is Rist pointing here to our habits of viewing which infantilize us into passive consumers? One of the video channels screens shows (Entlastungen) *Pipilotti's Fehler* (Pipilotti's mistakes) (1988), a 12 minute video of edited video noise and failed blurred footage cut together with different scenes of Rist staging her own moment of dropping dead, collapsing in a street, in a park, in a field.

Vera Frenkel's *Body Missing* (1993–4)[48] presented as both an Internet site and an installation artwork, plays with the overlap of three distinct realities to signal the clash of different perceptions in Linz where the piece was developed. Between dialogue of taxi-drivers discussing their racial prejudices towards ethnic minorities in the town presented in voiceover with footage of walking the streets, flows a list of all the artworks seized and catalogued by the Nazis as they invaded Europe. These missing works, many of which were found outside the town and intended for a Nazi museum in the town, were searched for after the war, but it is the precision of cataloguing and listing and the sheer volume of confiscated goods which Frenkel's work highlights. These fragmented narratives linked by their presence in the video are juxtaposed with photographs from the building looking out at the town where the work was made, which are presented in the form of lightboxes echoing the form of crates for shipping artworks. The piece works through the incredible disjunctions between these tales of disregard for human presence and tolerance in one place, contrasting past and present realities.

Lynn Hershmann's videodisc installation *Deep Contact* (1985–1990)[49] opens with the guide 'Marion' knocking on the projected screen asking to be touched. Through the touch sensitive screen,

touching any part of Marion's body, the viewer is led into different scenarios and spaces, where the viewer can move through the space following the guide or adopting a different character (a Zen Master, a Voyeur or Demon). Through the touch sensitive screen the viewer controls the forward/backward/replay scenarios. They can adopt 'phantom limbs', view the same screen from different viewpoints in this interactive fiction which explores 'reproductive technologies' and their effects on perceptions of the female body.

This cross-section of women artists' work represents only a sample of the rich diversity and activity in this field and the many themes and ideas tackled in their work: analysing conceptions of space, binary logic, traces of memory, the exterior and interior imaging of women's bodies, the implications of communications media and technologies of surveillance. The common link between such diverse works, I would argue, is a feminist 'vigilant analytic dissidence' detectable in the strategies used which critique common (mis)conceptions of women's bodies, and the position allotted to women in reproductive technologies, in mechanisms of surveillance and control, and in the residue of cultural memory and histories.

ESCAPE FROM THE FLATLANDS
The impact of new technologies on graphic design education

Erica Matlow

The title of this paper is taken from *Envisioning Information* by Edward R. Tufte in which he describes how the 'world is complex, dynamic, multidimensional; the paper is static, flat. How are we to represent the rich visual world of experience and measurement on mere flatland?' Tufte takes this concept of 'flat' from *Flatland: A Romance of Many Dimensions* by Edwin A. Abbott (1884).

My starting point is to discuss the changes that have occurred in graphic design education over the last ten years. The introduction of the new technologies, specifically computers, have had a tremendous impact on graphic design courses that has traditionally been involved with teaching design and production for print-based media focusing on the integration of type and image. This has also meant, at times, the incorporation of photography, illustration, animation and video.

Because the traditional discourse of graphic design has been transformed and its practice has changed, there has been a shift of perspective from the two-dimensional static surface to four-dimensional, shifting 'virtual' and 'infinite' surfaces. As Tufte notes, we 'navigate daily through a perceptual world of three spatial dimensions and reason occasionally about higher dimensional arenas with mathematical ease; the world portrayed on our information displays is caught up in the two-dimensionality of the endless flatlands of paper and video screen.'[1]

This shift presents far more complex problems for the student designer than previously when they were working with the more traditional print-based media. Students now have to structure and integrate moving images with sound, time, space and gesture. They produce work that exists in a virtual environment, it often has to be

interactive and constructed as a non-linear narrative. According to Steven Heller 'as an increasing number of graphic designers work on screen-based environments, people in education will have to redefine the designer's role, from manipulator of form to navigator of content.'[2]

UPSETTING TRADITIONS

I have taught on the Graphic Information Design BA (Hons) at the University of Westminster since 1988, and during this time have experienced many changes. The course started to use Macintosh computers in 1989 and over that time their use and their applications have transformed the curriculum. It has certainly been my experience that in the mid 1980s very few art and design colleges possessed the necessary computer technology for teaching computer graphics and it was only when colleges were able to afford the very basic PC systems and appropriate software that they were able to introduce their students to some of the computer graphic techniques that were currently being used professionally.

This transformation is most apparent in terms of the fundamental concepts that frame the project descriptions, the language that is used to describe the projects and the form and content of the finished works. It is also, at times, apparent in the gap between student and staff experiences of the new technologies. For some lecturers the computer has an intimidating presence which challenges preconceived conventions and ways of working while for others the computer is seen as enabling, potentially transforming a whole range of social issues and cultural forms. The editorial of the AIGA *Journal of Graphic Design* 1995, describes the advent of the computer as upsetting the traditional images of pedagogic authority, 'if education was once built on an apprentice system that included a careful mastery of tools, that system has been severely destabilised. Many students are now far more advanced in their control of their electronic tools than their instructors are.'[3]

MAKING THE VISIBLE INVISIBLE

In an essay titled 'Virtually Female' Margaret Morse describes a visit she made to the San Francisco Exploratorium in California. She was sitting at a computer terminal which was linked to a virtual city and

was 'caught up in an endless loop' when she suddenly 'noticed a little [boy's] hand under mine, clicking the mouse. Someone was tucked onto my seat and giving me little pushes', but luckily 'the little guy now in charge of my computer was caught in a loop too. Yet it was clear that something about our culture says to him, this is your place: claim it.' This description underlies the belief that the domain of the computer is still largely male-dominated and that access and the opportunity to develop an expertise in the technology are differentiated by age and gender. Cynthia Cockburn also acknowledges in 'The Circuit of Technology: Gender, Identity and Power', that the move away from the Age of Mechanisation to the Technological Information Age has not really produced any startling changes in the way men and women relate to the new technologies. Men are still considered to have mastery over the technology whilst women are believed to be simply incompetent.[4]

Sherry Turkle takes up this concept of the heroic mastery of computing in more detail when she divides the acquisition of computer skills specifically into male 'hard' mastery and female 'soft' mastery. These gender differentiations, she argues, are acquired at an early stage of infancy when the development of the child is still closely bound into the mother–child relationship. The separation of child from mother is the point at which she or he experiences the world 'out there' and develops a sense of objective reality. It is also the point at which the child becomes gendered. Turkle believes that the particular Oedipal boy/mother relationship results in the boy preferring distanced objective relationships while girls feel easier with 'the pleasures of closeness with other objects as well'.[5]

The concept of science as an objective tradition and as the typical male preserve can therefore be seen to be built on men's earliest experience of object relationships. Girls have a more continuous relationship with their mothers which then enables them to develop a different sense of themselves and 'other', to develop a 'softer' relationship to the 'hard' male world of science. This (heterosexual) binary division of gender into 'hard' = male and 'soft' = female should certainly be seen as problematic in that it continues to support the status quo and perpetuates gendered roles, but it can be a useful concept with which to approach the teaching of computing skills to

women. Turkle believes that it is also important to focus on the approach of programmers and the way that software is written if we are to change people's attitudes to computers.

Francis Grundy in *Women and Computers* details the various ways in which women are under-represented in the world of computing. She considers the relationship of women to computing in the home, at school, in further and higher education and in the workplace and argues for a feminist politics that would enable more women to become more creatively active in the world of computers at every level and in every sphere of their lives. She notes that computer games 'have a major influence where the vast majority of computers are bought by men' and cites research by Straker (1995) that says that 'twice as many boys as girls have access to a computer at home'. She sees this pattern repeated at school where 'boys make up the vast majority of the members of computer clubs, that when girls try to use computers in out-of-class activities at school, they are elbowed off, that in mixed classes boys hog the best equipment and boys tend to get more attention from their teachers of computing.' Grundy believes this behaviour at school simply serves as a microcosm of 'what happens elsewhere, reflecting and reinforcing it rather than correcting it'.[6]

Grundy acknowledges that women are currently under-represented in almost every aspect of computer culture, from programming to product design, to everyday use, and believes that this discrimination has yet to be addressed at any fundamental level within higher education in this country. Whilst it is apparent that disparities in access can be attributed to the differences in a child's development, social construction and socio-economic class, it is also evident that the computer's initial association with mathematics and science (typically male-dominated fields) may have helped create this inequity in use.

TRANSFORMING THE VISION

Even though there has been a profound transformation in the practice and teaching of graphic design with the incorporation of computer skills there has been little critical analysis of how these technologies have actually impacted on graphic design education. It is interesting therefore to speculate on what a new curriculum, that

would more appropriately accommodate the new technologies, would contain. There would, I believe, have to be a radical rethink of the whole rationale and content of curricula, which most courses would not have the resources, time or appropriate facilities to implement.

New courses would need to understand the differences between information that is presented on paper and that which is presented and communicated on screen and to construct the appropriate contexts for meaningful user experiences. They would also need to explore the differences that occur when the new technologies impact on existing staff's experience of graphic design and their ability to implement new course requirements and changes in the professional environment. Often these experiences can be identified in relation to gender, age and ethnicity. Cockburn argues that 'technologies are gendered'[7] insofar as men and women will use computers in different ways, for different reasons, in terms of necessity, control, functionality, sociality. Silverstone and Hirsch argue in their introduction to *Consuming Technologies* that the technologies are gendered not only 'as an object of consumption and as a means of production [and reproduction], but in both guises it [the technology] is subject to the complex relations of gender and age identity forged both inside and outside the [institution].'[8]

THE ROLE OF REPRESENTATION

I have been arguing here for graphic design courses to reconsider their existing curricula in order to accommodate the impact of technological change and to create a more equal access for men and women to acquire computer confidence. I believe that courses will need to expand their vision and incorporate other disciplines into their discourses such as cognitive science, linguistics and computer science. Because they are diverse and disparate forms of knowledge, course staff, of necessity, need to come to a shared language and consensus in the way this new language is used if there is going to be worthwhile discussion and exchange of ideas. A bridge has to be built across the cultural divide, between the language of art and design, between critical theory and the language of science. This is a vital process if the work of graphic design education is going to develop in any meaningful way in the future.

Fundamentally underpinning much of this new thinking would be a critical understanding and application of the term 'representation'. From a cultural studies perspective 'representation' is about the way we represent ourselves in the world and how we then are represented by that world in and through culture and discourse. This understanding is defined critically by the underlying power relations between our forms of communication and the objects with which we communicate. Representation, as a critical concept, enables an analysis which, according to Lupton and Miller, would 'focus not (just) on the themes and imagery of its objects (graphic design) but rather on the linguistic and institutional systems that frame their production'[9] and in the context of graphic design education, specifically at the meanings that computers have for the people that use them: or their access to them and their applications. 'In so far as objects function as extensions of the self, invested with personal and family meanings, the language with which people discuss their technologies tell about their identities, their needs and their desires, their ways of interpreting the world and relating to each other.'[10]

From a scientific perspective representation is about the cognitive and perceptual processes that people use to gain and store information about the world around them. It is more about the way humans think and less about the social process. It draws on computational theory and artificial intelligence, as well as the more contemporary thinking of environmental psychology and biological systems, to explore the way people categorize concepts and recognize the physical world. For Marvin Minsky representation is also 'a structure that can be used as a substitute for something else, for a certain purpose, as one can use a map as a substitute for an actual city'.[11] 'Representation' then has to be positioned in the curriculum to accommodate both social, scientific and psychological perspectives. Representation has a dual role both in relation to how we perceive and understand information, at a fundamental physiological level and also how we make sense of it in cultural terms, and if considered from this dual perspective students would be able to initiate new and exciting design concepts rather than simply rely on articulating the already known. For example, on the Graphic Information Design BA (Hons) module 'Representation and Mapping' taught at the University

of Westminster, students are asked to research the different representational modes used in concepts as diverse as linguistics, cognitive science, mathematics, psychology, computer science, history and cultural studies and to apply new ways of using them to map out information.

FINDING A NEW LANGUAGE

In graphic design education we have traditionally been using a language derived mainly from looking at pictures, for describing objects that exist on a two-dimensional plane within a particular framed format and which are considered mainly in relation to their form, with little consideration of their content. The dominant task of modern(ist) design theory, as described by Lupton and Miller, has been to uncover the syntax of the language of vision; that is, of finding ways to organize geometric and typographical elements in relation to the formal design oppositions such as orthogonal/diagonal, vertical/horizontal, and so on.[12] A formal language that is primarily concerned with organizing shapes on a two-dimensional surface no longer seems appropriate when discussing and accessing students' work that exists in a virtual space within a computer screen but is, at the same time, not contained by it. Heller believes that teaching students the new technologies must involve them in adopting more 'abstract forms of communication' than the more traditional 'formal ways'. 'They must become as skilled in the use of metaphors as they are skilled in the creation of literal narratives; they must reinvent old visual tools and develop new ones.'[13] The implication here is that graphic design courses should start to integrate new subjects into their curriculum from areas as diverse as science, mathematics, film directing and sound composition in order to be able to draw on new models for thinking about their practice.

NEW INTERACTIVE ENVIRONMENTS

In order to 'reinvent the old visual tools of graphic design', as suggested by Steven Heller above, it will be necessary for graphic design courses not only to integrate new subject paradigms into their curriculum but also to develop an underlying theoretical framework that could more easily accommodate the shifting world of technology.

This will necessitate them drawing on a wide range of specialisms which could include cognitive science, computer science, computer programming, mathematics, linguistics, psychology, film and theatre directing, acting, script writing, sociology, philosophy, anthropology, history, psychoanalysis, cultural studies and others. As Brody suggests, whilst the use of the computer to define a graphic representation is 'a dramatic step away from classic graphic design, the use of it as a tool says little about the necessities of conceptual design of an interactive piece. For this, we require a new branch of object design: we need to devise an immaterial architecture for the virtual information environments.'[14] This architecture should ensure the primacy of the concepts being communicated over the 'delivery technology' used.

New technologies have dramatically changed the nature and product of traditional graphic design practice with less emphasis on 'finish' and hand craft skills. Now the emphasis is on a different range of craft skills and 'finish', Cotton and Oliver state that a designer can now generate and interact with the complete range of electronic media sitting at one networked computer, by moving 'seamlessly from typography, to animation, to illustration, to image scanning, to video editing, to sound mixing, and at the same machine produce an entire interactive programme ready to be mastered on to CD-ROM, or networked to other machines.'[15]

Hoffos characterizes the design of interactive multimedia with four basic concepts:

1. Rapid random access, which ensures that information of all kinds can be retrieved both quickly and accurately.
2. Branching, which allows the user to follow specific lines of inquiry away from the main trunk of the programme into areas of special interest.
3. Transparency which ensures that the workings of the technology do not distract or inhibit the person in front of the screen.
4. Navigation, which provides the means for the user to move easily and confidently within the interactive programme.[16]

Teaching interactive multimedia presents the need to articulate ideas in a different way. Students must specify the information they will use to construct their presentation. This is a complex problem be-

cause they have to place the information within a hierarchical relationship and consider the various links and individual pathway choices and how they relate to each other. They then have to develop the different navigational routes and design the user interface. Students will have to be able to process information in relation to a particular environment, and orient and navigate themselves around it. They will need to investigate how to use gesture, physical action and memory patterns to describe the particular topology of that environment, to understand how to sequence time and structure narrative, design conceptual models and mental maps.

Students will also have to be encouraged not just to use the computer as a tool to effect designed products but to work with the potential of the computer to effect new designed concepts. According to Lanham, 'Visual modelling is now employed for all kinds of communication that formerly took place in words, through written prose and discursive conversation. All kinds of conceptual relationships can now be electronically modelled in dynamic and compelling ways.'[17] In doing this they will be asked to think about the way technologies have changed the way they think about things and the ways they have of representing the world.

The differences and similarities between the grammar of language and that of visual communication have been discussed at length in various semiotic texts ranging from Barthes in his essay 'The rhetoric of the image' to *Reading Images* by Gunter Kress and Theo van Leeuwen. Kress and van Leeuwen take the view that although language and visual communication are fundamentally similar in the way they construct meaning not everything that can be expressed in words can also be expressed with images. They also extend the definition of language beyond the verbal to cover most aspects of human behaviour, gesture, expression, images, dress and music.

This extended definition of a verbal and visual language is important when discussing interactive multimedia because it brings together a variety of different methods of communicating and constructing meaning. Language is a signifying system that is itself a multiplicity of many other signifying systems. So a text written on a piece of paper, or a text produced on screen, would not be understood as 'one text' but a multiplicity of texts. This multiplicity of texts

is crucial when considering the new technologies of writing and image making and the social, political and economic contexts of graphic design iconography in relation to multimedia design. For example when analysing an interactive multimedia graphic design project the visual mode is only one subset of the totality of modes that might have been used in its construction. These could include speech, sound, text, still and moving images, the programming language, the layout and environment of the computer screen, the relationship to the user, the context of its use and the overall production cost.

EXPLORING DIFFERENT NARRATIVES

Graphic design representations are now dependent on technology, they are produced digitally and enter the semiotic process as a range of electronically constructed representations enabling different readings and different understandings. Historically, the debates around representation have focused on the deconstruction of recorded film, photography, video and print. Contemporary analysis must now take into consideration, not only the production of the text/image relationship and the construction of meaning, but also the system, the applications and the software that support their production which also, according to Kress and van Leeuwen, to some extent, predetermine 'the limits of production' of digital media.[18]

Often this digitized imagery is appropriated from other sources and its original meaning expunged through the process of image manipulation. Image is placed on image, text over text, sound and movement inter-cutting and weaving different narratives, in different places and at different times. How are we to hold to meaning and intention when images can be exploited in this way and new images and new intentions are offered up as multiple choices?

CONVERGING DISCIPLINES

The new digital culture in design is a convergence of many different disciplines – it involves not only the designer as sole creator but a team of people with specialist skills who work together creatively. This working arrangement also fosters a different attitude to the way the work is assessed, with a group of people being credited instead of one individual. The traditional 'graphics' team of designer, director,

producer/printer has been replaced by an 'interactive multimedia' team of designer, programmer, producer/media, video, audio and post-production, the language of the graphic design studio has been replaced with a range of different experiences and specialist knowledges. Graphic design students will have to be equipped to participate and contribute to this new 'digital dialogue'.

It is my experience from seeing various photography, illustration, fine art and graphic design final year degree shows that the work on display is often linked by a common concept, 'interactivity' which relies on the same underlying programming system 'Director' with the addition of other multimedia applications. Studios that were previously the central focus for most courses are, more often than not, deserted with students dispersed to various computer workstations around the campus. The graphic design studio with students sitting at design desks has been transformed by the rapid encroachment of the culture of the computer.

The nature of students' relationships to each other on their own courses and to other specialist courses has also changed because of the introduction of networked Macintosh computers. This has had an effect on the students' perception of themselves in relation to their specialist course. They have more shared institutional knowledge, especially those undergoing a modular degree. The Mac computers often constitute a shared centralized resource with students, from a range of different disciplines, sitting together sharing ideas and working practices.

Students are using the WWW as the launch platform for their various products resulting in another convergence of conceptual creativity, production, dissemination and consumption. This Internet platform will have tremendous significance for individual or group authorship and intellectual property rights as well as implications for the loss of specificity and identity. The constitution of both graphic designers and audiences has also changed. We no longer have a homogenised 'mass' or the narrow definition of an 'average' audience. Both Katherine and Michael McCoy believe that in the future, 'narrow casting' will take the place of 'broadcasting' which will increasingly fragment the market into smaller and smaller 'lifestyle' groups and their own particular consumer needs and desires.[19] We have had

to develop the concept of a 'user' defining a set of particular individualised and personalised expectations in relation to product use. This user can now be modelled, more specifically, along cultural lines, in relation to gender, ethnicity, age and lifestyle. The human interface display for electronic media can now be designed with these specific users in mind; facilitating their programmed options and the integration of movement and sound in interactive multimedia presentations.

INTERACTIVITY AS METAPHOR

I have presented here a series of propositions about the future for graphic design studies, and have suggested that there might be tremendous potential for teaching graphic design theory, history and practice in the metaphor of 'interactivity', a non-linear, non-unified and a non-specific approach which would enable assessment of new design work that no longer sits comfortably within the traditional graphic design paradigms; the integration of static image and text. The transmission and reception of graphic 'images', their history and their production must be positioned within a critical framework that can encompass present and future technologies and technological change. Without a specific graphic design/history theoretical underpinning how much more difficult will it be to explore the territories of graphic design now they have become digital and increasingly 'virtual', multi-modal and interactive.

An example of a more interactive approach to teaching design history is offered by Jos Boys at De Montfort University. She has developed an active approach to teaching the history of architecture. She uses the concept of connectivity, as well as setting an interactive design project, which is to devise a concept 'map' that lays out the different categories of 'history', and asks her students to construct their own particular interactive and multimedia historical narratives. The chosen historical categories are then analysed in terms of the relationships of information that can exist between them. These can be approached in a number of different ways, from a number of different viewpoints and also at a number of different levels. The question can then be asked in relation to style, movement, ideology, individual, group etc, 'What is it that characterises this particular point in

history – what is important about this particular time?' It is possible then for a response to draw on a multiple range of answer choices and also at the same time for the students to make sense of the kind of relationships that can exist within this network of historical, social, cultural, and architectural information nodes.

This approach could also foster the students' own cultural and social values, it could 'represent the intersection of different voices' many of which are absent from most course programmes and educational philosophies. Tim Benton from the Open University suggests that multimedia applications present a natural terrain for the study of design history. 'Grouping and comparing images and associating them with fragments of arguments and explanation is a natural process in developing art and design historical ideas.'[20]

Victor Margolin in his introduction to the Spring 1995 issue of *Design Issues* states that in order to grasp the significance of the new activities of design as it moves further into the realm of the artificial 'we must be continually changing our understanding of what design is whilst we are simultaneously preoccupied with establishing its historical narrative'.[21] The old categories of design must be revised and considered in the light of the new technological developments. This means that we need to consider how we use computers, how we relate to them now and the kinds of expectations we have of them for the future.

I would like to suggest, therefore, the potential for an 'interactive' graphic design theory which would support a non-linear, non-unified, and non-specific approach to the study of the theory, history and practice of graphic design. This interactive approach would also enable the reading of interactive design work which cannot be interrogated along the same lines as static image and text. At the University of Westminster staff have considered this problem in relation to the existing course in Graphic Information Design and have defined an area for study that would have relevance and significance for the students and provide them with a critical framework to enable them to consider their future as professional designers. This framework would also be attentive to the way graphic design has evolved in relation to the new technologies and incorporate a history of technology as an important concern of its field of study.

CRITIQUING A NEW THEORY

Until 1994 the Graphic Information Design BA (Hons) course had developed a theoretical framework that was derived mainly from communication studies. It had been a very effective model through which students could learn to critically access the work of mass media and to place them within a cultural and social context. But it did not provide an adequate framework for the students to consider the impact that electronic media has and would have on their professional and private lives. In the new module 'the computer' has a biography and a history but as yet the virtual objects produced in and through this technology do not have an adequate language to critically describe them, one which could position them as material culture.

In 1995 the course introduced a new Critical Theory module that looked specifically at the transition from the human use of traditional tools to the human use of conceptual tools, knowledges and ideas. It illustrated the historical parallels that could be drawn from an understanding of the development of an industrial society to the emergence of the information age. Postman writes that the 'New technologies alter the structure of our interests: the things we think about. They alter the character of our symbols: the things we think with. And they alter the nature of the community: the arena in which thoughts develop.'[22] Students were asked to examine the development of language as the most characteristic skill of human beings and to investigate how language structures and creates meaning as part of a visual and verbal signifying system. They were encouraged to critically examine how the new technologies have changed the way we think about things and how we represent the world.

Sherry Turkle in *Life on the Screen* writes that 'we construct our technologies, and our technologies construct us and our times. Our times make us, we make our machines, our machines make our times. We become the objects we look upon but they become what we make of them.'[23] Because graphic design education and professional practice have, over the last ten years, undergone radical transformation, it is necessary to contextualize the way the 'objects' of graphic design have been changed and how we have changed with them.

Our students have grown up in an environment that is electronic and increasingly 'digital', and their sense of time and place is differ-

ent from that of twenty years ago. Children in a computer culture, according to Turkle, are 'touched by the technology in ways that set them apart from the generations that have come before'.[24] Postman suggests that it is not possible now to look back to a 'golden age of informational purity – the golden era of pretechnology communicated entirely by the printing press'.[25] Yet it is ironic that when asked, my students said they would prefer a world without computers – it might create a more caring society.

ESCAPE FROM THE FLATLANDS

In conclusion – what should we be talking about to our students? Should we be escaping from the flatlands and thinking about and constructing different ways of communicating information – digitally? Perhaps we should also be designing interactive multimedia – to teach with. We certainly should be considering what the future role for graphic design should be. Maybe we should even be considering if graphic design is still an appropriate convention for teaching new forms of design communication. We should certainly be considering a different convergence of disciplines that would address the future role of design communication more appropriately, especially in respect of gendered technologies. In doing this we should make sure that all students have equal access to, knowledge of and confidence about, using the new technologies, levelling out the 'playing field' and blurring the boundaries of practice to enable both 'hard' and 'soft' mastery of computer skills regardless of gender. Certainly we should be talking about it and helping students work with the new technologies to enable them critically to evaluate and assess them. And in the design of new courses, staff will need to play close attention to the continuing repercussion of technology on their sites of practice and on their individual institutional power relations and its potential impact on possible future course development.

I would like to thank my Ph.D. supervisors, Bridget Wilkins and Professor Tim Putnam, for sharing and discussing these ideas with me.

TECHNOWHORES

Welcome to the Whore House
Did you come to work or play?
A technowhore, a cyber rent-boy or maybe just a john.
The Internet is not a place beyond the body ... yet
Are you here to engage in the nameless pleasure of sexed
information?
We are promiscuous women, no better than we should be.
Illegitimate daughters of the myth machine.[1]

*

*Information superhighway, mediatrix, Internet, medianet – a kitsch sci-fi
wet dream. A sprawling cybertropolis of parallel mainframes capacitating
freedom, liberty and the American way. A virtual anarchic utopia, self-
governed, self-guiding and self-perpetuating. The epitome of postmodern
society, radically decentred and thoroughly disseminated.*
*Selling us the prospect of a paperless future, the data highway promises to
become the world's largest collection of intelligent binary digits.[2]*
*Defying class, race and gender barriers, you are invited to populate the
ultimate democracy – sorry technocracy. The cybernet is in place, eagerly
awaiting the twenty-first century as the old school information elites
crumble – the cybernauts are controlling the future.*

*

The Internet, famously libertarian, perhaps even 'post-gender'[3] is
not virgin political and cultural territory. The electronic frontier has a
history, geography and demography grounded firmly in the non-vir-
tual realities of gender, class, race and other cultural variables that im-
pact upon our experience of the technological. Technowhores work at
the interface teasing out disruptions in normative categorizations of
identity and location while, at the same time, working through these
categorisations and the ways they figure not only ourselves as sub-
jects, but the interface itself. We use interface here in the computing
sense, that is, the connection in time and space between a

person/people and their machine(s), but also invoke the meaning of interface as the meeting point of different processes. For this project we concentrate on the process whereby the subject becomes 'woman' and the process whereby the Internet becomes 'technology'.

<div align="center">*</div>

MOO: multi-user dimension, object oriented.

@help

MOOs are online communities which allow real time text based communication between many people in disparate places. Born of classic dungeons and dragons adventure games these arenas adhere to strict MOO etiquette. Users can take on an identity, defining characteristics for themselves, and 'build' their own 'rooms' within the virtual space. These domains are governed by their original programmers – traditionally known as the 'wizards', who are invested with the power to banish participants as well as performing general maintenance / housekeeping duties.

There are several commands available to allow you to communicate with your fellow MOOers.

say	— talking to the other connected participants in the room
whisper	— talking privately to someone in the same room
page	— yelling to someone anywhere in the MOO
emote	— non-verbal communication with others in the same room
gagging	— screening out noise generated by certain other participants
@typo @bug @idea @suggest	— sending complaints/ideas to the owner of the current room
whereis	— locating other participants
@who	— finding out who is currently logged in
mail	— the MOO email system
security	— the facilities for detecting forged messages and eaves dropping.

<div align="center">*</div>

The hypermedia bandwagon is gaining momentum, heading for the rush hour and the cyber commentators are strap hanging for dear life.

*Purveyors of the written word happily cash in on the new electronic
culture while contributing to their own demise.*
*The media are obsessed with cyberculture. Business pages, Sunday
supplements and lifestyle glossies advise us on financial benefits, net
jargon and the coolest matt black accessories.*
The cyberdroolers laptop it up, seduced by beeper culture.
*The promise of a globally networked product placement opportunity
inspires the 'new technology solutions' brigade in their quest to capture the
technocommodity market. While home shopping channels promise
agoraphobes the ultimate remote control new generations are lured from the
dangers of the arcade – 'consoled' in the comfort of their homes, joysticks in
hand.*
*Detached society – detached retina. Twenty first century vision – double
vision.*

*

Feminists working with the Internet must interrogate the cultural
and political construction of the technological in relation to gender
and the cultural and political construction of the subject position
'woman'. A deterministic, essentializing approach to gender locates
the technological beyond the realm of women. An approach that al-
lows women a positive and pleasurable engagement with technology
should work to deconstruct the practices and discourses that have
fixed gender as a bipolar universal category and the technological ac-
cording to values that are deemed universally masculine.

The political fictions, the dichotomous categorizations of enlight-
enment epistemology, hierarchical binaries such as mind/body, cul-
ture/nature, masculine/feminine, public/private provided the
founding principles for philosophical and scientific enquiry. Man or,
more specifically, men were enlightened to the fact that they might
dare to know. The knowledge they sought was that which might
allow them to dominate nature – a triumph of the mind, of the ratio-
nal, of culture. Scientific practices based upon a knowing subject and
an object that can be known, were developed as the basis for estab-
lishing truth and knowledge. Women were equated with nature both
metaphorically in representational practices and through their bio-
logical capacity to give birth. They were fixed firmly upon a corpore-
al plane, embedded within nature and it follows that a will to define,

dominate and contain nature was simultaneously working to define, dominate and contain women.

This knowledge system establishes the 'natural' location of women outside the realm of the technological – machines and processes developed within the scientific, rational, masculine sphere as part of a teleological process of development. The genealogy of the Internet as a military research project and its delivery via a computer interface, via technology, suggest that the Internet is not a 'natural' domain for women, and the demographics of the World Wide Web appear to support this theory.

Feminist analyses of the ways in which women might position themselves in relation to technology might be seen to parallel analyses of female identity and the sex/gender distinction, and the ways that these intersect with other variables such as race and class, for example, as foundations for theory and political consciousness. Feminist figurations that are beyond those metaphysical spaces formed by the enlightenment as truth allow an exploration of the possibilities suggested by new communication technologies such as Internet for working through reconceptualizations of subjectivity and the body, and also technologies of gender, that is, the symbolic and material processes whereby the subject becomes 'woman'. Furthermore, we might perhaps see ourselves as ideally constituted to exploit the reterretorialization of power structures and ruptures in traditional boundaries that are a hallmark of late capitalism.

*

Event Scene
You look around you. You see a luxurious boudoir draped in velvet, the lighting is subtle, soft music emanates from the stereo, a cigarette slowly burns down in the ashtray. You are offered a drink of your choice and your hostess pulls back heavy curtains to point out the exits.
Obvious exits: The Playroom, the Lounge Bar, the Stairwell, Emergency Exit
@who

Participant	Connected	Idle time	Location
technowhore (#95)	39 seconds	0 seconds	Event Scene
Lulu(#15615)	a day	2 seconds	Switchboard

X. (#15932)	22 minutes	3 seconds	The Playroom
Head (#6888)	36 minutes	7 seconds	The Playroom
BRENT (#9649)	3 hours	5 minutes	Paradise
Code Warrior (#157)	2 hours lap	7 minutes	On technowhore's
Harley (#6350)	16 minutes	10 minutes	Vegas
Gates (#13442)	9 hours	13 minutes	Lounge Bar
vampire (#11182)	3 days	a day	Secret Locker Room

Total: 9 participants, 4 of whom have been active recently.
@go the Lounge Bar

*

The technostate is ready and waiting. A Situationist dream or a Gatesian nightmare? Shattering the spectacle in favour of free speech and a truly interactive democracy or reinforcing power structures and hierarchies embedded in the politics of power, access and information, the currencies of control.
As the hackers attempt to subvert clipper chip culture, big money moves in and the corporations become terminally wired.
The digital dream revolves around infospace and new communication technologies control and manipulate data flows through a new dimension. Powerful networks (compu)serve the 'public' domains of the hard core mac-burners. Data highways map the new terrain. The new information elites are accessing all areas. Our 30 second attention span is suffixed with new protocols. http://www.everyone_should_have_one.com

*

On-line computer communications technology mediates between the embodied self and the 'I' that is simultaneously present in the virtual realm. Identity is experienced simultaneously as 'self' and 'other', in embodied and imaginal domains. These polluted, in-between spaces, arenas of imperfect communication disrupt the coding of the unified subject. Displacement seems to encourage reflection. There is a release of textuality in this, often literally, textual world.[4] One cannot help but think of oneself in terms of multiples, within a network, marking out and being marked out in turn.

Feminists such as Donna Haraway, Monique Wittig, Teresa de Lauretis and Judith Butler conceive of the subject as process. Female subjectivity is seen in terms of a process network of multiple, perhaps

contradictory, variables simultaneously constituting identity. The emphasis is upon the contingent, situated nature of these networks. Attempts to constitute a unified female subjectivity, or name a homogeneous female identity as a basis for social and political change are disciplining and exclusionary. Concepts as central to feminist debate as 'gender' and 'woman' come into question as regulatory fictions.

De Lauretis sees gender as a 'technology', as a material and symbolic process that constructs categories of identity in the same moment it describes them. It is a regulatory process that produces categories such as man, woman, homosexual, pervert etc. that intersect with normative variables such as race and class to construct socially normal subjects. She argues that feminists must find new definitions for the female subject that disrupt the normativity of the dominant forms of sexed identity. There is a call for feminists to produce a new array of non-coherent genders.

Thus, feminist politics is about the power to claim subjectivities and identities that reflect the situated nature of knowledges, to find a place of enunciation, new ground. Boundaries demarcating centre and periphery will be defied and transgressed. It is about the wilful creation of new feminist foundational myths, outside of the regulatory fictions of patriarchal, colonialist ideologies, as a basis for the empowerment of women.

*

technowhore enters the Lounge Bar.
Code Warrior enters the Lounge Bar on technowhore's lap.
Gates says 'Hi technowhore'
technowhore – temporarily incarnate, cyber shape-shifter. You see the morph, the movement, the passing.
Voluble, voracious and infinitely volatile. technowhore disrespectfully mixes and matches variables, there are no handlers here.
gradually the Lounge Bar fills up

*

Ever nearing the Rheingoldian vision of virtual embodiment, we anticipate the 'reach out and touch me' age of tactile technology. Beyond territorial boundaries fringe science, pop culture and the truly bizarre merge in cyberspace.
Surfing between far flung satellites, cyber galactic nomads ride the crest of

the technological wave searching for the ultimate roller – unsure of their destiny.
A networking infrastructure facilitating the free flow of visionary ideologies. The Internet conveniently disowns its murky genealogy, conceived within a marriage of science and the military, to monitor and control, guard and protect, it revels in its pseudo-utopian image – a complex web of semi-legitimate, oppositional and alternative subcultures. This community of co-creation believes it can defy traditional barriers and power structures in its attempt to build a world unmediated by authorities and experts.

*

Donna Haraway proposes the disruptive figuration of the cyborg as a means of thinking through and subverting normative categorizations of female subjectivity. In the presentation of this monsterous hybrid, 'born' of developments in the biological sciences and microelectronic technology, neither wholly organism nor wholly machine, Haraway's Cyborg Manifesto argues for 'pleasure in the confusion of boundaries and for responsibility in their construction'.[5] For Istvan Csisery-Ronay, Haraway's impact lies in her 'imagining utopia by moving through the heart of dystopia'.[6] The cyborg cannot be encoded as natural. There can be no recourse to an original unity or vision of a 'naturally' inevitable masculinist technological domination. The cyborg recognises the potential of the restructurings and symbioses occurring through new technologies. It emerges as a fusion of fiction and material reality that allows us to imagine positive political, social and technological transformations from a subject position that does not pertain to wholeness. Subjectivities, knowledges, are always situated and partial.

Questions like 'Should women compute?' become utterly redundant. 'Woman' and 'technology' cannot be bracketed off and analysed as innocents or villains in relation to white, patriarchal capitalism.[7] For Haraway, 'Intense pleasure in skill, machine skill, ceases to be a sin, but an aspect of embodiment. . . . Cyborg imagery can suggest a way out of the maze of dualisms in which we have explained our bodies and our tools to ourselves.'[8]

Her approach to subject position parallels her approach to technology. That is, the meanings of machines are contingent. They too exist

between worlds, the human and the non-human, mediating our desires. The interfaces of microelectronic technologies have become metaphor, they exist on a virtual plane and so can be moulded according to our hopes and fears and desires as they, at the same time, can shape our imaginations and realities.

The Cyborg Manifesto proposes a grounding for meaningful political action. It is intended as 'an ironic myth faithful to feminism, socialism and materialism'. Haraway asserts the need for new strategies to resist the 'Informatics of Domination' the system network of global power resulting from the evolution of science, technology and information systems. The cyborg must represent a foundation for collective political interventions, transformative interruptions in the power matrix that the military code C3I – command, control, communication and intelligence. Collective resistance must be formed on the basis of strategic, temporary and mobile affinities rather than exclusionary and normative formalizations of woman as victim, or by claiming solidarity based upon an image of original unity. Affinity politics accommodate the multiple, often contradictory subjectivities of individual women.

Theoretically, the internet is ideally constituted to meet the requirements of affinity politics. As well as meeting power structures embedded within information technology head on, the very structure of the network provides a blueprint for these new conceptions of subjectivity. The internet is a rhizome. Deleuze and Guattari describe some approximate characteristics: 'any point on a rhizome can be connected with any other, and must be . . . A rhizome never ceases to connect semiotic chains, organizations of power, and even events in the arts, sciences and social struggles . . . Multiplicities are rhizomic, and expose arborescent psuedo-multiplicities . . . There are no points or positions in a rhizome, as one finds in a structure, tree or root. There are only lines.'[9]

Thus, the rhizome as a model for 'thinking the present' works outside of phallogocentric discourse. Deleuze's aim of thinking the present differently is linked to his concept of 'becoming' . . . 'the affirmation of difference, meant as a multiple and constant process of transformation'.[10]

*

Head waves to technowhore
X. says 'Hi technowhore'
Lulu waves to technowhore,'how are you?'
technowhore says. 'fine. what's going on here?'
You see a faint shimmering force wrapping itself around Head and hugging her warmly ...
Then the shimmering force disappears slowly and silently ...
Head would like a man in her life.
Lulu nods.
X. [to Lulu] 'don't you have a man?'
Lulu [to X.] 'ah no'
A pimply faced teenager arrives in a delivery truck from shopping arcade with postcards of PostModernCulture MOO for Lulu.
The truck speeds away.
Head has to go.
Head has disconnected
The housekeeper carts Head off to bed.

*

Androgynous body-hoppers inhabit the murky depths of MOOs, MUDs, MUCKs and MUSHes.[11] Virtual environments populated by twenty-first century reincarnations of ancient mythological creatures. Freed from the restrictions imposed by sight, sound and scent, cyberspace defies our very sense of reality.

Gender as social construct becomes gender as cyber construct as characters discard physical form on entering the matrix.

The persistent on-line preoccupation with human identity and sexuality however, is far from the post-gender hyperbole touted.

Often framed by radical body politics MOOspace encounters attempt to transcend the social conventions of gender identity whilst constantly anticipating realworld eyeball contact.

Gender, sex and sexuality become front-end issues as on-line relationships culminate in face-to-face MEATspace rendezvous.

*

For Rosi Braidotti Haraway's utopian vision of a world without gender is not strategically useful. The becoming-subject of women, the redefinition of female subjectivity, cannot be achieved by force of will alone, for desire must be mobilized to achieve political change.

119

Her strategy of the affirmation of sexed identity is a mimetic one, but Braidotti argues that the process of change requires the consumption of the old. Before feminists can dispose of the subject position, 'woman', they need to work through its complexities to achieve, through the affirmation of counter-values, a radical re-embodiment of 'woman' as the desiring nomadic subject. This nomadic subject addresses the need, 'to connect the "differences within" each woman to a political practice that requires mediation of the "differences among" women, so as to enact and implement sexual difference'.[12] So Braidotti's emphasis on the role of unconscious desire in the process of becoming requires the radical embodiment of the feminist nomadic subject.[13] That is, the recognition of a body with a sexed identity as the always already of the feminist subject. She emphasises that this essentialism, the deployment of feminine excess, is a strategic move aimed at creating difference. It requires that women engage in the process of remapping the 'dark continent' (Freud) according to their own topologies of location.

There is no call for a 'common language for women in the integrated circuit'.[14] Rather it is the opening up of the discursive spaces between the different voices that is the concern of the nomad.

*

Lulu thinks a small herd of men should be kept as breeding stock.
X. laughs at Lulu
Harley is looking for docile ones
technowhore says 'too much submission can be a bad thing.'
X. [to Harley] 'you've been hanging out with the wrong men.'
Gates nods in agreement with X..
Lulu [to X.] 'The ideal would be wild in bed and nicely docile outside of it.'
Charlie digitally reconstructs here.
Code Warrior waves to Charlie
BRENT would like to find a man who is sweet, nice, lovable, listens, has time for her yet has friends to be with.
Lulu hugs Charlie with a warm and loving embrace

*

Within constantly shifting boundaries, caught in a quandary between 'digital city' and 'virtual community' we become nomads of the new

*geographies. Forever rewriting our position, essentially transient, of no
fixed abode.*
The Internet invites us to take control, establish new territories.
We're good at this – well practised in the art of controlling the imaginary.
*The constantly moving target keeps us on our toes – encourages us to
transcend our fixations with place/space/time and with our ontological
insecurities discarded a new existence awaits.*
*Perfect candidates for the 'post human condition', our flighty femininity
lends itself to the task – to shape this inherently malleable form.*
An ideal opportunity.
So we're told.

*

At the interface, the common boundary between women and com-
puter technology, the regulatory nature of the network of material
and symbolic operations that have created both the feminine subject
and the technology are thrown into stark relief. The interface itself can
become a material and symbolic barrier to productive interaction. But
it is the interface, this in-between space, that also offers so much po-
tential for thinking and working through feminist figurations.
Inequalities of access to the discursive and technological tools re-
quired to take advantage of this potential cannot be ignored and tech-
nowhores fully acknowedge our privileged position. A way forward,
perhaps, is to reject the language of hype and teleology that sur-
rounds computer technology and the Internet and refigure our tech-
nology as positively intermediate.[15]

The conceptual tools that allow an understanding of the mythic na-
ture of the foundations for identity also allow one to consider the
technological in terms of its contingent meaning. Consciousness of
one's own political agency in the telling of alternative narratives de-
mands that one implicates oneself in how the technological is consti-
tuted. The dissimulation of power relations with regard to gender in
many on-line communities that results from the absence of a materi-
al body denies this common ground, resulting in mimetic interactions
that reinforce phallogocentric ontologies. Virtual subjectivities should
be regarded in material terms and seen as strategically useful in the
pragmatic project of the radical re-presentation of the female subject
as political necessity. The interface is ideal territory for the working

121

through of the subject position 'woman'.

*

Brent hates driving

X parks his ass at the table

Lulu is babbling

Harley bought a new car two weeks ago.

Brent [to Harley] 'what kind?'

Harley says 'BMW series 8'

Brent says 'Nice'

X says, 'I've got a new company car and now I love driving'

Brent says, 'I have to cross Bay Bridge to Berkeley to go to work and you've never seen traffic like it. bumper to bumper.'

Lulu [to CodeWarrior] 'yes I have, in Houston'

Gates grins at Brent

 X wants a vacation

Harley [to Gates] 'do you have a car?'

Gates to Harley 'sort of, a truck'

Harley to Gates 'Is that one of those ones that you need a ladder to get into?'

Gates [to Harley] 'No – I just have regular suspension'

Lulu says 'I am so tired'

technowhore heads for the stairwell

@quit

disconnected

RE-PRESENTING MARGINALIZED GROUPS IN MUSEUMS
The computer's 'second nature'?

Helen Coxall

> Educators emphasise the computer's nature as a teaching machine or an analytical engine, but give insufficient attention to, and even deny the computer's 'second nature', as an evocative subject, an expressive medium that people use for self-projection and self reflection.
>
> Sherry Turkle

Computers have been used for some time in museums as information databases of documentary details about objects in their collections. Although initially for the use of museum staff and researchers, some computers have been designed specifically to be accessed through touch screens and made available to museum visitors. A more recent development is the design of multimedia interactive touch screens which enable visitors to access stories, themes and issues – as opposed to objects – which will be discussed later. In this chapter I will look at the potential differences that interactive touch screens can make to museum exhibition display, and will focus on the ways that people's lives and work are represented.

Traditionally, museums have displayed their collections accompanied by interpretive information. Such information may range from a minimal amount, as in the form of a discreet label in an art gallery, to a comprehensive account of an object's function, such as in a science museum, or an anecdotal account of a way of life, as in a social history museum. It may take the form of printed text on the wall or in a brochure, or prerecorded narratives at an audio point. How much difference, if any, does it make when this information, and in some cases the objects too, are offered in the form of interactive multimedia instead?

123

According to Beardon and Worden, the fruitful development of multimedia systems relies on empowering the users by enabling them to set their own agendas.[1] Certainly, offering museum visitors the possibility of choosing their own pathway of exploration through a variety of information fields on computer touch screen, instead of a restricted line of enquiry prescribed by the exhibition creators, has the potential of personally empowering them . . . but does it? Is it really a transference of power that occurs when clearly an anonymous person, or team of people, have had total control over the choice, selection and design of what appears to be 'seamless' information made available on the touch screens in the first place? Conversely, it is possible that methods of gathering and selecting information for multimedia application may be potentially less restrictive – and that is an observation that warrants exploration.

Some more traditional methods of documenting objects, such as a flat iron or an Adam fireplace, indicate possible limitations that can be placed on the interpretation of those objects. Using objects as tools to illuminate stories of the past requires a much freer classification of objects that is often practised in museums. The institutions themselves are commonly classified according to their collections: science and industry, art, natural science, maritime, decorative art and so on. which tends to exclude the stories of the people who both made and used the objects in the museum's collection. Even history museums such as museums of war, labour history, coal mining and so on, are in danger of excluding a social historical perspective due to the restrictive nature of their field of concern. Thus museums themselves are classified according to their collections, and the objects in these collections are documented according to a classification of their perceived sphere of use.

CLASSIFICATION AND MARGINALIZATION

Any method of classification inevitably has the potential to impose limits on the interpretation of objects. For example, SHIC (Social History and Industrial Classification) recommends that each object should be classified as pertaining to one of the following areas of use: community life, domestic and family life, personal life and working life: each of which has numerous subsections.[2]

Thus, for example, work objects used by women during the nine-teenth century for such paid occupations as dressmaking, taking in laundry, home nursing, child-care and factory out-work, tend to be classified and documented as 'domestic' because the work was large-ly home-based. This effectively removes women from the histories of work in the nineteenth century, creating the impression that it was only men who worked at that time.

In her explicitly titled essay 'Present but not visible: searching for women's history in museum collections', Helen Knibb focuses on the collection policy itself as being biased against women's history:

> Intangible heritage such as customs, traditions, folklore, myths and dance are now recognised as an integral part of a meaningful collection, yet few museums have the re-sources to engage in any systematic activity in this field. The objects in a museum's collection are those which have survived, not necessarily the most useful, relevant or meaningful in women's lives.[3]

It is not only women's lives that can be rendered invisible by collec-tion policies: the poorer people in society can also be marginalized due to lack of material evidence of their lives. Gaby Porter describes how this comes about:

> The objects which reach our collections are generally those which have survived through abundance, or supe-riority and permanence of material or construction, and because people had the space and resources to store them. They are the legacy of more prosperous individu-als or groups.[4]

Any museum that displays lifestyles – with furniture, room sets, pe-riod memorabilia – is likely to come across this difficulty. It is true that it can be pointed out to the visitors that a room occupied by the largest proportion of the population would not have been like this, but being told about another way of life is not quite the same as experi-encing it. Such apparently unconscious discrimination against women

and other marginalized groups has serious implications because:

> Museums are not merely reflections of the world around
> them – they are instruments, and instrumental in form-
> ing and consolidating identities . . . As produced and
> presented in museums, the roles of women are relative-
> ly shallow, underdeveloped and muted: the roles of men
> are, in contrast, relatively deep, highly developed and
> fully pronounced. [5]

Such attitudes are largely unchallenged by museum professionals
themselves, for as Helen Clark, curator of the social history museum
in Edinburgh called 'The People's Story' which tells the stories of the
people of Edinburgh, explains:

> Bias tends to be a term levelled at the museum by other
> professionals, who do not accuse museum displays
> which challenge the status quo and uphold the Estab-
> lishment as presenting an extremely limited view of the
> past.[6]

She also makes the revealing observation that when her exhibition
'The People's Story' was opened, some people complained that the
display was biased in favour of women. In fact, there were exactly the
same number of women featured as men, proving that as their equal-
ization had the effect of favouring women, the unconsciously accept-
ed 'norm' has always been biased in favour of men. In the display the
curators had taken positive action to counteract this unconscious
'norm'.

While working at the Hackney Museum in East London, Christine
Johnson developed a fifth extension to the SHIC classification system
which she called 'positive action', in response to the needs of the com-
munity that her museum represented. She recommended that each
museum should develop their own system to suit the needs of their
own community. Her own subdivisions to her fifth extension are as
follows: African-Caribbean, European, Jewish, Indian Subcontinent,
Other Asian, Women, Lesbian, Gay and Attitudes. Such subcategories

permit sections of society rendered invisible by the SHIC classification system to become visible by moving away from a purely object-based approach to a people-based approach to recording history.[7]

HISTORY AS BIOGRAPHIES

However, telling history from a people-based (as opposed to an object-based) viewpoint, carries its own difficulties for museums. In spite of the persistence of 'official' versions of history, it has long been acknowledged that there is not just one version, but as many different versions as there are people to experience them, and as Linda Hutcheon points out:

> What is foregrounded in post modern theory and practice is the self-conscious inscription within history, of the existing, but usually concealed, attitudes of historians towards their material.[8]

Any past events provide potential material for constructing images of the past, but 'the ones that become facts are those that are chosen to be narrated'.[9] And of course museum staff choose which versions of history to relate, as we all do. However, the difference is that such selection in museums – which are generally regarded as centres of excellence and knowledge – result in other versions being publicly rendered mute. The selection of material to be included, and even more significantly, to be excluded, indicates the viewpoint of the selector: as does the language chosen to narrate the chosen histories. 'Language in an important sense speaks us.'[10] Attitudes to others – to race, to sexual orientation, to gender, to class, to world wars, to events in history – are all indicated by chosen ways of saying. Language is a site of power, and people are marginalized or endorsed by its use. Museum visitors bring different, experiences and perspectives with them with which they will reinterpret meanings of their own. However, if the available information has been closed down by evasions and gaps, and if visitors bring limited knowledge with them, their potential as negotiators of meanings will be severely restricted. Thus, the choices made by creators of exhibitions about the interpretation of their materials relating to versions of history are crucial. A

museum is an institution for informal education. Part of that remit is to illustrate aspects of what has happened in the past to help people understand the present and make informed choices about the future.[11]

Many museum curators claim, with some justification, that the amount of information they have room for limits the scope of the choices they are able to make and this is what is responsible for closing down access to alternative narratives. With increasing emphasis on the need to provide 'user friendly' text that is quickly read and easily understood, the last thing they wish to create is 'a book on the wall' that will not be read anyway. One immediate response to this is that the use of CD-ROM to store a wide variety of material, and an interactive touch screen to access it, would solve their dilemma. Another response, however, is that if available space for interpretive information is to be limited, it is even more vital that the selected gaps do not result in an exclusive seamless historical account that validates a single evolutionary narrative (alternatively referred to as 'progress').

Foucault, and many post-structural thinkers since, have named the pursuit of origins as futile because it represents an attempt to capture the real essence of things, and therefore assumes the existence of immobile forms: in other words, of definitive meanings. In fact he claimed that what is found at the historical beginning of things is not the inviolable identity of their origins; it is the dissension of other things – it is disparity.[12] Foucault argued that exploration of evolution is invalid because such explorations exclude discredited, neglected and single events that do not fit neatly into the pattern but are nonetheless equally as valid as events that are included. Instead of histories he used the word 'genealogies' which he felt permitted the discontinuities of biographies that seamless history-making does not allow. Tracing genealogies:

> attempts to reveal the multiplicity of factors behind the event and the fragility of historical forms. In this view of history, which Foucault's writings exemplify, there can be no constants, no essences, no immobile forms of uninterrupted continuities structuring the past.[13]

Perhaps a clue to a way into reinterpreting the past is this concept of genealogies or biographies. Roger Silverstone offers the view that objects themselves have biographies, rather than fixed meanings, once they have reached 'their last resting place' in the museum. He maintains that the biography of an object gathers its meanings from the different circumstances of its use from the 'various social, economic, political and cultural environments through which it passes, and its passage can in turn illuminate those environments in a way that a flare or a tracer illuminates the night sky'.[14] It is not just the authenticity of the museum object – such as a silver chalice, for example – that is of value but the object's potential for the retelling of events, of people's stories and of practices from the past. What is crucial is how the creators of exhibitions use the chalice.

This way of looking at objects has prompted the staff at the National Museum of Denmark to develop a multimedia collection data base – GENREG – which is available to the public in the Ethnographic Department's exhibitions. It contains text and pictures of nearly 10,000 objects, of which only 3,000 are on display. What is exceptional about this database is that it provides information about the history of each object's creation, ownership and subsequent usage. This system evolved over time because it was quickly discovered that objects did not always follow the rules as defined in their original analysis which looked only for details of accession, provenance, determination, description and administration. The GENREG team found that objects can be transformed and used in ways quite different from their original purpose, and objects can enter a variety of relationships with other objects.[15] They acknowledged that taken out of context objects were robbed of their biographies. This database is of course still object-oriented.

Thus it appears that certain current practices of documentation and classification can have limiting effects on the nature of stories told about museum objects. Also, object-centred approaches to interpretation can exclude the people who made, used or owned the objects. Conversely, telling people's stories can also cause exclusions as a direct result of the historical perspective taken by the exhibition staff. Lastly, lack of space can curtail the availability of information.

TOUCH-SCREENS IN MUSEUMS

As the collation of information for CD-ROMs is not restricted by physical difficulties of dealing with large collections could their use in conjunction with interactive touch screens avoid some of these potential difficulties? The use of CD-ROMs to store images of objects in the collection and interpretive text is not new in museums and a brief look at some current examples should serve to answer this rhetorical question. The Micro Galleries in London's National Gallery and the Imperial War Museum use interactive technology as information catalogue and guide to supplement material already available. In the Imperial War Museum, the touch screens are integrated into such selected galleries as the main atrium where users can access more information about the aeroplanes, tanks and weapons on display. Similarly in the section about the First and Second World Wars historical interactive videos are available to clarify the events of campaigns. The touch screens in the 'Secret War' exhibition add a certain sense of excitement by creating the impression that the user is accessing secret MI5 files never before seen by the public. Sounds of creaking doors, filing cabinets and drawers being opened add to this effect. Although the information to be viewed is largely textual, the 'secret' element is popular with children. An archive video interactive which was designed on laser disc in 1989, provides information about all art works owned by the museum up to that date.

Micro Gallery's data-based interactives are not integrated into the galleries, instead they form a separate resource that provides visitors with information about every single painting in the National Gallery's permanent collection. Because the information in the Micro Gallery is designed to function as an autonomous unit independently from the collection, copies of the CD can be purchased and viewed elsewhere.

The Micro Gallery collection takes the form of an illustrated catalogue of 700–800 artists. Information is divided into five categories: general reference index, historical atlas, picture types index, artist's biography and painting details. Each of the twelve touch screens has a printer that will print out an orientation map with the location of paintings that the visitor wishes to see. Similarly any screen can be printed out in black and white for reference purposes – which clear-

ly benefits students. The programme provides the possibility of cross-referencing between the categories and seeking explanation of technical terms. The purpose of the on-screen catalogue is clearly educational and informational and is heavily used by English speaking tourists (the database is not multi-lingual), students and occasional visitors. Clearly it is an information resource that is interactive in so far as it permits personal selection. However, the information provided is very similar to that one would expect to find in an art history text book (albeit presented in accessible language). It is also presented in a way that is likely to appeal to a non-specialist audience. Those with more detailed knowledge of art would find the information limited. As this was one of the of the first database resources in this country designed for art gallery visitor use (it opened in July 1991) its interactive nature has not been developed beyond this purely informational facility. The latest version of the Micro Gallery in the National Gallery of Art in Washington has been developed much further than the original in London.

The National Gallery of Ireland has a multimedia interactive application which was developed to record a touring exhibition of selected paintings from this gallery entitled 'Master European Paintings'. Its purpose differed from that of the Micro Gallery as the paintings were preselected, and the programme was designed to 'engage and educate' rather than as an information resource. Although forty-four paintings feature in this programme only ten specially selected 'major works' were dealt with in detail. With an emphasis on images, written text is kept to a minimum in favour of the spoken word, and topics do not duplicate information found in the catalogue.

The fact that the title 'Master European Paintings' was chosen and that ten major works were preselected for the viewer, upholds an artistic canon which is not without prejudice and represents another unchallenged 'norm'. A brief look at an exhibition (albeit, not using multimedia) but which set out quite deliberately to challenge this practice, will clarify this statement.

'Women and Men,' an exhibition shown at the Whitworth Art Gallery in Manchester in 1992, deliberately set out to demonstrate: that the category 'great' and the category 'art' have themselves been socially constructed and, in a patriarchal society, this means that

131

ideas about gender difference have informed our beliefs about exactly what constitutes 'great art'.[16] Sarah Hyde, the exhibition's curator, went on to give an example of what she means by socially constructed categories of great art being a product of a patriarchal society by citing the case of Judith Leyster. Art historians had praised as 'great art', portraits which they had attributed to Leyster's contemporary Frans Hals. When these same paintings were discovered to have been painted by Leyster and not Hals, art historians suddenly discovered 'feminine weaknesses' in them and they were no longer included in the canon of 'great art'.

Using only works that were already in the museum's collection, some of which had never been shown before, the works were hung in pairs of similar subject matter and date, one by a male and one by a female artist; but they were not identified. The challenge was to guess which was which and then to look at the concealed information.

> Like most public galleries in this country, the Whitworth frequently presents women as images in art, for consumption and possession, but rarely presents them as producers of art. One aim of this exhibition is therefore to show that women have always made art, and that one reason why we sometimes think of women artists as a rarity is that the art galleries, and the art historians with whom they work closely, have ignored them for most of the twentieth century . . . Most people going round this exhibition have concluded that it is not always possible to distinguish women's art from men's.[17]

The perspective of 'Women and Men' had the same effect as the title of Griselda Pollock and Roszika Parker's book *Old Mistresses* which drew attention to the essentially male perspective implicit in the practice of referring to great works as old masters.[18] It foregrounded the fact that there are alternative perspectives which could contribute to the choice of exhibition objects (or in this case paintings) as well as alternative perspectives on the selection of information about them. Unlike 'Master European Paintings', 'Women and Men' did not provide a digital interactive component, but it did provide an

alternative view, thus empowering a particular user. This observation takes us back to the question of whether the use of multimedia technologies necessarily empowers the user or whether this depends on the selection of available information that is made in the first place.

With regard to 'Master European Paintings', although there were choices for topic selection and interactivity around each painting, it is interesting that the designers were careful to restrict the range of opportunities for interactivity in order to preserve the linear nature of the narrative, and to prevent the user from navigating off onto alternative pathways and losing contact with the theme of the particular painting.

> One of the most difficult tasks in planning a multimedia production is defining clearly the contents of the digital presentation and often this can consist of placing limits on the information that will be included. Given the nature of the technology is is easy to be carried away with the lack of space restrictions . . . This can, however, be a serious mistake and could detract from the overall impact of the presentation. The work must be based on a story or narrative and given the non-linear nature of the technologies and tools being used it is too easy to wander away from the basic narrative and include extraneous information or loosely associated but not necessarily relevant information.[19]

Given the previous discussion about the potential limitations imposed by more traditional display methods, it is rather a surprise to read that an opportunity for allowing greater freedom for the user can be seen as a source of difficulty for the designer; also that imposed restrictions on the lines of available enquiry were seen as desirable. There is clearly a conflict of intention and interest here. On the one hand it has been seen as empowering to give the user control over the information they wish to call up, whereas on the other hand it is regarded as possibly resulting in an uncontainable, confused experience for the user. And such uncontainability effectively removes ultimate control from the designers of the display.

Control of, or authority over, meanings is not visible in digital interactive information. The apparently effortless facility for navigating through information appears more seamless and unconstructed than would negotiating information in a book. Books tend to be more readily identified as the work of (and therefore the viewpoint of) a particular author, whereas the majority of digital interactive information is unattributed (which is also true of most museum exhibitions). However, the concept of readers making their own meanings is hardly the revolutionary concept that it appeared to be thirty years ago when Roland Barthes wrote his influential essay 'The death of the author'.[20] Since then the main focus has shifted away from accepting the writer as creator of a specific meaning to understanding that the reader performs that primary interpretive role. Text as meaning is produced at the moment of reading, not at the moment of writing, because readers are living people; social beings with different backgrounds, different contexts in which they read or view texts.[21]

This of course mirrors the post-structuralist attitude to the interpretation of histories and the concept that there are many possible versions to be narrated. If curators deliberately close down avenues of enquiry they would appear to be attempting to preserve a long outmoded status quo. However, to be fair to writers or exhibition designers, using a linear narrative mode is clearly less time-consuming although the opportunity to provide alternative pathways will certainly be attractive to many who will welcome the more expansive potential of a non-linear approach. 'Lifetimes', which tells stories of the people of Croydon, and 'My Brighton' are two exhibitions that have deliberately set out to use interactive digital technology in this way.

Both of these are social history displays. 'My Brighton' is a community history project using interactive multimedia touch screen within the Brighton Art Gallery and Museum's refurbished Brighton History galleries. The idea for the project came out of the realization that social and local history museums should be about the people themselves, but that their displays were limited by their collection. For example, the only evidence of women's work during the war that they had was one photograph of an all-woman street-mending team. Although the museum was not object-rich it did own a large collection of engravings, paintings and photographs which could not be displayed

in the gallery, however, they could be used to great effect in a computer application. By the end of the project two and a half thousand images had been incorporated into the interactive. Also the curator felt that the old display had been dominated by a minimalist labelling aesthetic and that in order to be able to provide more detailed information a multimedia approach was the best way to proceed. In fact, there are 18 hours of taped conversations and a whole book of text, all of which which would now take 45 hours to go through. The content is delivered in the form of sound, video images, voice-overs and text, all of which was only possible because of the technology being used. However, the curator was very clear about the exhibition being concept and not technology led. Visitors' comments and further information that they may provide are still being added to the system.

The sections available on the opening interface are: Index, Personal Tour, Specialist Tour, Encyclopaedia and 'About My Brighton'. The Index enables access to all the information available, so that the user can find screens they had viewed before. The Encyclopaedia is an entire encyclopaedia of Brighton's history on disc as text. The Tours are the personal choice of people chosen as representatives of different age, sex class and race. For example, a taxi driver, a blind person, an office worker, a school girl, a lesbian, an artist, a railway worker, a beach entertainer, a pensioner, a local historian and several others. The guides walked their tours taking photographs. The places photographed were then investigated by the voluntary workers, which included research into the people who lived and worked there as well as the history of happenings on that particular site. Thus, although the original focus of the information is places of historical interest in the town, the available information is not limited to this. Specialist excursions were conducted in a similar way but by local experts and enthusiasts. Users can explore with their chosen guides or go off on their own investigation into particular aspects that interest them.

'LIFETIMES'

The second exhibition that I want to discuss that has used digital interactivity is at Croydon Clocktower. Museum staff there have produced multimedia programmes for two temporary and one permanent exhibitions, but 'Lifetimes' is by far the largest project.

'Lifetimes' is a permanent, but frequently updated, exhibition. Its in-
teractive touch screens and large screen monitors located throughout
the exhibition allow several people to view at once. There is also a
separate room of computers for serious users. Before setting up this
new exhibition museum director Sally MacDonald and her team con-
ducted surveys among the local people to find out what kind of mu-
seum they would like. The message which came back was basically
that museums were generally boring and stuffy, static, old and de-
pressing. What they wanted was something to 'inspire you', to 'en-
courage participation', to 'make you think', to 'be relevant to today',
to 'make connections with the past', to 'take you out of yourself', to
be 'bright, busy, sociable and funny'.

It was decided, therefore, that multimedia would be the most suit-
able way to meet these needs because it could offer a much more com-
prehensive information facility with a modern feel that would be
enjoyable to use and would appeal to non-museum goers. As the
building was shared by the main library it was envisaged that users
would return on a regular basis. The package provided film footage,
sound, music, images, text, actors' voice-overs and voices of the local
people featured in the displays. Research was conducted both chrono-
logically and thematically. Chronologically as lifetimes from
1840–1880, 1881–1918, 1919–1938, 1939–1955, 1956–1970, 1971–present day;
and thematically in each of these periods as: World Events, Food and
Farming, Homelife and Housing, Taste and Fashion, Crime and Law,
Sex and Love, Health and Disability, Demography, Work, Education,
Retail Trade and Shopping, Dying and Bereavement, Transport and
Travel, Media and Communication, Politics and Economy, Parent-
hood, and so on. There are twenty-three themes in all, and each one
is illustrated in the accompanying displays by relevant objects – col-
lected in the main to illustrate the themes, rather than the other way
round. Many of the objects in the displays were donated by the local
people who recount their life experiences on the screen.

Visitors can opt to access information on any of the topics from
any period. They can explore one topic throughout history or con-
centrate on one time period. They can take part in a quiz, find out
about the objects on display and the life stories of the people who own
them. The voices are those of people from different 'walks of life',

races, ages and religions, talking about their own lives and those of their parents and grandparents. Thus, the museum team have designed their own classification system to suit their particular needs and to enable them to be inclusive, rather than exclusive of particular groups. They have been involved in a massive oral history exercise that would not have been possible without multimedia technologies. By combining an enlightened approach to gathering information and the use of interactive computer technology, people often marginalized by museum display have been re-presented.

For example, the theme of women and work is made visible by placing an electric drill in the 1971 to the present day display. The voice of Meg Williams tells the story of her struggle within a male-dominated workplace while training to become an electrician.

> In 1981 Lambeth Council introduced a new scheme . . . I applied and got a traineeship . . . It wasn't easy . . . because I was the only women electrician they took on . . . Some of the men were OK, some of them were absolutely hideous – they were awful.

There is a model of Sabina Hussain in the display. There are photographs of her in different clothes on the touch screen as she speaks on the subject of fashion and taste. But the focus is not on her as a representative of people of Asian descent but as a fashion-conscious teenager.

> I love clothes . . . At the moment I shop at Apreal in St George's Walk. It has smart casual clothes with a name basically. If you got Georgio Armani name on your jeans, you're bad. I got bored with my hair, because the typical Asian look is the long black hair, and I went to Toni & Guy and had it all chopped off. My mother had a fit!

Similarly the theme of fighting in Northern Ireland is dealt with through the experiences of a local black soldier. Under the heading 'A Soldier in Northern Ireland':

> You don't really think about it, you just do your job. All
> of us there were experienced guys. And you're trained to
> look out for certain signs of what not to do . . . Like
> never opening gates in South Armagh. You walk over
> the fence, or through the fence. Cos all it takes is a cou-
> ple of wires, and you open the gate and . . . BOOM.

Other objects permit subjects not commonly dealt with in museums to be featured, for example, a pregnancy dress which was accompanied by the story entitled 'Choosing to be a Lesbian Mother'. The briefcase and books of a social worker were the objects associated with the theme 'Fighting Child Abuse', and an electronic hand carried with it the story of life with Crones disease. A newsletter enabled a local man to relate the struggle for gay liberation since the Croydon branch of the Campaign for Homosexual Equality was founded in 1971. The last four examples were chosen to illustrate the themes of parenthood, welfare, disability and politics respectively.

Of course these touch screens do not only show people and issues usually marginalized in museums. Many and various aspects of life and experience are covered as can be seen from the list of themes quoted above. I have selected these examples to demonstrate the point that such a breadth of information is usually outside the scope of a traditional museum display. The objects have been explored for their biographies in the way that Silverstone proposed when he suggested that the biography of an object gathers its meanings from the different circumstances of its use from the 'various social, economic, political and cultural environments through which it passes, and its passage can in turn illuminate those environments in a way that a flare or a tracer illuminates the night sky'.[22] But is it not only the people whose stories are being told, or the objects themselves, that have been empowered but the museum visitors too, who are free to locate and explore the information that is most relevant to their own lives. This would appear to support Beardon and Worden's claim at the beginning of this chapter that the fruitful development of multimedia systems relies on empowering the users in ways not generally realized.

WHAT HAVE SCIENCE, DESIGN AND TECHNOLOGY GOT TO DO WITH GENDER?

A conversation between Uma Patel and Erica Matlow

Uma Patel and Erica Matlow both work in design using different concepts and in very different contexts. Uma comes from a social science and engineering background and Erica from art and design theory and practice. They came together to discuss what impact these differences have had on their approach to work and whether there is any similarity in the way they address issues of gender in their own design processes.

WHERE IS GENDER AT THE HUMAN COMPUTER INTERFACE?

Erica: When you are designing a new interface, do you think you need to consider issues of gender? For instance, in my field, when a graphic design student works on an interactive design project they have to consider who is going to use their application and whether their design is going to be appropriate or not – gender and age therefore must be one of their considerations. When you are designing a new interface, do you consider the needs of a particular user?

Uma: Yes, we do consider the user. Requirements of individual users are considered in terms of how the user might want to tailor the interface and the software to suit personal ways of working and taste. Software requirements have a functional, and a non-functional part. The functional part is what the software should do which is driven from work the user has to do. The model of the user underlying this analysis is also functional: the user is defined by work tasks. In this sense uniformity in the cognitive capabilities of individuals is assumed. Non-functional requirements specify other requirements like usability. So if the group is composed of young children, we might consider using attention-grabbing techniques like animation and sound to accompany main functions in the software. For example in

a children's drawing package the undo button could be accompanied by a zapping noise. For older people it would be appropriate to consider the size of buttons, and text font size. Ironically, the emphasis on users detracts from the significance of socio political differences between users who do the same work. Gender differences, in my opinion, are not considered because the emphasis is on function, i.e. the work that is done rather than how it is done.

Erica: So you are saying that normally the gender of a particular user is rendered invisible in the design of an interface and that there is no such thing as a gender specific interface. It might be that difference in gender simply does not afford a particularly different form of interaction with an interface. As you said, there is assumed to be a uniform cognitive capability across all users. Is this assumption based on any testing?

Uma: No, it is just a general assumption, there is no empirical evidence to support it that I am aware of. It is also a difficult question for me to answer as I work within a specific context and my personal considerations are not part of the general inquiry. In the search for a totally elegant, minimalist, general and universal solution, issues of gender are not on the main agenda.

Erica: Do you think these issues are important though? Do you think that for Human Computer Interface (HCI) design to be a really meaningful science it should actually take into account the social, cultural, and in particular gender differences?

Uma: Yes, in general I am very optimistic. HCI in my opinion is an applied design science which is redefining the process of discovery . . . but what does 'meaningful science' mean? There are three categories of complaints I can raise in this context which are a critique of what I do as much as anybody else.

First, it seems to me that gender is rendered invisible because almost by convention we assume that gender is not a significant indicator of anything to do with the designing of human computer interfaces.

Second, gender differences are rarely measured. There aren't any funded projects investigating gender differences and HCI design. I have not heard of any proposal to that effect or a grant to support that kind of a proposal.

Third, in my opinion, professional HCI designers, male and female, usually invoke negative stereotypes as an explanation of gender differences. These stereotypes, as you might expect, are not based on any substantive evidence though I can give you an anecdotal example where data was collected in an attempt to provide objective evidence of gender difference.

A colleague, it would be unfair of me to name him, was telling me about some data he had collected as part of a computer supported collaborative work (CSCW) study. The data showed that women talk for longer than men in certain kinds of meetings, that they continue the conversations for longer. He interpreted this data in terms of women wasting time, and gratuitous chatter. The point is there are other interpretations; for example that women don't stop until the goal of collaboration has been resolved; they don't stop at a premature stage . . . Actually neither of the interpretations can claim to have the status of objective truth based on the data. I think it is fair to say that the assumptions he is making are the norm, whereas my criticisms are at best considered eccentric and at worst a threat.

Erica: Is the problem to do with what counts as science?

Uma: The problem is political. Two decades of work in various fields have shown that gender differences are significant in terms of beliefs, behaviour and expectations. I think researchers need to describe and explain gender differences, and understand the design implications of gender – as a requirement of 'good' science. Historically, where feminists have tried to seek out and challenge the hidden agenda to argue for a better science, this has led to gender issues becoming rapidly and sometimes aggressively politicized. This means that what should be debated turns into a battle ground.

Of course, for feminists, gender is and always has been political. Gender, in my opinion, is an area of social relations where patriarchal dominance is justified by both difference and the absence of dif-

ference. Historically dominance has been justified by difference. In 1873 it was argued that higher education for women would shrivel their reproductive organs and render them sterile. In 1996 a popular science programme reported that during pregnancy brain cells die faster therefore women become less intelligent. The relationship between gender inequalities and HCI design seem less immediately unjust, which breeds . . . indifference.

Erica: Do you find that you are in a minority in your field in relation to gender?

Uma: I am probably in a minority in terms of thinking about gender issues as relevant to how we apply science . . . I think an interesting indicator of where a community is at, in terms of gender issues awareness, is how public behaviour is regulated and what is regarded as acceptable humour. At present there is no requirement to use gender-neutral terms in publications. Even more telling is the experience I often have had of listening to gender-specific derogatory language in male HCI paper presentations and once again it is impossible for me to give you a specific reference here. Words such as spinster, frigid, old bag, nag, the wife at home, the French skirt have simply gone unnoticed. People don't feel uncomfortable about it as they do about using racist language. It is interesting what Dale Spender says about man made language – until a few years ago an important HCI journal was called the *Journal of Man-Machine Interfaces* and now this has a neutral title. The American HCI community seem more aware of gender issues – CHI Computer Human Interaction conference (which is American) offers paper writing guidelines which advise on using gender-neutral terms.

WHERE IS THE INDIVIDUAL IN HCI?
Erica: How are individual differences addressed in HCI?

Uma: One way is looking at requirements for configurable user interfaces.

Erica: Tell me about configurability.

Uma: This is where the design includes parameters which can be altered so that the application is tailored for different sets of needs and preferences. A simple example is the way your desktop looks, you can change the background, you can change the pattern and you can change the way your folder looks – the interface look is changed to suit your preferences. The question is that with more complex systems – how much work people are prepared to put in.

Erica: That is interesting, I think configurability is only for people who have confidence to go into that environment and change it according to their own needs. I would feel quite frightened to do that in case I would mess it up. If it works for me at the moment I would not be happy to make those kinds of changes in case it didn't work afterwards. I think there is a degree of confidence that comes through that.

Computers are not like other artefacts which can be modified. I mean, how do people change their surroundings? In fashion it happens all the time: people modify their garments. People modify things in their homes in order to make their homes more personal to them, they put an archway in the living room wall, they put in different windows, they might change the door. You look at any modern block of flats and notice how every one of those window spaces has been dealt with in a different way, frilly curtains, window boxes, blinds and so on.

Uma: And that is fundamentally different from being able to modify what a computer does, which you are saying some people don't have the confidence to do, because they are less confident about the possible outcome.

Erica: Yes, for instance, I would find it rather difficult. I have noticed that some of my colleagues have changed their desktop, have changed the way they configure the desktop and it suits them. I have started to think about doing it, I have changed the desktop background but I don't really think about the configuration in the way you think about it. I know I should do.

Uma: Why should you?

Erica: Because it is there and the opportunity is available to me, I don't have to take it as a given.

Uma: OK – but it is obviously not given to you in such a way that enables you to think, right I can change this and I can change that and there you are, the choices are not effortless. There is joke about this, if Mac users have problems they blame the machine – it's bad design, usability errors, not user friendly, not my fault, not my problem etc. If PC users have problems the angst is personalized, it must be me, I'm not usually this stupid, the solution is there if only I can find it, I can do this just give me time, a bit more time.

Erica: I usually blame the technology, I find it very frustrating – I also work on a Mac! Maybe if they put a new interface on the desk top and made it easier for me to know how access and change it then I might think about it.

Uma: Does it look difficult, is that what is off-putting? Is changing your environment really fundamentally different from changing the computer? Isn't the computer like any other artefact, or is it fundamentally different? For example is changing the way you organize things on your work desk in a real environment comparable to tailoring your computer desktop?

Erica: No it is not, it is the computer, the technology is stopping me from doing it. I think it is not as transparent as people sometimes talk about it being. I would organize things on my work desk in the real environment in order to make my life easier. Now I don't have the same confidence to organize my virtual desktop in order to make my life easier. It is to do with familiarity, I think.

Uma: Now you see an interesting question is whether men have more confidence with new technology than women. Women are proficient users of white goods, but!

Erica: Yes, they use domestic technologies every day like the microwave and the washing machine – these are complex pieces of technology.

Uma: I think loss of confidence begins with inequalities of access to technology in our early years and continues into our working lives with a poor infrastructure to support flexible working. As we know there are some women who are unafraid of technology, and some women are generally competent with appliance technology, but this is not the point.

A POSITIVE FUTURE

Erica: Yes, what does feminism mean for you personally – and technology?

Uma: Feminism is my emotional home, the issues which have concerned feminists for two decades are the ones which make sense to me and help me to make sense of the world; equality of access, justice, personal freedom and responsibilities, social construction of gender, the significance of power in social relations. If women, who share my roots – my friends, if we are all obsessed with what this means in terms of how we live our lives, how we behave and what we expect and strive for – at work, at home, in our relationships, in the products of our labours. In the 1970s and 1980s feminism was my ideology. Like many others I taught myself to be angry and proactive, taking on the struggle as a way of life.

Now – I still feel strongly about the core issues but the perceptions which inform the passion have changed. Ideology is minimalist. Relations between the sexes are complex and defy minimalist cant. Anger, after all, can be quite negative, it burns the common ground which is fine if you are separatist. The description and explanation of gender differences in any sphere, is not a trivial undertaking, but we still can't afford to lose ground.

Erica: Yes – I have similar feelings, mainly around the question of power and how gender relations specifically position me in different social contexts, in my work place and in relation to my friends and family. I would be interested to hear how you think technology might question, redefine and reposition gender and gender inequalities?

Uma: I think emerging communication technologies could redefine

the notion of work and productivity to give women more genuine equality of opportunity. People who find it hard to compete in the world of work are those with caring responsibilities. It is difficult to share caring responsibilities because traditionally 'real' work is done away from home – it means going to another place at set times. For many jobs this is a social convention and unrelated to the work that needs to be done. Technology offers a working life where space and time are controllable and can be managed. The worker can combine working from home with 'going into the office' and flexi-hours are a real option. A computer, modem and telephone line makes asynchronous communication possible, so a perfectly viable collaboration does not have to be in a particular place at one time. That is one way in which the technology is totally liberating because it becomes possible to integrate two worlds without compromising on performance or quality.

Erica: Absolutely – but isn't there a problem with this particular concept of 'liberation'? Couldn't it just mean that women were only 'liberated' to enable them to continue to combine their two worlds of work, the public and the domestic?

Uma: I think the problem is getting enough women to recognize the potential of technology – to get over the confidence barriers. If enough women are in the industry then their voice will determine how technology is used and perceived. An exciting prospect is that technology will offer greater equality of opportunity and restructure social relations. The situation suggests two possible visions for the future. In one, technology is colonized by male dominance – systematically, aggressively, reproducing existing structures in another dimension. People, mainly women, work at home but are underpaid, undervalued, and suffer poor conditions of service. In the other vision, technology changes the nature of work in terms of performance criteria, indicators of success, bounds of creativity and more. Feminism can be a positive creative force in this struggle for cultural change and a positive future.

ACCUMULATION OF SUBTLETIES

Date: 12 February 10:27:33 (PST)
From: Danielle Eubank <d.eubank@utech.edu>
To: everyone@western.consortium.org
Subject: Accumulation of Subtleties
Message-ID: <Equal.ALT.49239B-273000@western.consortium.org>
This is a MIMIC-encapsulated message
Att: 5

– Transcript of session follows –

For many, the debate over the pros and cons of a politically correct society ended in the 2020s with the Gender Reform Bill. This Bill, passed by an overwhelming majority of the American public, was quickly followed by the Public Sex Act, its equivalent in the United Kingdom. Within five years all English speaking countries and most of the rest of the Western Consortium followed suit creating the closest thing to the first Universal Law. As we know it today, The Rights Edict includes the right to own property, the right to life, the right to bear life, the right to free religion, race, and gender, and the right to free speech.

The Gender Reform Bill specifically examined the issues surrounding gender representation in business. It legally enacted what had become widespread behavior by the late 2010s: not to dishonour or discriminate against others by referring to superficial attributes such as their sex, physical appearance, or age.

Dr Chris Wallace, Professor of Sociology at Philomath University, Oregon, has been the first person publicly to question the Gender Reform Bill since it was first passed in the early 2020s. What Wallace advocates in the infamous publication *Good Fences Make Good Neighbours* is the necessity of including gender information for decoding the meaning of communicative messages in improving business relationships.

In light of this book, I have interviewed numerous people, including Dr Wallace, in an attempt to examine the candid reactions to the Bill by various members of society. Included in this essay are five of those interviews, chosen for their diversity of opinion. Some of the interviewees have requested anonymity, therefore I have withheld their identities.

Good Fences Make Good Neighbours has created an unprecedented furore, not over the freedom to make statements against the Bill, but over Wallace's intentions for making them. What this highlights is the common fear of returning to a reactionary culture which pigeon-holes individuals into specific groups based on hereditary, and often arbitrary, attributes. Wallace's theories are derived from accepted communication theory. In brief, Wallace states:

> There are two ways of conveying information, voluntarily and incidentally. Each method is a valid way to communicate and neither can be considered more accurate for garnering information than the other. Rather, both methods, working together, are valuable ways to learn about a subject.

For example, you may be chatting with someone who volunteers that they are from California. Or, you may be able to deduce this information from your own observation, that is, through the incident of your encounter. By their dress, their accent, or the number of times they say 'cool' in any given period, you may be able to ascertain their origin for yourself. This, of course, is a straightforward example. More subtle communication is probable, especially if the topic is potentially precarious. Citizens of Northern Ireland are likely to understand the implications of using either 'Derry' or 'Londonderry' to refer to the same town. On the other hand, people who are outside this group may not even notice the clues.

It could be argued that a vocal, social person is easier to get to know than a quiet, or shy, person because gregarious people talk about themselves more openly, communicating their ideas and attitudes. If the listener generally accepts what they say, they may feel

they understand or know the speaker in that situation. However, since beliefs and language itself can distort the message emitted, the information which the speaker gives about themself is biased by their own judgment. It's easier to believe what they say than to investigate, to read between the lines, observe their actions. Naturally, whatever they tell the listener is what they choose to tell them. With a shy person, a friend may need to work harder, observe more, to get to know that person. Therefore their knowledge will be primary, from their own observation, instead of through the discretion of someone else.

According to Wallace, our approach to gender representation in personal and public communication will have to be changed. Wallace proclaims in *Good Fences*: 'Our lives have been completely sanitised by the way we have stripped all reference to age, race, creed, and especially gender, in mass and business communication. There is hardly any room for misinterpretation anymore.'

– Forgive me for misinterpreting your statement, but what exactly do you mean by this? Are you implying that misinterpretation is positive?

– Workers used to be men working, flight attendants used to be stewardesses, humankind formerly was mankind. Males and females alike wear suits, wear their hair long or short, call each other by the same first names. We have denuded our language of all clues to our sexual identity. If I'm writing to my lawyer's firm asking for advice, for example, I see no reason why I shouldn't have a better idea of the individual with whom I am communicating. Why should it be socially unacceptable to find out what sex they are, or what their age is?

The argument for the Bill has been that this information isn't necessary to conduct business; that we don't need to know the sex of the person we're talking to in order to hold a conversation. The big argument has been that gender information only provides room for discrimination or sexual harassment between bosses and their staff.

Gender helps provide clues to the significance of a statement. Whether it provides constructive meaning or not, it still helps to instruct the message. This is partly what causes the misinterpretation.

Some clues are picked up which are arbitrary, and some clues are quite important but are missed. We each decipher and emit data differently. Communication makes us individuals. It's what makes us unique. And to deny the opportunity to express that information subjugates us into some kind of an ambiguous mass.

Now that gender is rarely expressed in personal correspondence and mass communication, many people fear emitting any kind of biased judgment. For example, in a department store if two clerks approach you, each of a different gender, if you respond to one instead of the other, you may fear that you have inadvertently communicated sexism, bias towards one sex. You fear that it appears as though you've chosen one over the other due to their gender. This fear is known as 'offendaphobia.' Parents feel this towards their children, bosses with their staff. When racial tensions were high in the last quarter of the twentieth century, this used to happen between blacks and whites. For example, if you hired someone out of two short-listed candidates, one black and one white, you might fear you've miscommunicated bias based on race. Fortunately, this cause for offendaphobia was eventually eradicated by an acceptance that race was hereditary, equal, not chosen, not better, and therefore not worth worrying about, although some offendaphobia still occasionally exists in this area.

What I mean to say is, that even by referring to a style of dress like jeans or skirts, which, of course, can be worn by both sexes, one might communicate what sex they are and thus throw the entire correspondence out of whack. This can make communication very stressful, especially in a business environment, where stress is generally high anyway.

You see, it's the miscommunication about gender and sex that's fun. By fun I mean that tension caused when a woman asks a man to lunch and he doesn't know if it's purely for business or if she has something else in mind; the miscommunication that used to happen when male bosses would tell their female staff that they looked nice; that 'did I get the job or do you just want to sleep with me?' feeling. That doesn't happen any more, now that people feel free to just come out with it, 'Will you have sex with me?'

I miss the fun of questioning my boss's authority by telling ageist jokes in front of them, by watching their reaction when making bor-

derline comments about their dress. People enjoy getting their wires crossed. That's partly what flirting is. People love irony; they love proving others' assumptions about them wrong. Particularly artists. Visual art works because it fools the eye or it questions the validity of certain concepts. Without those initial assumptions, irony doesn't exist.

– You have two lawsuits against you at the moment; we have seen the resurgence of eight national men's rights groups and nine national women's rights groups since your book was released last April. Clearly you have upset thousands of people. What could possibly be your intent in publishing such a book?

– Well, as I've outlined above, I feel it should be acceptable to communicate one's gender in written communication. It is common to fear accidentally expressing bias, which I feel is largely compounded by the Gender Reform Bill and thus The Rights Edict. Sexual tension is partly what makes us human beings; we enjoy the give and take and playful communication between the sexes. I'd like us to return to this kind of society wherein we can express ourselves freely. I don't see why we shouldn't be able to make sexist remarks, frankly. If that's our way of assuming attention or provoking or teasing others, then so be it.

Kula Smith is a visual artist from west London. Smith's work examines visual clues emitted by the sexes in the form of dress and body language. Smith is best known, however, for the spray-painted guerrilla art stencils around Camden and Clerkenwell which say 'SEXISM NOW!' and 'I'LL SHOW YOU YOURS IF YOU SHOW ME MINE.'

– The professor is completely mad! As Wallace would agree, the way to overcoming sexism isn't by not communicating gender. However, Wallace seems to want to bring back the old references to gender and the stigmas attached to them. Instead of accepting that everyone is different, the professor wants to emphasise the differences and then denounce people for them. Bizarre.

You see, communication isn't just about words, it's about clues. It's an accumulation of subtleties which informs our sex, age, social standing, nationality, music preferences. I'm an artist and a designer so I do my best to observe how people express themselves verbally, literally, visually. This instructs my work. I can't profess to be an expert in semiology, but communication is one of the primary elements of visual art and design, and vice versa. I have a commercial understanding and an inherent interest in gender representation and what gender means.

One of the things you learn about by being an artist, is how people watch and are aware of being watched by others. If you go to a gallery and stare at a painting of a nude figure, for example, three things are likely to be occurring. First of all, you are watching the subject of the painting. Secondly, you are being watched, often, by someone else in the gallery. And finally, the figure in the painting is being watched. Like an object, the figure is on display, nude. In that situation you are watching and are aware of being watched at the same time. You may also be watching another spectator in the gallery. We are all curious and observe others; some of us are aware of being watched, examined. Sometimes a smile, a wink, or a 'hello' means more than it first appears.

Since the Gender Reform Bill was passed, so long ago, there's been a huge change in the way heterosexuals dress in public during the wicked hours of the evening. It's wonderful. Everyone is available to touch when they dance. Men heighten their maleness by wearing strap-ons, chaps or tight skirts, and Stag cologne. Half of them, body builders, strut their sinewy selves, and the other half chew tobacco and call out catcalls to the ladies. Forget finding a clean-shaven man in Soho on a Friday night, unless they're over 35. Women embody femininity in furry fuchsia brassieres and patent leather stilettos as they waggle down the walkway with pink parasols. Everyone wears a 'married,' 'single,' or 'divorced' necklace in this season's colours.

That's the fashion this week. Everything we wear communicates something about our taste, social status, age, sex. Collectively these things communicate about society, its ills, social norms. That's why I use these symbols in my art. And my art sells.

Actually, the change in dress has nothing to do with the Bill. It was about that time, at the turn of the century, that people started to spend more time communicating electronically; all they had to communicate with were the written words and an Internet connection. The handicapped, women, anoraks, and most others found this liberating because they weren't judged on the types of things they used to be judged on, like age, sex, creed, nationality, race. This is what brought about the Bill in the States, enacted just before the Public Sex Act here. The new liberation allowed people to be whoever they wanted to be. You used to get email from men pretending to be women and vice versa, children that paraded as adults to order comics, subversive material, 18-rated films. The Bill was intended as a liberation, as a way to allow people to escape hurtful stereotypes more than anything else. Because, in business relationships, how people judge you can affect how much money you make, your position on the corporate ladder, or even if you get a job.

But what Wallace fails to examine in *Good Fences* is the way that people act in public since the Bill was passed. Because almost everyone spends something like 80% of their awake time in cyberspace, their time among other people is like a pheromone frenzy – especially young, sexually active adults. Unlike in business, in a social atmosphere others have very little power over you. Unless they're especially malicious, they can't hurt your livelihood.

I read an article about some kids in Glasgow in the mid 1990s that had to be re-taught childhood games like Hopscotch, Rounders, and Kiss-Chase. They had forgotten how to play them because they spent so much time using computers and watching videos. Oh, wait, I think they couldn't be taught Kiss-Chase, actually, because it was too sexual or something. I am from the electronic entertainment generation too. We never used to play outside with the other kids unless our teachers made us. And when we did go outside, we'd sneak out our hand-held cyber-games with us. This means we never learned 'normal' social behavior. We never learned the stereotypes that other generations learned about boys and girls, blacks and whites, Jews and Gentiles. Instead, it was like the whole outside world was really frightening, unless it came through our tellies or computers. And, of course, this is the way it still is, in both private and public schools.

I don't think it will ever change. No one wants to subject their children to things that scare them, unless it's the dentist.

Don't get me wrong, I'm not advocating the Gender Reform Bill or the Public Sex Act. I just think Wallace is barmy. Yes, I think a genderless society is bad. People give off clues, anyway, so why not be more overt and just say, 'I am a teenage Pakistani atheist lesbian on the dole with an illegitimate child!'

– Aren't you being a bit flippant?

– Do you think it will help me sell my art?

Professor of Sociology, Val Segal, University of California, Berkeley, is an expert in the change of social behaviours over time. Segal's most recent book, *Telegraph Pizza* observes the effect of the telecommunications industry on the social composition of Berkeley. Specifically, the book examines how physical change, on a personal level, affects social change, on a macro level.

– I've heard Wallace's argument that not identifying one's gender in business communication turns our society into an 'ambiguous mass.' Well, firstly, Wallace doesn't appear to make a clear distinction between business behavior and social behavior. In fact, *Good Fences* hardly mentions social behavior at all. The Gender Reform Bill clearly only applies to business communication, so let us not apply its stipulations to something else. And, secondly, identifying oneself as male or female hardly frees them from ambiguity. All it does is identify them with one half of the population or the other. That's the opposite of claiming individuality – it's joining an enormous mass!

Conversing without seeing or hearing the people you are communicating with is liberating. It tears down the social barriers and norms that society has created, bypassing the hierarchies, castes, and other barriers to communication. Some superficial judgments are suspended.

This results in the freedom for individuals to determine how they want to present themselves in cyberspace. Visual clues go by the wayside while other clues take over. I can be a gorgeous six foot tall

blonde if I want, or a stout body builder, or a plump couch potato. In business, it won't matter because these attributes won't be revealed. But on the social sphere I have the freedom to create my own identity. What we are is what we want to be, which creates a new kind of equality.

Because you can choose who you want to be, more or less, it's much more difficult for others to discriminate against you. Discrimination has traditionally been based on those things which 'matter.' For some reason, the things which 'matter' have been unchangeable attributes like sex, race, social standing, age. Putting someone down for something that they can't change is like arguing them into a corner. How are they supposed to defend themselves against a fixed, true statement? All they can say is, 'Well, yeah, you're right. I am female.' They can't argue against that. On the other hand, discriminating against someone for a mutable quality like, say, that they're a bad cook, doesn't hold so well because the argument against that is partly subjective, 'Well I think I'm a good cook,' and partly because they can learn to be a good cook. It's harder to put something down that can easily change.

The freedom that people now have in cyberspace to be who they want to be is evidenced in the real world on Friday and Saturday nights. Go to downtown San Francisco, or the Haight and you'll see everyone's imaginations come to life. Women are people who choose to be women and likewise with men. Clothing, make-up, extra padding here or there – none of it is permanent. The art to the style is the ability to change your identity quickly. Should you be in a different mood next week, express it! Everything is in style and the only thing that isn't cool is staying the same for too long. That's too much like permanence which is like giving in to nature or the status quo.

As I've already expressed, when communicating electronically, you have the freedom to appear, by way of words, however you imagine. Perhaps more importantly, however, is that the people you're writing to will make you out to look and act how they imagine. This is likely the main reason why video phones never caught on. When MCI and BT had a huge ad campaign in 2008, they tried to allay two fears. First, that their networks could handle the data and not fall over; and second, that we would all be comfortable being in front of

the camera. We wouldn't mind being taped in our robe and slippers, hair uncombed.

Unfortunately, the telcos seriously faulted. The real reason video telephony never prevailed is due to the way we wish to imagine the way people are when we're talking to them. When talking to someone on the phone, for example, we always imagine a picture of what they're doing. This is usually idealised. Whether sitting at their desk, lying in bed, or on the patio by the pool, we imagine them giving us their full attention, looking as they usually do: shaved, make-up on, hair combed. Needless to say, we don't usually think of them picking their nose or trimming their toe nails. The ad campaign cost around $12.7 million – expensive, but a valuable lesson to learn about human nature.

Now that we don't have sexist constraints in our culture, social and business communication have become much more open. People are more likely to be open about the way they feel when they know they won't be judged unfairly. Naturally, this has brought people together in the social spectrum; and business is more efficient – no time wasted with polite platitudes and left handed point-scoring sexist remarks.

With open communication, people can candidly express their sexual and emotional desires much more than before the Bill. Of course, no bill will ever eliminate shyness. But legitimizing the act of expressing sexual desire eliminates a lot of inhibitions. This applies to written, verbal, and physical communication, which I spoke of earlier.

My final point in all of this is that the combination of open communication, the freedom to define our physical reality, a reduction of superficial judgment, all due to electronic communication in our homes and offices, means that we have learned to value people primarily by what they think, not because of what they look like. This is a huge step for humankind. It is the closest thing we've ever achieved to free love. In real terms, in the last 50 years we've witnessed a sharp decrease in divorce (down from 51% to 27%); an increase in gay love (up to 18%); 40% fewer people are treated for stress each year; and, curiously, an enormous reduction in heart disease (down nearly 75%). Now that is cool.

I have interviewed Lee Vrieberg on numerous occasions over the last seven years, or shall I say, two terms. Vrieberg is a senator for the state of California. Always helpful and willing to take the time to answer my questions, Lee is most respected for giving straight answers to often difficult questions. California has seven environmental and human rights propositions for the November ballot which has recently put Lee under the spotlight. I conducted this interview nearly a year ago, six months before the November election.

– For me, the issue is about the freedom to be yourself, to be who you want to be. As with any right, you have the right to do more or less as you please, unless it greatly infringes upon someone else's right to do as they please. This is altogether fitting and proper.

There are a handful of issues to consider when examining the Gender Reform Bill debate. I'm happy to lay those out for you as I see them, but, as you may imagine, I'm not prepared to say anything at this point that will adversely affect my chances for re-election. Let's be clear about that from the start.

It's important to remember that the Bill was approved by the public because its provisions had become widespread social practice anyway. Communication is rarely done face-to-face. Something like 76% of it is done via email, and 15% via traditional telephones, so it makes sense that new social rules on communication have developed.

The best thing about cyberspace is that it allows people who wouldn't have any other interaction to communicate, share ideas, and in some cases even become friends, without ever meeting, or having the ability to meet, in person. This has been an amazing asset for our senior citizens. They play Bridge, talk, and shop together. And better yet, many are subscribers to RealLife which provides them with superb simulations of activities including running, playing basketball, and even sex. Conceived in liberty, we began subsidizing this for our elderly nine years ago, with amazing results. I received a letter from a seventy-eight year old last week, in fact, thanking us for being able to run a simulated Boston Marathon. The voter hadn't actually run in over twenty years!

As you know, citizens can vote over the net. This provides complete confidentiality since they can do it from the privacy of their home. I'd

like to think this allows them to be more relaxed in making their choices; allowing them to take the time to make the right choice.

Conversing via electronic devices usually means that we are alone or around others besides the people we're addressing. This can be extremely emancipating. Considerable information about our creed, sex, culture, national identity is manifested in the way we look, dress, and speak. Without seeing or hearing the other person, none of the visual or auditory clues which may trigger prejudice are present. Thus, social, sexual, racial, religious barriers are destroyed. Hurtful judgments are avoided. It's no wonder hate-crimes have sharply reduced since the Bill and the Rights Edict were initiated. Within the Western Consortium, hate-crimes have dropped by 37% – and this is when we include such areas as Rwanda, Bosnia, the Middle East, Northern Ireland, New York, South-Central Los Angeles, the South, Northern and Southern California.

I realise that this is beginning to sound like I'm just promoting successful initiatives which I've been a part of. It's just that there are so many good things that technology can offer our people-with the right leadership. We must be dedicated to the great task remaining before us.

Remember Affirmative Action? Should the disadvantaged get a little preferential treatment to help them along? It was because of Affirmative Action that the public was ready for the Gender Reform Bill. Once the Bill was enacted, Affirmative Action was no longer needed. The first time it was voted down was in the late 1990s in California. The timing proved to be premature. It wasn't until much later, actually, that Affirmative Action had done its job and was ready to be abolished.

It's a shame we can't meet Dr Di Paola who originally proposed the Bill. I've always wanted to meet a forward thinking mind like Di Paola, Einstein, Jefferson.

All people are created equal. Finally, two hundred years after this idea was expressed by Abraham Lincoln, we're beginning to act like it! Now that everyone in America is treated equally, it is a much better place. This nation has been given a new birth of freedom. And it is due to this government of the people, by the people, for the people, that these rights shall not perish from the earth.

<p style="text-align:center">***</p>

Taylor Sophie works in Tucson, Arizona, as an office manager for a Fortune 500 company. The company is antiquated in its attitude to the working environment. The entryway is a great circular expanse, Palladian in style. With columns and hanging plants, it feels more like a home than an office. The office managers sit in the middle, surrounded by accountants' offices. What's unusual about this establishment, besides the lobby, is the fact that the accountants actually work there. Although they could work remotely, they choose to come to the office, probably owing to its resemblance to the home.

– I've been a secretary for 42 years for this accountancy firm. When I first joined it was considered unusual for someone like me to be a secretary. Now, though, the office attitude has changed. I wouldn't say the others here accept me as an equal exactly, how could they when we have such different jobs? But other than that, I don't feel any bias against me in the office.

Soon I'm going to retire. I spend a lot of time at this desk contemplating all sorts of things. My dream, if I could do anything imaginable, would be to become an eagle. I'd take my family and my grandchildren with me and glide in the sunshine. I want retirement to be like that. My job is to do what people say; if I were an eagle I would be free to do what I want.

I remember what it was like before email and the Bill. I wouldn't say it was bad, but I'm glad things have changed. I think now it's much easier to communicate as equals with people of different social stature. You can't tell how much money people make by their email addresses.

When I communicate with someone electronically, we each have a kind of anonymity. It's strange. I don't know who the other is. And it's because we don't know each other that we get to know each other better. Do you know what I mean? When I correspond with someone I get a good idea of what they're thinking – what is really inside them – I don't get distracted by their clothes or hair style.

Being more or less anonymous can be really dangerous as well. Face-to-face I would never walk up to someone and call them a dirty name. But, electronically, people can insult you from 15,000 kilometres away. So what can you do? You can flame them, but then they'll

flame you back so you don't bother. It's like they have total freedom to say what they want. There are no social implications which would prevent them from doing that. It's freedom. And it's chaos.

I correspond with people daily who are looking for jobs here. Some of the qualifications I read you wouldn't believe! People are so used to being whoever they want to be in cyberspace that they make up all kinds of details about themselves. Some people just don't have a grasp on reality. I probably shouldn't tell you this, but when we ask someone to come in to see us, we take certain measures to find out who they really are. We need to do that to protect the company and make sure we don't waste our time in interviewing them.

Then again, why should anyone communicate accurately about themselves? Sometimes I shave off a few kilograms, take off a couple of years. It's dishonest, I know, but I would only do that at a cyber-party. Once I even told someone that I was a distant cousin to the President.

I'll tell you something I sometimes think about when I'm sitting at this desk. Sometimes I think the freedom to be who you want to be is a way of lying, making up whatever you want. And it's anonymity. But, do lies equal anonymity? And, do lies equal androgyny? I'm a little old fashioned, I know, but when I see all the kids parading downtown, I don't know if they're boys or girls. They change their appearance so often that they are anonymous in a way. And they're androgynous. Are they free?

Overall I'd say kids have it pretty easy nowadays. Thank goodness it isn't like it was in the old days when people had to talk face to face all the time! That was so confusing with all the gender stuff flying around everywhere. No one was ever sure where anyone was coming from. Even though I work in an office which is quite old fashioned, I don't have the same face-to-face problems as there used to be. I never witness lascivious behavior from the accountants or the clients. There's a time and a place for that, and it's not here and it's not now.

When I'm at home with my spouse, and I think it's the same for most people, it's like magic. Most people spend all day by themselves, with their machines. So, when we spend time together it's really nice. I don't mind telling you that our sex life is very good. I've heard that simulated sex is just like the real thing. I don't know, but I suspect

that the real thing is heightened by our mostly solitary lifestyles.

And for young people, when they dance on the promenade they're free to touch. Anyway, what I was talking about before was the freedom to be who you want and say what you want. I was saying how it can be dangerous because others can say what they want about you and there's really no way you can stop them. Even if it's libel it's only after the fact that anything can be done. By then it's too late. The First Amendment guarantees the right to free speech, but doesn't enforce it, certainly not in the public arena. In the media, they have the right to say whatever they want but they have to please their paying audience, so they don't. If newscasters were allowed to refer to people as 'black,' 'white,' 'racist,' 'feminist,' 'Nazis' or whatever, they'd have so many lawyers on them, they'd never work again. I'm not saying that they should talk about people that way. It's a combination of laws and social customs that protects those of us who aren't in the majority from being treated unfairly.

There's always going to be some way that people will discriminate against others. It's people's way of trying to get up the pecking order. That doesn't make it right, of course, but we need to be aware that people will always find a way to think of themselves as being 'better'. This is just human nature. If it's not race, it will be sex; if it's not sex it might be social standing, or both, or education, or rank in the company. What we need to make sure of, is that these sorts of attitudes don't get manifested into actions which hurt people. People can think whatever they want, in the privacy of their own heads, but don't give me a dirty look, or deny me that promotion.

Two more years till retirement. I've had a great life, so far. When I retire it will be even better. I will feel a lot freer.

That's what we need to do as a culture, to figure out a way that we can be free and be ourselves at the same time. The way it is now, people change themselves, and so they aren't judged. But it should be the other way around; they should be themselves and others should change their views. Is this possible? I think about this a lot as well. I don't think there will ever be a society that doesn't see deviation from the conventional as a threat. I guess that's just the way we are. I don't know, can we ever be free?

<p style="text-align:center">***</p>

Since the Gender Reform Bill of the 2020s, business communication has mandatorily been free of reference to attributes such as age, physicality or gender. Now, Dr Chris Wallace questions the absence of these types of references, claiming that they are important aspects of business life in *Good Fences Make Good Neighbours*, undoubtedly the most contemptuous book in recent years.

However, Wallace's challenge is healthy. The publication has caused a bracing re-examination of our views to ensure we can substantiate them, and that they contribute to a working environment free of unnecessary superficial judgements.

Our solitary working environment, masked by a basic interface, springs from a more overt desire to publicly express ourselves in theatrically gendered ways. The freedom to be any gender in cyberspace has encouraged the affectation of any gender in real life. People who constantly flip-flop their sexuality claim to be free, free to be what and who they want to be at any given moment.

Expressing oneself without being seen or heard is one way to be anonymous. Changing one's identity regularly is another way. Anonymity is one way to avoid discrimination, although maybe not a means to eradicate it.

Two freedoms are involved: to freely be who you want to be versus the ability to freely discuss gender in business. Wallace advocates neither. Instead, Wallace suggests that we reincorporate old references to gender complete with stigmas attached. And, that we have little choice in who we are.

Wallace's intentions may not be as straight-forward as selling this year's most notorious book. Rather, there exists a genuine desire to bring back a part of us which makes us human: flirtation with the boundaries of what is acceptable communication.

– Transcript ends –

©Danielle Eubank

FROM SLAVESHIP TO MOTHERSHIP AND BEYOND
Thoughts on a digital diaspora

Janice Cheddie

> The flashing lights of the dials and the rest of the imag-
> istic paraphernalia of science fiction functioned as so-
> cial signs – signs people learned to read very quickly.
> They signalled technology. And technology was like a
> placard on the door saying 'Boys club! Girls keep out.'
> Blacks and Hispanics and the poor in general, go away.
> Samuel R. Delany.[1]

Over the past three years, the key concept of a 'digital diaspora' has
emerged in discussions around Black British arts[2] practice and digi-
tal technology. This term is described by multimedia artist Keith
Piper in his paper 'Notes on the development and use of a digital di-
aspora',[3] as one linked to the concept of diaspora as a metaphor for
physical, spiritual and cultural displacement. Within Piper's analysis
the notion of a diaspora stresses the commonalty of Black peoples
around the globe who have experienced slavery, indenture and eco-
nomic migration. For Piper, the advent of digital technology which
gives rise to 'an opportunity' for these globally dispersed and dis-
parate communities 'to re-connect with each other in a pan-global
communications network, sharing and exchanging experiences and
information'.[4] – the digital diaspora.

According to Piper the concept of a diaspora is one which can be
easily translated to our experience of cyberspace as a fluid and shift-
ing terrain. The main focus of this chapter is an attempt to draw
upon conceptions of cyberspace as an emerging social space. I will be
using the concept of social space as defined by Henri Lefebvre in *The
Social Production of Space*.[5] In Lefebvre's concept there exists an
inter-related triad:

Material spatial practices – physical and material flows, transfers and interactions that occur in this space. (*the experienced*)

Representations of space: signs, codes, significations. (*the perceived*)

Space of representations: imaginary landscapes that imagine new meanings or possibilities for spatial practices. (*the imagined*).[6]

Central to Lefebvre's analysis is the relationship between the idea of the spatial and the operation of any kind of ideology.[7] Thus in order to grasp the meaning and significance of cyberspace we must not only understand its formal structures and codes, but also who owns and controls its system of operation. The concept of space and spatial dimensions are thus crucial to understanding and the ways in which these construct cyberspace and digital technology as potential sites for Black arts production.

In my analysis I am aiming to begin a dialogue about the spatial dimensions of cyberspace; and about the ways in which these categories of *the 'experienced, the perceived and the imagined'* might be used as a conceptual framework to explore notions of a digital diaspora, as an emerging social space. Within this concept of a digital diaspora three dominant themes emerge: *music, interaction and redemptive return*.

Diaspora has been a powerful metaphor for exploring the ways in which the differing post-1945 Black British settler communities and their children have negotiated complex constructions of social and cultural identity. Identities which draw their cultural references, social and political formations from more than one social, cultural or geographical location.[8]

The parallels between the concepts of diaspora and cyberspace are easy to read; both seem to defy notions of a singular powerful one nation state and draw upon notions of collective memory, imaginings and non-linear narratives.[9] As 'imagined' spaces, both, diaspora and cyberspace, construct notions of identity which are fluid and multiple.[10]

GOING AGAINST THE GRAIN

In the development of the contemporary African diaspora music has been a powerful communicator of meaningful messages of life affirmation and protest. Forming the basis of cultural industries which have enabled initially African diasporic communities, and subsequently other groups, to construct subjectivities and public spaces which resist the dominant social order. Music has emerged as a vehicle by which these diasporic communities have been able to challenge the *experienced* material spatial practices, and cultural significations of their spatial locations, the *perceived*, whilst also providing the means by which to imagine new visions and possibilities, the *imagined*.[11] Within the articulation of the concept of a digital diaspora, music has also provided the basis for the exploration of Black peoples' historical relationships to technology. Historical relationships which stretch from Black music's earliest recordings through to the use of technology within the production of musical genres such as disco, hip-hop, techno and jungle and so on.

Keith Piper seeks to use Black music production with its critical engagement and appropriation of technology as the basis of a strategy of intervention and subversion within Black visual artists' use of digital technology. This tactic is fundamentally different from claiming that the technology itself has an 'essentially female or Black component'.[12] Piper's position, as I will illustrate, highlights the place of the margins, through social and cultural exclusion, as a source of innovation. In this way, Piper seeks to provide a model for Black cultural intervention within its use of technology which on one hand recognizes its continuing use within the systems of power and control whilst on the other hand seeks to celebrate Black innovation and subversion of the dominant systems of power and control. Piper's position is foregrounded by asserting that technology is a tool which can and should be used by a range of socially excluded groups as the basis for cultural production. However, this simple transference from the use of music within the process of Black music production to Black visual arts practice raises a number of issues and concerns.

In order to locate digital technology as a tool for Black cultural production, Piper's analysis focus on the areas of contestation over the *perceived* and the *imagined* spaces of technology. A conceptual

framework which recognises that the ownership, production and control of technology has been concentrated and located within the West (the *experienced*); but the codes and symbols (the *perceived*) of technology have been a site of contestation for Black cultural practitioners: and within the space of the *imagined*, technology and its modernist associations with progress, control and subjection, technology has also provided the basis for Black artists to construct a critique of contemporary racial order and imaginings of the future. This critique can be seen in the recordings and imagery of avant-garde jazz recordings of Sun Ra in the 50s and George Clinton's album *Mothership Connection* (1974) and is explored in Black Audio Film Collective's film of the same name.

In focusing on the *perceived* and *imagined* elements of technology Piper seeks to dislodge the assertion that technology can only be experienced by the disenfranchised as a tool of subjection, surveillance and control – a common experience in Britain's inner cities – though his work has also dealt with these themes.[13] Rather Piper's analysis engages with that of critic Margot Lovejoy[14] – technology-as-threat, technology-as-liberation dualism concerning the use of technology within making art. A dualism which has centred around whether technology is viewed as providing the ability to gain access to new forms of knowledge and representation: or the alternative view which argues that artists should recognize that technology of cultural production, particularly digital technology and the Internet, has emerged out the arms and weapons industries, whilst also examining the social and cultural ramifications of technology.

In seeking to negotiate this dualism, Piper's analysis seeks to reclaim and assert a series of historical technological interventions within the production of Black music. The model of Black music production firstly provides a critique of the dominant discourses which have sought to place Black cultural production outside western modernity through the primitivist discourses. Secondly, this claiming of a historical Black relationship to technological cultural production also positions itself in opposition to common-sense techno-phobic assertions of technology as being specifically white and male – thus not the preserve of the Blacks, women or the poor, whilst also disrupting linear accounts of the history of technology,

and placing within its developments and uses other voices and communities. This approach is not specific to Black practitioners or theorists.[15] It is precisely upon this basis that Sadie Plant uses Ada Lovelace's 'Difference Engine' to claim technology as 'female and dangerous'.[16]

Keith Piper's 'Separate spaces' documents his own introduction to technology as a source of cultural production through the British reggae sound systems of the late 1970s and early 1980s. Piper disputes the idea that Black British artists have only recently come to integrate technology into their practice. He notes the 'on-going commitment to the tools of modernity',[17] through the use of photocopying, collaging and soundscapes within their print based, tape slide, video and now multimedia work, a commitment which has been pursued despite the inequality of access to these tools experienced by Black British artists and communities. Within his analysis technology is the foundation of an argument which seeks to dispel the ghettoisation of Black cultural practice as 'ethnic art', a label which has been used to exclude the work of contemporary Black artists from mainstream contemporary cultural discourses and denigrate their work as 'primitive'.[18]

By highlighting the issue of the inequality of access to technology, Piper locates the distinction between the social space of digital technology as a contested 'space of representation' where Black artists can produce their work: and the 'material spatial' processes which inform issues of access to technology and impact upon Black artists' use of digital technology.

However, musician, multimedia artist and designer Derek Richards locates the historical struggle by Black cultural practitioners to gain access to technology as a possible source of innovation and subversion of the dominant technological discourses:

> I found [the photocopier] quite liberating, . . . the thing about the photocopier is because it's only dry copy you have an instant result. You can use print making techniques to montage images, to move images, but you have spontaneity of not having to wait for it to dry. So what's going on in your head can manifest itself quite quickly with the machines.

I liked the idea of using a medium that wasn't designed for images, [it meant] that you could invent as you were going along. You were not bound by someone else's construct of what your images should look like. [With photocopying] there were no shoulds.[19]

ALTERNATIVE PUBLIC SPACES

Diasporic Black music production has provided another theme to the concept of a digital diaspora: the construction of alternative public spaces.[20] One of the key components of the development of the concept of a digital diaspora has been the assertion that through the use of technology Black arts practitioners can come together across time and space to construct new cultural spaces within 'cyberspace' for cultural exchange and dialogue.

A key idea which has underpinned the organization and operation of Black British 'cyber-diasporic' events[21] which have sought to bring poets, musicians and djs (disc-jockeys) and vjs (video-jockeys) exchanging sound, images and music across the African diaspora – primarily English speaking and Western. Within these 'cyber-diasporic' events the diaspora becomes a spatial dimension, whose diverse locations around the world can be reconnected, through digital technology.[22] In this process of reconnection cyberspace is positioned as a space where the fractured and displaced African diasporic subject can be reconstructed as a centred Cartesian subject, ignoring both the miscegnated realities[23] and de-centred subjectivities that have created the contemporary diaspora. In this sense, these cyber-diasporic events have positioned cyberspace, as a social space of reconnection which appears to exist outside historical relationships of domination.

The focus of these 'cyber-diasporic' events has been primarily on the socially excluded communities and artists of colour gaining access to digital technology and overcoming the perception of cyberspace, as white and male dominated. Within these events there has been very little exploration of new ways of imagining and engaging with the spatial dimensions of cyberspace, or disrupting and subverting its material flows (the *experienced*).

Thus assertions of reconnection with the diaspora through digital technology raise a number of issues. Firstly, as Delany's comments

highlight, it fails to address the ways in which technological spaces have signified through a multiplicity of signs (the *perceived*) a space which does not welcome Black access.[24] Central to challenging this perception would be the construction within the imagined social arena of cyberspace as a site for Black cultural production. This would seem to be very difficult to do as there is very little musical, visual or literary material, with a few notable exceptions, of Black cultural production which focuses on speculative imaginings of 'the future'.[25]

But perhaps more critically, this positioning of digital technology as a means of reuniting diasporic peoples refuses to engage the key feature of cyberspace: as a space which produces fluid and complex identities. However, the utopian assertion of cyberspace as a social location which eradicates difference, needs to be questioned. Cameron Bailey's 'Virtual skin'[26] locates the ways in which stereotypical notions of difference and racism remain a theme in social interactions within cyberspace.

The failure to address these issues has been underpinned by an assumption within these cyber-diasporic events that the spatial codes of cyberspace are the same as 'real' physical spaces. Thus the spatial codes of cyberspace do not represent new challenges or demand new modes of translation and contestation.

Even if we draw upon the Black music analogy we can see acts of cultural translation.[27] The often quoted example of this is the use of samplers in musical genres such as hip-hop and techno. Prior to Black performers' and producers' use of the sampler[28] as the basis to construct whole pieces of music; the sampler 'for the most part, . . . w[as] used to "flesh out" or accent a musical piece, not to build a new one'.[29] Within this process of appropriation of the sampler, rap performers and producers transformed the logic of the sampler as a thing which needed to be disguised because it lacked the authenticity and craft of 'live' musicians into a piece of technology which could be valued in its own right, disrupting the western notions of individual authorship, copyright and creativity. Rap performers and producers in their appropriation of sampled pieces of music, 'us[ed] samples as points of reference, as means by which the process or repetition and re-contextualisation c[ould] be highlighted and privileged'.[30]

These 'cyber-diasporic' events have also, to date, failed to convey and capture the power of Black-derived musical culture's ability to dissolve the barriers which separate artists from audiences while also failing to devise strategies for appropriation of the technology in order to communicate effectively the immediacy and intimacy of Black music performance. Artists and producers of these events have also not addressed themselves to the differing experiences of virtual and 'real' time. The technology often forms a barrier between genuine audience participation and the performer.[31] Furthermore, Black-derived music's emphasis on the body as a critique of western modernity's wage slavery and oppression,[32] is difficult to reconcile with cyberspace as a disembodied social location which places its emphasis on establishing new forms of communication and interconnectivity. This, as yet, remains territory which has largely been unexplored.

CALL AND RESPONSE – INTER–ACTIVITY

For Keith Piper, the existing interactive relationship between artist and performer within Black-derived cultural forms – the call and response – provides a notion of interaction when transferred to the digital realm and refutes the idea of orderly interaction with clear, stated and author-controlled pathways through a piece. For Piper, the Black musical performance model of interaction refutes what he sees as cyberspace's modernist need for order and control:

> the traditions of 'call and response' in black cultural
> events, or more recently in 'Scratch' music where the DJ
> intervened with the received pre-recorded disc, creating
> a new 'interactive' collage of sound, is at odds with the
> artist and audience scenario of western 'high culture'.[33]

Piper defines cyberspace as a space which is *experienced* as modernist and which seeks to re-establish the dominant material order of the existing 'physical' realm. As a *perceived* space, contemporary cyberspace generates, for Piper, the dominant codes and symbols of the existing physical realm of western economic and social domination. Into this space the Black presence emerges – as within the codes and

symbols of technologies of surveillance and control which operate in contemporary city centres – signalling disorder, transgression and danger.

Thus within Piper's analysis the 'riot' zone is not a site of violence, but rather one of struggle waged by various communities who are surveyed and policed by a hostile force, this is a struggle for control over their social spaces. It is in this sense that the Black presence transgresses the dominant social order (the *experienced*) and challenges the existing representation of social space (the *perceived*):

> Within this zone, treasured and privileged resources are redistributed and exclusive spaces democratised. It is within this nightmare scenario for the controllers of Cyberspace, that the digital equivalent of the disorderly black of urban chaos and transgressive behaviour steps into full visibility. It is at this symbolic point that Cyberspace changes from a sterile zone at the service of the establishment, into a free domain within which everyone becomes a liberty to seize a portion of terrain and reshape it to their individual needs.[34]

Rather than engaging with the terrain already mapped out by the utopian discourses of cyberspace, Piper suggests a critical engagement which embraces the sampling, manipulating 'cut and mix' techniques of production and performance in urban contemporary Black music. Such an engagement refuses to 'respect' the corporate ownership of artistic production and celebrates polyphony, difference, diversity and freedom. The Black presence is conceived as disorderly, disobedient and disruptive, which enables the transformation of cyberspace from an elitist privileged zone of the rich into an open democratic zone which empowers and enables all.[35]

Within this framework, cyberspace can emerge as a space of the *imagination* to explore and expand the non-linear, non-narrative, cultural referencing and layering that already exists within Black artists' work. The importance of Piper's strategy lies in his attempt to provide a conceptual framework which allows Black artists to appropriate technology, and which places centre-stage Black peoples'

marginal relationship to the mainstream technological discourses and practices as a source of innovation, freedom and subversion.

Piper's analysis and its premise of an unproblematic transference of one mode of Black cultural production, music, to another, visual art production, fails to highlight the different dimensions, language and mode of address, as well as audience interaction and production that exist within the realms of Black musical forms and visual art practice. Though within the realm of multi media production such as the audio-visual CD-ROM, there may be scope to argue that these divisions are collapsing as visual artists engage in sound, vision production techniques. In drawing attention to the distinct and discrete modes of production within Black music production and visual art production I am not arguing for some purity of language, as I recognize the inter-textuality of contemporary visual art practice. Rather, I am arguing that we need to understand the ways in which each of these cultural forms places differing emphases on the importance of a communicative experience centred on the body.[36]

FROM SLAVESHIP TO MOTHERSHIP

The ship has been a central image in the development of African diasporic narratives, it runs through narratives of diaspora beginning with the transportation of enslaved Africans to the New World, through to ships of indenture and post-1945 migration taking migrants from Africa and Asia to the shores of Europe.

The image of the (space) ship, as a vehicle for a redemptive return to a pre-diasporic Africa, also stands prominent in the development in what been dubbed Afro-Futurism.[37] In Black Audio's *Mothership Connection* (1995), Afro-Futurism constructs a linear account which begins with the blues of Robert Johnson, through to Sun Ra's avant-garde jazz of the 50s and 60s, the recording of Lee Perry's Black Arc studio in the 70s and George Clinton's *Mothership Connection* (1974) to include the science fiction novels of Octavia Butler and Samuel R. Delany. (Though Ngozi Onwarah's *Welcome II The Terrordome* (1994) can be added to this list).

In *The Black Atlantic*, Paul Gilroy proposes an African diasporic critique of modernity and places the image of ships in motion as central

to his analysis. Gilroy suggests that this image is a repository for the construction of racial memory and diasporic identifications. For Gilroy ships in motion signify notions of a diaspora as a social space which does not respect national or state boundaries. Ships also emerge as the physical carrier for 'the circulation of ideas and activists as well as the movement of key cultural and political artefacts: tracts, books, gramophone records and choirs'[38] across the African diaspora. Through this image he proposes new chronotropes for analysing the development of a double consciousness of being Black Britons in contemporary Europe.

Gilroy's *Black Atlantic* is seeking to construct a central image of the African diaspora within the West. Through it he seeks to explore the centrality of the collective cultural memory of the horrors of the Middle passage and its continuing effects of displacement in the construction of diasporic consciousness.

These diasporic journeys have also provided the basis of narratives linked to the development and rehearsal of a collective racial memory. The idea of a digital technology as a site for racial memory resonates within both the work of Rita Kegan and her poetic mediations on her family imagery, and Russell Newall's *Black Peoples International Place Of Remembrance*,[39] a space where peoples of African descent can list those who have died as a result of slavery and its historical legacies. However, the image of the ship and its associations with slavery, indenture and migration as a metaphor for displacement is one that is fraught with problems for the Black woman. For although Black women shared these experiences with their male counterparts, the image of the ship as a 'social space' is associated most significantly with the experience of male power.

Within representations of feminine adventure, experimentation and travel, the image of a ship is one which is seen to negate the idea of femininity and the place of the domestic.[40] Thus, one has to question its usefulness in constructing affirmative images of the future for Black women in the diaspora attempting to form new spaces of representation within cyberspace (the *imagined*). The ship is also *perceived* by those who travel upon her as a division between 'nature' and 'culture' in that the physical structure, body/nature, of the ship which is coded as feminine, but she is crewed, run and owned by men-culture.

If cyberspace is to emerge as a social space for the construction of new landscapes of Black female desire and possibilities, this conceptualization of the image of the ship seems to be inappropriate. Teshome Gabriel's idea of the 'nomad' may be more useful as providing a conceptual framework for making new images and landscapes. In constructing new cyber-diasporic narratives Gabriel's concept is appealing because it continues the diasporic stress on journey, movement and transition, whilst also removing us from the idea of a redemptive return – whether spiritual, physical or metaphorical. Like the nomadic wanderer in Octavia Butler's *Parable of the Sower*,[41] which allows for the construction of communities which embrace and celebrate difference and plurality of our past, present and future realities.[42]

In Gabriel's analysis the similarity between nomads and Black peoples lies in their similar conceptualization of language – not verbal or written language but language as 'symbolism, metaphor, music and performance'.[43] Also in terms of the construction of social spaces; nomadic and Black cultures stress not the physical territory but the space of the imagination, and the importance of cultural memory transmitted through sound, and imagery.[44]

Gabriel's conceptualization focuses not just on cultural products of a diaspora, rather it turns our attention to the spatial. For Gabriel the attraction of nomadic aesthetics is that it disrupts linear ideas of time, space and narrative. Thus, Gabriel's conception of the nomad is one that allows for the construction of a conceptual framework which challenges the inter-related *experienced-perceived-imagined* triad of contemporary cyberspace. The 'nomad', perhaps more importantly, allows for the idea of the feminine.[45]

Section 3
Spatial Perceptions

A REFLECTION ON *MIRROR, MIRROR*

Gail Pearce

Imagine this; you enter a small room, the room is dimly lit with a single light casting a warm glow. It looks very cosy, there is even a tufted rug on the floor. A large mirror on the wall reflects an image, that reflection is you. You sit down on the stool in front of the mirror, you are sitting at a dressing table. It seems very familiar. All the objects one normally associates with feminine grooming are laid out on the table before you, or are they? Look closer, what do you really see?

Mirror, Mirror is a digital installation, a storytelling device, which uses the computer as sculpture. My original starting point was the wish to explore aspects of women's anger and the possibility of enabling women to avenge that anger in a safe and secure environment. I designed *Mirror, Mirror* as part of an exhibition for my Masters Degree in 'Interactive Multimedia' at the Royal College of Art and the London Institute. I have created a small corner of a bedroom, and have used the dressing table, an icon of femininity, to subvert the dominant associations of specific gender identity in order to explore aspects of violence and technology and to create possible alternative scenarios.

A person, the user, comes into a small room within the exhibition environment and is confronted by an apparently ordinary piece of furniture, the dressing table.There is a stool to sit on and a rug on the floor. The light is dim and the lamp on the dressing table casts a warm glow. The whole room creates a feeling of warmth and domesticity, there is no evidence of a computer or of technology of any kind. A large mirror reflects the person as they enter the room. When they sit on the dressing table stool, the computer is activated and they can start the process of interacting with the mirror which is in fact the computer screen.

177

They hear the voice of a man complaining, he nags relentlessly, his image is a threatening reflection superimposed 'behind' the user's reflection in the mirror. There are various objects on the dressing table, the diary, some train tickets and a telephone. These are known objects, imbued with different kinds of meanings, carrying different kinds of information and inviting a range of different choices and opportunities. The objects which trigger information are the diary, train tickets and telephone. The objects which kill the nagging man are a gun, a bottle of poison and a pair of scissors. A small ornamental skull and a toy ambulance allow the user to choose whether the man can be resurrected or remains dead after being killed. When the sequence is over the user is given their own character analysis as a printout or text on the mirror/screen according to the choices they have made.

In *Mirror, Mirror* I used the dressing table to create an invisible screen, to place all the sequences of the narrative in a 'real' environment and not on a computer monitor, and I wanted it to contain a combination of cinematic and arcade game effects. I achieved the 'invisible screen' effect by using a two-way mirror and back projection. It is like an observation mirror which works on the intensity of the light levels. If the space is dark behind it, the mirror is opaque and looks, to all intents and purposes, exactly like a normal mirror. But to the person standing behind the two-way mirror it appears transparent and everything on the other side is visible. I was interested in controlling the light levels so that the mirror would begin as a normal mirror, then would change to reveal a hidden world and its hidden stories.

Mirror, Mirror incorporates moving images. The sequences of the man moving in the frame of the mirror were shot on video. The low lighting levels of the room helped to create the illusion that the events were really happening. The use of video as part of the interactive sequences, where they were blown up to full screen size and moved smoothly from one sequence to the next was a real test of ingenuity and the capacity of the technology. I created the illusion of the cinema and its filmic effects but used computer technology to enable the user to interact with the moving images.

I also used sound to frame and highlight the different forms of narrative. The stories revealed by the telephone, the diary and the train tickets, and the death sequences, all have sound that relates to them specifically and aim to encourage users to suspend their disbeliefs and to become immersed in the different story lines. *Mirror, Mirror* aims to cross the boundaries between film and the computer by using sound and image to create a narrative but also by offering the user choices in the construction of that narrative and opportunities to create alternative ones.

As an artist I use visual stories to explore individual behaviours and to question power relationships. I believe that stories affect our sense of identity, and of history, and our sense of time. We understand through stories where we are in time, our place in a community, where we come from, what we remember of past events. The telling of stories and the construction of linear narratives are threads that pervade contemporary literature, cinema, television and CD-ROMs; linear narrative is the dominant genre and I was interested to explore what would happen when a linear narrative thread became disrupted by the addition of interactivity.

This disruption of linear narrative also happens when one uses Hypertext as part of a multimedia experience though it can also enhance storytelling and make it more akin to the past experiences of telling and listening to stories. Hypertext is a fluid and changing application that enables links to be made with information on a number of different levels, it can reference one event and link it backwards and forwards to other times, to other places and to other people. In *Mirror, Mirror* I have used an interactive multimedia application in a similar way, by offering the user different choices to produce their own narratives, to tell their own stories and, according to their own needs, to construct alternative story lines.

Spoken storytelling originally relied on audience interaction, the responses of the listeners would affect how the narrator paced the tale, set the events, waited for the right moment for a climax. This would have taken place originally in a disruptive, human environment, with children playing, dogs barking and the weather adding extra random effects. In written stories, the relationship of narrator and audience is changed and the reader chooses how long to read for

and where they will read. Film, on the other hand, is a more controlled approach to narrative, of fixed duration, in a dark collective environment. With television or video this containment becomes more erratic. The home environment is almost akin to that of the spoken story: the audience is free to take tea-breaks and there are the added technological interruptions of the telephone and fast-forward options on the video player.

When we go to the cinema, however, we can expect to relinquish the realities of our daily lives by escaping into the fantasy of the film narrative. As audience we can immerse ourselves in the pleasure of the story line without needing to consider our actions or their effects. With an interactive film we are being asked to intervene in the narrative and to make decisions as to its outcome, to take actions which will have effects. I needed to find a way of enabling the user of my interactive story to experience the same kind of pleasure that they usually had when they watched a film. I needed to create a situation where the user would want to have an 'effect'. I wanted to allow the female user to relate easily to the choices on offer and to make the male user less confident, slightly displaced with the technology, slightly out of the story. I therefore created an environment that would be interesting to men but particularly meaningful for women which at the same time, questioned the power relations between them.

> To question the masculinity of computers is tantamount
> to questioning our image of masculinity itself.
> Computers are power, and power, in our world, must be
> in the realm of men.[1]

The idea for *Mirror, Mirror* developed from a short film (*Cut*) I had made in the mid 1990s. *Cut* was based on events in the life of Mrs Bobbitt, who, when severely provoked, cut off her husband's penis with a kitchen knife. Lorena Bobbitt was imprisoned for this offence but was later released for 'for reasons of insanity'. It seemed to me that the key to Lorena's action, that of cutting off her husband's penis, was an act of revenge, indeed the court decision to release Lorena sanctioned the right of a wife to respond in an extreme way if heavily provoked. After years of being the subject of her husband's abuse her

anger finally drove her to commit her crime, to focus on the prime object of her anger, her husband's dominant and sexually aggressive behaviour, by removing the symbol of that aggression, his penis.

I wanted women to be able to experience this same kind of release of anger and to be able to express it, of course, within secure limits. I used the dressing table as the site for playing out these women's fantasies because it is a metaphor for the 'feminine'. The objects on the dressing table are real objects that have their place in our own experience. They are actual objects, not virtual ones, you sit at a 'real' table and experience a believable sequence of events. These events are threatening, and they can result in murder and death.

This personal and intimate dressing table then becomes a site of oppositions, on the one hand, frilly and feminine and on the other, violent and full of unexpressed (sexual) and murderous desires. It is an illusion on more than one level, it hides behind its facade a mass of the technological paraphernalia and importantly the suppressed desires of its users. Whilst the gallery 'Comments Book' can be misleading and members of the audience's written responses are immediate and also, possibly misleading, they are nevertheless almost the only way artists can derive feedback from those who visited their exhibitions. Some of the comments in my visitors book about *Mirror Mirror* were helpful in my trying to determine how the installation worked for others. I gleaned that a recognizably domestic area in a gallery space both reassures and disturbs visitors who are both curious and suspicious. Some male users seemed pleased to have an opportunity to surrender to the story and the atmosphere. The character of the belligerent man, the 'villain', seemed not to produce as much emotional reaction in men as in the women users, to whom the events were chiefly directed. The comments from women reflected their ambivalence towards violence and guns, and showed some surprise at their own reactions. Two examples demonstrate this, and make one wonder about the extent to which this ambivalence was also part of the experience of male participants.

'It's really making me think . . . I AM a predator'

'The gun terrifies me but it is interesting to go through your fear'

There is an ephemeral nature to work in installations. The presence of *Mirror, Mirror* in a gallery setting decontextualized it, made it more reliant on illusion and once the illusion of the dressing table was accepted, the audience wanted the illusion to be increasingly complete and total. Factors that had been added for ease of use became irritating as they detracted from the illusion. Markers for the correct replacement of the objects, the gun, the diary, etc. on the dressing table meant that spontaneous use was less likely. The dressing table signals solitary use, as do the computer screen and many arcade games, providing space for absorption and reflection. Many of the user/participants came as couples, with friends and/or family, expecting perhaps, to share an intimate experience in an atmosphere where secrets could be told and confidences exchanged. It is the events behind the screen/the mirror that transform the experience.

Now all that is left of *Mirror, Mirror* is a videotape of some of the users, participations, a selection of magnetized items left on the shelf of the dressing table and a list of comments in the visitors book that present a range of reactions to my work. These comments have been illuminating, they hover between the two extremes of women who loved the violence and the expressions of violence, the guns and killing, and those who just hated it. They expressed the confidence that some women had about using the technology and also the diffidence experienced by other women. *Mirror, Mirror* has been an attempt to draw attention to some of these differences and to create a situation where some of these differences and inequalities can be redressed, at least virtually.

POSITIONS IN THE LANDSCAPE?
Gender, space and the 'nature' of virtual reality

Jos Boys

In this chapter I want to examine some of the conceptual mechanisms through which we attempt to form our sense of ourselves. I want to explore how ideas about bodies-in-space are generated out of both imaginary and concrete spatial metaphors, are played out through social and spatial materialities and are persistently transgressed, contested and rewritten via these media. I am particularly interested in how the 'shape' of imagined spaces, of the material world and – more recently – of virtual space, all affect how we think about our identities, and about gender in particular. And I will argue that some of the dominant analogies currently in vogue for conceptualizing how bodies are 'placed' in both concrete and virtual space actually restrict rather than enhance our abilities to think creatively about gender identities.

Many authors have argued that the 'modern' western world[1] was and is one framed by simple binary oppositions: where concepts of femininity and masculinity are defined through their assignation to separate and mutually exclusive spheres – to home versus work, public versus private, passive versus active, consuming versus producing, emotional versus rational, transcendence versus immanence, nature versus culture, the body versus the mind. The 'space' of concepts is thereby turned into oppositional pairings, where one idea is defined only in relation to its Other. This 'commonsense'[2] method by which we so often inscribe assumed characteristics onto bodies and spaces has three other key characteristics. First, one term is consistently believed superior to the other, privileging, for another example, men over women, white over black, 'western' over 'eastern', middle class over working class, able bodied over disabled, and heterosexual over homosexual. Second, these characteristics are structured around the

basic premise that spatial and social territories correspond, that they can be used interchangeably and that spatial transgressions (stepping across 'boundaries') may also be social trangressions. Third, these strings of associative qualities and their oppositions become a conceptual mechanism for evaluating whether specific gendered characteristics – or spatial zones – are good or bad. The critic may therefore literally and metaphorically locate the 'good' woman by utterly aligning her to a domestic/stable space (and locate her opposite, the 'impure' woman, firmly in the chaotic street) or instead, by a process of straightforward binary reversal, define woman/ home as bad/constraining and make the superior side of the pair either women/street/liberating or, more conventionally, men/street/liberating.

We all know, of course, that there are many differences between these 'commonsense' mental geographies based on simplistic dualisms and the complex practicalities through which gender identities are played out in everyday life. What is more, these commonsense assumptions are themselves continually being contested, resisted and reshaped at all levels; through theoretical struggles over what constitutes femininity and masculinity, in day to day individual and group negotiations over social and spatial categories, and through the sum results of everyday actions in space. We also know that such 'commonsense' geographies are not neutral, but underscore and legitimize specific patterns of power and control. However, the 'location' of gender identity through spatial analogy (and the policing of its boundaries, both in language and in physical space) remains deeply recognizable and powerfully resonant.

THE 'SPACE' OF CONTEMPORARY THEORY

More recently these spaces of binary opposition (whether of theory, imagination or materiality) have been increasingly seen as inadequate descriptions of, or explanations for, society. Many theorists and writers argue that we are moving to 'a condition of postmodernity'[3] where changing economic, social and spatial patterns are altering our very relationship with the world – by unbalancing these binary relationships between men and women, behaviour and space, 'good' and 'bad' and replacing them instead with a new 'depthlessness' and confusion. Doreen Massey summarizes some of these views:

Emberley writes of a new world where 'the notions of space and enclosure and time as duration are unsettled and redesigned as a field of infinitely experimental configurations of space-time' where 'the old order of prescriptive and exclusive places and meaning-endowed durations is dissolving'. Baudrillard speaks of the delirium and vertigo in the face of a world of images and flows. Harvey argues that the disorientation in present times is giving rise to a new – almost necessarily reactionary – search for stability.[4]

What is more, within this perceived aesthetic and spatial disordering a whole new category of space has been invented – cyberspace – the virtual reality of computers and electronic networks. How, then, can we decipher if and how our mechanisms for delineating, maintaining and transgressing gender identities-in-space are being reshaped?

Many recent writers – ranging across subjects as diverse as cultural studies, urban geography, sociology, pyschology and linguistics – have been attempting to disrupt the underlying structure of spatial dualisms, by imagining alternative locations such as the 'margins', borders and 'thirdspaces'.[5] Rose calls this paradoxical space and quotes de Lauretis on how such a space might be investigated:

It is a movement between the represented and what the (represented) leaves out, or more pointedly, makes unrepresentable. It is a movement between the (represented) discursive space of the positions made available by hegemonic discourses and the space-off, the elsewhere of those discourses.[6]

I am not concerned here therefore with assessing whether virtual space is liberating for women, or the material world of the home oppressive or city streets dangerously inviting. Instead I want to step sideways; to try and disrupt the binaries of men/women, gender/space, good/bad. I want to explore the overlaying of virtual space and material landscapes as an attempt to fracture the conventional 'commonsense' whereby gender identities are both assumed to be articu-

lated and to be judged through associational analogies with metaphorical and material spaces.

I will begin by considering some key issues for thinking about the impact of virtual space. Then I will explore a few aspects of the ways we conceptualize bodies-in-space and how we play out those identities in the material world; first, gaze, talk and touch (that is, the making and maintaining of emotional, corporeal and intellectual connections between bodies); and second, gender 'territories' – how (and by whom) definitions of gender are constructed in 'commonsense' and then maintained and contested through allocated activities and experiences. I will argue that (via a self-referential analogy) both bodies-in -space and space itself are now dominantly seen either as 'neutral', controllable and activity defined, or as 'spectacular', uncontrollable and emotionally charged. While historically these associational strings were linked to bodies and tagged 'male' and 'female' respectively, they are now increasingly seen as simultaneous – albeit contradictory – characteristics of space. Here, I want to suggest that these are not the only ways to imagine space – yet often they are used to set the boundaries of debate.

GENDER, SPACE AND THE PROBLEM OF DISTANCE

It is the underlying theme of this chapter that the tendency remains in technological developments to want to overcome the perceived incapacities of bodies-in space; by attempting to 'order' the world into bounded and mutually exclusive categories, by overcoming the 'base', corporeality and physical limitations of the body and by 'conquering' distance, time and space. These can be positive and empowering mechanisms. We know, however, that this need for specific forms of control is often itself based on fear (and therefore attempted exclusion) of the unknown or Other. But it is this framing of bodies-in-space within a need to control – and its associated feelings of fear of being controlled, and pleasure in releasing control – that has become deeply embedded in the social encoding of white western masculine identity; and which continues to limit the 'shape' of ideas about gender and about space.

This tendency to want to remove the body from its own materiality (its 'meat' as William Gibson calls it,[7] to 'separate' bodies from

186

each other and to enable bodies to overcome distance, is supported through other sorts of 'distancing' – such as the belief in objective reason over subjective emotion, the focus on visual over other senses and the separation of reproductive and productive activities particularly through the distancing effects of money. To quote Gillian Rose:

> After examining many of the founding texts of philosophy, science and political theory and history, feminists have argued that the notion of reason as developed from the seventeenth century onwards is not gender neutral. On the contrary, it works in tandem with white bourgeois heterosexual masculinities. To generalise, they argue that what theorists of rationality after Descartes saw as defining rational knowledge was its independence from the social position of the knower. Masculinist rationality is a form of knowledge which assumes a knower who believes he can separate himself from his body, emotions, values, past and so on, so that he and his thought are autonomous, context-free and objective. . . . the assumption of an objectivity untainted by any particular social position allows this kind of rationality to claim itself as universal.[8]

As Massey has noted, these attitudes constitute a 'very specific form of masculinity',[9] which links to logic and science and thus through to the exponents of 'neutral' expertise – the professions and academia. Such concepts also link through to other Enlightenment notions of individual freedom, of the individual as the 'free-ranging' decision-making personification of Reason. A set of socially constructed, internally coherent and resonant codes are thus supplied with which both men and women can identify. This is not to forget that it has been in the interests of particular men to describe the world as a justification for, and legitimization of, their own preferred gender identities. It is, however, this bundling together of an associated set of concepts around one, powerful, version of 'masculinity' as rational observation which has framed the shaping of spaces and technologies in particular ways. I will suggest that much contemporary criticism, whilst

often aimed at challenging the limitations of such distancing mechanisms, instead substitutes other means of maintaining separation, that is, via the valuing of specific kinds of emotion which incorporate distance through the act of observation/voyeurism/ tourism (in material space) and the addition of literal non-proximity in virtual space.

ADDING THE VIRTUAL

There are also some areas for interrogation generated by the specific qualities of virtual space, compared to the material world. First, it is clear that there is a transference (at least initially) of mental geographies developed in the material world onto cyberspace: these 'commonsense' shapings of gender in physical space thus may produce confusions, realignments and transformations in the different environment of virtual reality. Second, the key characteristic of cyberspace is its literal spacelessness compared to the constraints of distance and physicality of the material landscape. Finally, the inability to reduce bodies to pure non-physicality means continuing tensions between the traditionally 'male' public, outreaching, uncontrolling, non-spatial work-and-leisure oriented aspects of cyberspace and the contained, local, spatial and 'messy' aspects of those activities, conventionally female,which have at some level to take place in material space and through the body, such as sexual reproduction, 'nurturing', eating and washing.

Perhaps because historically women have lacked the resources to make dominant marks on the landscape and have simultaneously been linked in 'commonsense' to the 'inferior' location of emotion/corporeality/interior/locality (as opposed to the 'superior' site of reason/intellect/exterior/distance which some men allocated themselves), these assumptions, and the distancing strategies they contain, have often failed to fit comfortably – as 'we lumber around ungainly-like in borrowed concepts which do not fit the shape we feel ourselves to be'.[10] The aim here, though, is not merely to re-introduce as 'good' or 'superior', the 'feminine' values of emotion, tactility or subjectivity but instead to use these uncomfortable feelings as a mechanism for exploring how this tendency in modern western society towards distancing – the disembodiment of individual corporeal-

ity and the despatialization of the material world – comes to be embedded into the spaces of theory itself. These are not automatically to be considered 'bad' ideas merely because of their masculinist roots, only ones that need to be unravelled and, perhaps, re-woven.

To begin this process I want to examine further how bodies look, talk and touch each other in cyberspace: how gender identities are constructed conceptually in the virtual realm and how these territories of gender are maintained, controlled and transgressed.

GAZE, TALK AND TOUCH

Gaze, talk and touch are the key mechanisms by which we engage together as bodies and as people. All have been, or are being, 'detached' from physical proximity and spatial connection by technology: by the telephone, the screen, by networks and by virtual reality. Here, I want to explore this increasing facility to 'distance' the intimacy of basic interactive body functions and its impact on the way gender identities are constituted across imaginary, material and virtual spaces.

The space of the gaze

The bundle of concepts around 'look' which conventionally have differentiated hetrosexual gender positions have been well documented.[11] In the material world women are stereotypically the object of the public male gaze: delineated by it as passive and sexual – against the active rationality that his ability to 'look' itself enables. Men may reinforce this particular way of looking, through its reproduction in magazines, film and other media. Simultaneously, though, whilst women are meant to appear sexually attractive to the male gaze, they must not attract men sexually – that is, they may be blamed for 'leading men on'. As Valentine has shown, lesbians and gay men are then simplistically defined as 'twisted' versions of this relationship, as 'effeminate' men and 'butch' women: here the public gaze (from both heterosexual men and women) is again the defining act, but is likely to be both fearful and hostile (as it is for other 'non-fits', framed around perceived physical, racial, religious or cultural differences). As she says:

> . . . gender is the repeated stylization of the body, a set
> of repeated acts within a highly rigid regulatory frame-
> work that congeal over time to produce the appearance
> of substance, of a natural sort of being. In the same way
> the heterosexing of space is a performative act natural-
> ized through repetition and regulation . . . These acts
> produce 'a host' of assumptions embedded in the prac-
> tices of public life about what constitutes proper behav-
> iour and which congeal over time to give the appearance
> of a 'proper' or 'normal' production of space.[12]

Such gazes are attempts at gender territory definition and bound-
ary control whose edges are ultimately forced by violence, but which
are also maintained through more everyday harassment aimed at
defining a deliberate 'out-of-placedness' and which also may lead to
defensive self-policing strategies. As Valentine shows, in material
space, those confident of the normality of their gaze (and their acts)
fail to notice its partiality 'precisely because they take for granted
their freedom to perform their own identities', whilst those of us lo-
cated in the zone of Other 'are constantly aware of the performative
nature of identities and spaces'.[13]

In the inital stages of networks and virtual space, the 'gaze' was re-
moved; as were all other clues to gender identity, except name. The
imposition of disembodiment, for a while at least, might have put
everyone in the position of 'Other'; of being required to define their
identity through repetitive and self-conscious performative acts, lim-
ited to written communication. Critics and writers tend to find the
potential for occupation of this new kind of space as either a liberat-
ing freedom (enabling transgression and transformation of conven-
tional gender boundaries) or a danger and a threat, precisely bcause
of that potential for disruption.[14]

The removal of the gaze, which is so forceful a mechanism in our
attempts to define, reinforce and transgress existing gender differ-
ences in material space (and through its representations in other
media), offered up clear possibilities of new types of communications
which were not gender defined. However, it looks like the expansion
into virtual space mirrored the positions on gender taken in the

material landscape; a dominance of men in numbers, a lacking of self awareness of their masculinist codes of operation, the 'policing' of women by a minority of men and a tendency to rely just as heavily on gender and other stereotypes in mental geographies and language use. Just as early virtual environments relied on the 'commonsense' imagery of the boy's comic book, based on simple storybook metaphors (dungeons, castles, war zones), so the language of engagement of MUDs (Multi-User Domains) and their equivalents, can be at worst a masculine adolescent kind of chat up line.[15]

New kinds of talk, old kinds of talk?
Just as with the gaze, women's and men's talk is stereotyped into oppositional binaries. Women are seen as talking more than men, with female language often devalued as trival (gossip) precisely for its concrete and immediate nature (that is its lack of 'distance') compared to men. In fact, as Spender has shown, the amount girls and women talk is actively policed by boys and men, with women seen as talking more than they actually do. In Spender's research women deferred to men in mixed company in both material and virtual space.[16] Whilst much email and conferencing seems to explore the informality of 'rapport' talk, other aspects of virtual space centre either on 'report' talk (about technical or factual information) or can be deliberately confrontational.[17] Now, as developments in bandwidth enable the reincorporating of gaze and the introduction of touch, these tendencies to resort to conventional masculinist codes seem even more likely to become congealed into cyberspace.

Pleasure and distance
Both gaze and talk already have a history of disembodiment across distance in specific forms, via the telephone and the television. Interestingly it is touch, the most difficult of the senses to disembody, where the newest developments in virtual space are being played out.

Non-immersive games first enabled the same distancing of (and control over) emotion and physicality in the ritual playing out of bodily contact through aggressive action, power and intelligence – traditional boys' socialization. Developments in both augmented and full virtual reality, meanwhile, focus on, first, an interest in designing

191

mechanisms for sexual linkages across distance, second the 'rational' control of touch across distance and third, the exploitation of 'sensation' in game-playing. As William J. Mitchell writes:

> There are endless reasons for robotically extending your reach. If you are a skilled surgeon, you might want to make your capabilities more widely available through the use of remote manipulation techniques, or you might like to stay away from dangerous places like battlefields or the South Side of Chicago. If you are an astronomer, you might wish to use a telescope without having to go to some distant isolated site. . . .
>
> Just as boxers with long arms stand less chance of getting belted in the jaw than opponents with shorter reaches, so cyborg soldiers equipped with teleoperated weapons can stay safely in the rear echelon and avoid the dangers of front-line combat.[18]

Mitchell emphasizes the ability to initiate action globally whilst maintaining control (and safety for the physical body itself): others concentrate on the 'transgressive' and exciting aspects of sex (imagine skin which feels like fur) and violent game-playing scenarios. The extension of touch across distance is thus defined and contained within a very partial space – framed by the false continuity (and simultaneous opposition) between controlled rationality and 'sensational' release. In all of this, other potential framings of gaze, talk and touch are marginalized. Would we don suits to see/touch our own children, grandparents or friends? Why hasn't the massive expansion of informal modes of talk across networks thrown up new analogies for informal and sensuous ways of looking at and engaging with each other both in material space and across distances? Why don't these new ideas about augmented and virtual reality 'fit' with how my daughter already uses the phone – as a causal, conversational medium through which 'disembodied' talk is easily and unproblematically integrated with activities undertaken simultaneously in material space? Why does William Gibson's dysfunctional vision of cyberspace continue to dominate as a model for academics, compared to say, Neal

Stephenson's narrative of new kinds of knowledge sources linking interactive human role-playing with embedded life experiences and layered imagery?[19]

I want to suggest, then, that the conceptualization of virtual space is here being dominantly framed through masculinist codes of either controlled rationality (based on the intellect and the need for order) or emotion/sense release (based on the body and a pleasure gained from lack of control): where debate becomes constrained to these channels and where the 'poles' can be seen as oppositional (one good, the other bad) or simultaneous (both good and bad at the same time) or continuous with each other (both good or both bad). In many writings, where older assumptions of mutually exclusive gender differences are no longer so potent, men and women can and do exist in both 'rational' and 'sensual' categories and slide similarly across the range of possible evaluations. It is the making of separate categories (each around a limited bundle of associations),which constrains the possibilities of thinking about female (and male) gender identities.

MENTAL GEOGRAPHIES AND GENDER TERRITORIES

The 'commonsense' meanings of our material landscapes have a deeply sedimented history and can seem to be literally embedded in concrete physicality. The meanings inscribed, for example, into 'home', 'work' and 'leisure'; 'public' and 'private'; or 'uptown', 'downtown' and 'ghetto' concern both physical places and conceptual locations for gender and other identities.These 'meanings' about both gender and space are not natural or fixed but continually contested and subverted.

Not surprisingly, analogies aimed at describing virtual space take a starting point from those existing mental and physical geographies; what is important here is that, to date, the dominant conceptualizations are framed from the viewpoint of a specific type of masculinity and in relation to a specific idea of space. 'Commonsense' spatial analogies are still in the process of construction and contestation as part of attempts to offer a resonant metaphor for visualizing cyberspace. These range from the neutral rationality of network and nodes[20] to new 'frontiers' for exploration (and conquering?) through to the subversive and potentially transgressional images of hackers

and cyberpunks. These all combine a trail of associations, linked by the idea of exploration and adventure: from the neutral and rational observer/scientist who makes 'breakthroughs' to the frontiers-man who tests himself against virgin territory and 'masters' it, to the space 'cowboy', who refuses both spatial and social boundaries and conventions. The term 'adventurer' in a thesaurus provides a chain of continuous associations from experimenter/researcher/analyst/ explorer through to desperado/daredevil/tearaway and terrorist. 'Adventuress', by comparison, links straight to loose woman/flirt/ bint/wench/hussy/sex kitten/temptress and scrubber. When female identity is linked to exploration or transgression, it immediately con-sititutes an 'out-of-place' region, defined negatively and solely through sexuality.

Here, then, ideas describing virtual space are deeply intertwined with characteristics, socially coded as masculine (particularly a kind of American male). These, however are not framed in reference to an Other. There is no explicit female presence in virtual space concep-tualized as a network/frontier, whether oppositional or not. Rather an identity is being defined in relationship entirely to a space, the right to operate actively (and potentially invasively or subversively) in that space, and pleasure invoked precisely through freedom of movement, transient contact, ease of escape and the thrill of potential transgression. Despite their roots (popularized in a long line of Westerns, Road books and movies) these analogies do not necessari-ly produce a gendered identity. Many women have supported this conceptualization of freefloating individualism, the freedom – prob-lematic in the existing physical world for many women – of unlimit-ed exploration and escape enabled precisely through disembodiment and despatialization.

But of course gender identities come to cyberspace with consider-able prior baggage. It has been all too easy for the 'frontier' analogy of virtual space implicitly to reinforce gender stereotypes. As Miller shows, such a metaphor frames women and men differently and thereby affects how issues of power and control are articulated:

> (In) the classic Western narrative, the frontier is a law-
> less society of men, a mileu in which physical strength,

courage and personal charisma supplant traditional authority and violent conflict as the accepted means of settling disputes. The Western narrative connects pleasurably with the American romance of individualistic masculinity; small wonder that the predominantly male founders of the Net's culture found it so appealing.

[but] In the Western mythos, civilization is necessary because women and children are victimised in conditions of freedom. Introduce women and children to a frontier town and the law must follow because women and children must be protected. Women, in fact, are usually the most vocal proponents of the conversion from frontier justice to civil society.

The imperiled women and children of the Western narrative make their appearance today in newspaper and magazine articles that focus on the initimidation and sexual harrassment of women on line.[21]

These are not trivial matters. Struggles for the repositioning of male and female gender identities are currently erupting in the media in both Britain and America around fears for the safety of women and children and a recurring image of the home and 'traditional' family values as a defence for men and women against the 'uncontrollability' of modern life – whether in the city or across the Net. These debates are dangerously limited, precisely because they are framed around a specific set of 'commonsense' conceptualizations of gender and space. As such they reinforce, in fact often justify gender difference and inequalities.

CLAIMING/OWNING/BELONGING

How access to, and control over, both resources and 'meanings' is structured is thus key to how gender identities come to be articulated and contested in both material and virtual landscapes. Masculinist power is here not seen as located in men (as either biologically or as socially constructed beings) but in a dominant and dominating set of values and characteristics linked to specific understandings of masculinity and femininity (in which different men

and women collude to varying degrees). Here there are three linked issues in examining the impact of virtual space. First, particular types of men have considerable powers of ownership over conceptual, material and virtual spaces compared to women. Second, particular types of men have dominated technological and spatial developments, and have unreflexively incorporated assumptions based on a specific framing of gender relations. Power, here, lies precisely in the confidence of its own unawareness, in its inability to imagine alternative positions. Third, certain types of masculinity (adolescent masculinity in particular) are allowed to claim both space and technology as form of power over others – from joyriding to hacking to on-line harrassment . Such actions are simultaneously seen as 'beyond the bounds' of acceptable masculine behaviour and in continuity with 'proper' forms of manhood. Such behaviour thus often acquires simultaneously a reluctant (secretive) admiration and calls for prevention, regulation and control (particularly of young men who use such power to compensate for powerlessness in other areas). Thus, a notion of potent (potentially transgressive) masculinity is enabled, enjoyed and reinforced through a particular relationship of male bodies to space and technology, whilst its control is centred on the protection of women and children in that space, and from the consequences of that form of technology (consequences which are in fact the result of the masculinist nature of the orginal conceptual frameworks). The cycle of imagining material and virtual spaces as either rational and controlled order or uncontrollable, unsafe chaos is thus both self-referential and self-reinforcing; and in the mental and material spaces framed around these assumptions, Woman as a category is given only two alternative and oppositional positions, neither of which relate to the complexities of everyday experience: lone explorer (but not as good as a man) or victim (needing the protection of men).

MEN AND TECHNOLOGY

Researchers such as Cythnia Cockburn and Doreen Massey have provided invaluable work on the impact of introducing information technologies on gender relations.[22] It is clear in the cases that they studied that men linked control over technology with gender territories:

whilst the print workers interviewed by Cockburn were initially threatened in their conventional gender roles by the introduction of computers, the information technology experts investigated more recently by Massey operated in a world where men clearly belonged and which offers a powerful underlining to specific forms of masculinity:

> On the one hand these machines, and what can be done with them, embody the science in which the employees are involved. They are aids and stimuli to logical thought. On the other hand, their relative predicability (and thus controllability) as machines, insulates them from the uncertainities, and possibly the emotional demands, of the social sphere.[23]

Paralleling this preference for control and order of information, is the ability of virtual space for the same distancing of (and control over) emotion and bodily contact through the ritual playing out in computer games of aggressive action, power and intelligence. Benedikt explicitly links the engagement of boys with computers as a key act of transgression on the way to a brotherhood of manliness. He writes:

> It is no surprise that adolescents, and in particular adolescent males, almost solely support the comic book, science fiction and videogame industries (and, to a significant extent, the music and movie industries too). These 'media' are alive with myth and lore and objectified transcriptions of life's more complex and invisible dynamics. And it is no surprise that young males, with their cultural bent – indeed mission – to master new technology, are today's computer hackers and so populate the on-line communities and newsgroups. Indeed, just as 'cyberspace' was announced on the pages of a science fiction novel, so the young programmers on on-line 'MUDS' (Multi-User Dungeons) and their slightly older cousins hacking networked videogames after midnight

in the laboratories of MITs Media Lab, NASA, computer science departments and a hundred tiny software companies, are in a very real sense, by their very activity, creating cyberspace.[24]

Cyberspace is here being claimed as part of a predominantly male identity – not because it is ordered and logical but precisely because it is visualized as a site of ritual and adventure.

Such forms of claiming would be unproblematic if they were merely part of an ongoing intellectual arguement or could be contested through the actions of equally 'placed' individuals. But such spaces are ultimately defended fiercely against other notions of bodies-in-space, both through a naturalized 'belonging' by those who are comfortable in masculinist defined conceptual and spatial territories and through the aggressive enforcement of boundaries by a small minority of individuals. As Grosz writes:

> Men build a universe built upon the erasure of the bodies and contributions of women/mothers and the refusal to acknowledge the debt to the maternal body that they owe. They hollow out their own interiors and project then outward, and then require women as supports for this hollowed space. Women become the guardians of the private and the interpersonal, while men build conceptual and material worlds. This appropriation of the right to a place or space correlates with men's seizure of the right to define and utilize a spatiality that reflects their own self-representations.

One thing remains clear, though, unless men can invent other ways to occupy space: unless space (as territory which is mappable, explorable) gives way to place (occupation, dwelling, being lived in): until space is conceived in terms other than according to the logic of penetration, colonization and domination: unless they can accord women their own space, and negotiate the occupation of shared spaces: unless they can no longer regard space as the provenance of their own self-expression and self-creation, unless they respect spaces

and places which are not theirs . . . can they share in the contributions that women have to offer in reconceiving space and place.[25]

Beatrix Campbell graphically illustrates the impact of this aggressive claiming of physical space in her book *Goliath: Britain's Dangerous Places*.[26] Spender shows how it operates in virtual space through the prevailing structure of on-line discussion, the tendency to single 'transgressive' women out for particularly aggressive treatment and the considerable amount of sexual harrassment.[27]

Women don't 'belong' in these specific conceptual fields, then, via three interlocking mechanisms; first because the concepts themselves are constructed around masculinist codes within which other possible identities are contained, second because such gender territories are maintained in specific shapes ultimately by aggressive defence and third because there are often severe disjunctures between conceptual 'commonsense' definitions of gender-in-space and the lived out experiences of different individuals in material and virtual landscapes.

NEW CONCEPTS, NEW LANDSCAPES

I have shown elsewhere how the dominant concepts of western architects and planners about the physical form of building and cities, from the mid-nineteenth century onwards, were an attempt to inscribe such values of rationality, distance, visual clarity and spatial transparency literally into the fabric of cities and towns.[28] I have also shown, how, in these transformed material landscapes, it was women who were predominantly disadvantaged by the embodiment in the material landscape of functional separation and deliberate physical 'distancing'. Here, specific mental geographies reinforced (and were reinforced by) attempts to manipulate physical space :

> the design of the built environment has maintained a consistent 'distancing' of women from sites of production (and for that matter from other facilities). This has combined with the general lack of access to resources suffered by women because of their social 'place' in relation to the labour market and the family, to exaggerate women's isolated position in the social structure.

In a society which has been built around individual physical mobility, women are less mobile than men because they have less money, less access to transport facilities and more responsibility for other less mobile persons such as children and old people. Women's lack of relationship to the sites of production (their amount and range of choice of paid employment) is thus intensified, both by this relative immobility and by the physical distancing of home and work generated by the decentralization of dwellings.[29]

As Roberts shows (in this volume) more recent concerns, by architects and planners attempting to control free market development, have swung to the other pole (from order/hierarchy/control/function to disorder/fragmentation/free-market/pleasure) in their interests in generating 'mixed use'. Meanwhile, many authors have become deeply interested in the city, not as a site of rational order, but as the location of myth, danger and transgression.[30] As with dominant images of cyberspace, the material landscape of the city is now increasingly envisaged as either a network of 'neutral' flows and functions or as a place of emotional (and particularly sexual) charge, violence and excitement. And, mirroring discourses on virtual space, debate on the 'proper' shape of material landscapes has become focused on issues of safety, particularly for women and children. The crucial point here is not that safety is not a problem, but that these conceptual boundaries delineate the place of bodies-in-space in one mode only – as a seesaw between terror and exhiliaration, with the richness, complexity and variety of different lives simplified to the experience of a funfair ride.

Conceptual, material and virtual spaces thus remained shaped predominantly throught a masculinist paradigm, based on a need for 'distance' and the containing of imagination to specific notions of control/release via spatial and bodily transcendence. In these spaces freedom is defined as individual freedom of movement. Experience is framed by an either/or conceptual division between rational neutrality or emotional release (which is, however, removed from immediacy and corporeality). Debate becomes contained within this simple

binary – an apparent sophistication in its judgement generated through letting 'rational' and 'emotional' hold values which can be in opposition or in association and tagged 'good' or 'bad' depending on the author's position. And these conceptual territories are ultimately defended by both a 'rational' refusal of their own partiality and by sheer 'emotional' aggression and harrassment.

Many women do not 'belong' in these conceptual, material and virtual spaces, even though we occupy and inhabit them. The effect of masculinist 'distancing' (whether in some contemporary theories about space, in the design of modernist city forms or in the developing technologies of virtual reality) is to make places which remain articulated around the assumptions of conventional male hetereosexual identities – of what the spaces of masculinity are or should be like, and into which alternative identities are subsumed.

This, then, is the potential site of another 'thirdspace'; one which sits astride (and disrupts) the conceptualizations of space as either a network of abstract and neutral flows or as the setting for intense and uncontrollable desires. Writers who have challenged the old binary oppositions for describing identity have begun to suggest alternative analogies, for example that of the cyborg (neither man/machine or woman/nature) or more recently, 'marginality', built on the experience of immigration, colonialism, and the self-awareness induced by not being or making oneself central.[31] I would suggest that alternative analogies for space need to incorporate this sense of partiality and tentativeness, but would add immediacy, embeddedness, experience and a lack of distancing or need to control. It is this way of imagining space in relation to its occupancy which is still lacking in today's writing. Grosz, quoted earlier, calls such a space 'dwelling', an intensely problematic term if untransformed, because of its links both to essentialist ideas of feminity-as-home and to the associative chain linking women through the home to the stable and 'known'.[32] Not surprisingly, given our binary history, it is difficult to develop a terminology about space, and our positions in it, which goes beyond false rationalities and engages with embeddedness, without echoing the static and restricted. Kirby tries this in her response to another (male) urban critic's anxiety about, and obvious need for, both contemporary spatial and social worlds to be knowable and explorable.[33]

She tries to articulate her experiences of space, which includes the erotic/dangerous axis but makes it neither central nor defining:

> Jameson worries that the 'postmodern body' is now exposed to a perceptual barrage of immediacy from which all shelter and intervening mediations have been removed. This account appeals to me partly because of its obvious eroticism, and partly because it describes so well the experiences I undergo traversing all kinds of public spaces. . . . I recognise this state; I enjoy its representation at the same time that I feel ambivalence about the state itself. The crisis of boundaries I undergo in public spaces is, on the one hand, detestable (and for me probably more than for Jameson, a sign of the physical, as well as ontological, dangers I face). On the other hand I experience it as a continually promising phenomenon. It is a sign of a real and vital contact with an outside and an 'other' and an opportunity for substantial interaction and personal transformation.[34]

Spatial analogies, as we begin to find them, must not only refuse any universality but must also connect in a potentially transformative way both with the playing out of roles in material space, and with the changing shape of material and virtual realities. The ideas we use to imagine gender identities should not be separated out from analysis of the mechanisms which enable access to both resources and 'meaning-making', nor from the materiality and potentialities of bodies-in-spaces. Only when we think harder about how spaces themselves are constructed, how we apply mental geographies to them and how we simultaneously occupy theoretical, imaginary, material and virtual spaces, can we begin to rethink the place of gender.

BODIES OF GLASS
The architexture of femininity

Alex Warwick

REFLECTIONS

glass (-ahs) n. 1. Substance, usu. transparent, lustrous, hard, and brittle, made by fusing sand with soda or potash or both and other ingredients.

<div align="right">(Oxford English Dictionary)</div>

Glass is one of the oldest of technologies, yet it has the curious status of never having been 'invented'; seeming somehow to have always existed, its origins lost, it is regarded as almost 'natural'. One of the most frequently offered accounts of its appearance in human culture figures it as a kind of gift from the gods; sleeping travellers waking to find that the embers of their fire contain lumps of a magical compound, created in darkness, apparently from nothing. Glass is produced in intense heat, but resembles ice, reinforcing its 'naturalness' and drawing to itself the ephemeral, fragile yet slightly dangerous qualities of frozen water. It has a mystical, almost alchemical, character in that from the basest of matter is produced that which seems to defy logic, a transparent solid. The paradoxical is the defining mode of glass, both in physical structure and in the range of its use. We are reminded that glass is always 'in between',[1] between high art and technology, between the everyday and the extraordinary and frequently, between us and the world.

Although glass has ancient origins and long histories of use, it remains the marker of the absolutely new, the medium at the cutting edge of practices as varied as architecture and communications. 'Old' technologies are constantly re-invented through glass; whereas the uses of iron, bronze and other early coercions of natural substances and simple compounds seem to have reached their peak in the first industrial revolution, glass appears to be inexhaustible, infinite. It

was the keynote of that summary moment of nineteenth-century art and technology, the Great Exhibition of 1851; a celebration designed to reconcile the populace to the changing fabric of their times through the juxtaposition of beauty, wonder and mechanical efficiency. The construction of Paxton's Crystal Palace was the pinnacle of contemporary building achievement, and glass was conspicuous in many of the exhibits, from the grand glass fountain to the plates and lenses of the wonderful optical sciences of microscopy and photography. For the Modern movement in architecture at the beginning of the twentieth century it represented a utopian future in which glass buildings could exist because stones were no longer thrown. At the end of this century it is the essential element in the equally utopian, and perhaps equally flawed, vision of the information revolution, carrying millions of pieces of data at the speed of light in fibre optic cables. Despite, or perhaps because of, its universal use, it remains magical, uncanny, never quite stable in its significance.

So how can this ancient and elusive substance be read? What are its meanings? Can there be a poetics of transparency? This chapter is intended as a provisional attempt to think about glass in some of the ways it has functioned in twentieth-century culture by examining two kinds of artefact, the modern building and the postmodern body, and one particular relationship, of women and glass. This is also an attempt to think through glass, to suggest that the substance and structure of glass itself can offer a means of thinking about the world, that we may be able not just to see through glass, but to think through it as well.

Isobel Armstrong, in her work on glass in the nineteenth century, takes the notion of mediation in order to explore the cultural meanings of the substance:

> Glass is a transitive material . . . which [makes] one intensely aware that, in the movement between one state and another, there is a third term . . . In its scopic desire, a culture of the gaze tends to will away this interposing element between antithetical states . . . and yet the more it is willed away the more this material returns to remind the seer, or user, of its function.[2]

Glass is not inert but active, physically its state is never fixed, moving from liquid to solid, and similarly it is not passive in its mediation. What is significant in the analysis of glass is the process of mediation, the particular means of its coming between and the examination of the ways in which the interposing element is employed in this culture of the gaze. In recognizing glass as a transitive material it is crucial to differentiate glass from mirrors. Although there is a relationship, a partial sharing of properties, the mirror as a metaphor has swallowed the signifying potentialities of glass, just as the mirror itself swallows the qualities of glass, blocking and dazzling the eye with the seduction of reflection. It is the mirror that fascinates; Lacan's preoccupation with the mirror is typical, central to his ideas on the construction of subjectivity, it has become central to much other theoretical endeavour. Lacan's work repeats much older notions of the beguiling and untrustworthy mirror image, for him the mirror is ultimately deceptive, endowing the body with a false unity and the self with the endlessly unfulfilled promise of rational, integrated plenitude and power. It also offers a closed visual relationship that returns upon itself. The gazer in the mirror is locked into a tight circular look, returned from the eyes of the reflection to the eyes of the gazer and back again. Glass does not return the look in the same insistent fashion, the eye looks both at and through, and the observer is simultaneously reflected and projected beyond the pane, there is a constant shift of depth as when one looks into and out of the window of a moving train. But to pass beyond the mirror is unthinkable, for Lacan it remains the stage of constant enactment of subjectivity, on the other side is the profoundly unsettling world of *Alice in Wonderland*. Foucault outlines the totalizing effect of the mirror:

> It makes this place that I occupy at the moment when I look at myself in the glass at once absolutely real, connected with all the space that surrounds it, and absolutely unreal, since in order to be perceived it has to pass through this virtual point which is over there.[3]

The visual experience of glass is not one of absolutes in the way that Foucault suggests of the mirror, but one of temporality and partiali-

ty, of partial reflection, partial vision. The mirror encourages the possessive gaze, I wish to be that which I see, but glass does not, it occupies the realm of the glance which is not penetrating or possessive, but momentary, flickering. The reflection in glass cannot be an ideal like the self of the mirror stage because it is already incomplete, the transitivity of glass always signalling that which is beyond. Perhaps here a gendered difference is already indicated. If, as some have argued, the gaze is male and the glance female, has glass been coerced into the dominant scopic regime of the male gaze, despite its characteristic refusal of such absolutes? Robert Hughes' remarks on early twentieth-century glass architecture suggest this, 'The glass building was either perfect or it was not there. It admitted no moral compromise.'[4] By looking at, and through, the use of glass in the Modern movement it is perhaps possible to see the process of the attempt to fix transparency and to limit its mediation within particular bounds.

BODIES UNDER GLASS

> . . . it aroused feelings that seemed to belong only in the
> world of dreams.
>
> (Siegfried Giedion, *Space, Time and Architecture*)

Giedion's description of the response to the Crystal Palace is interesting because it speaks of a connection between glass and the unconscious, rather than the more common association of the mirror and the unconscious. It is not a chance remark, he deliberately uses a psychoanalytic frame of reference in his analysis of modern architecture and its emergence from the constricting obfuscation of nineteenth-century aesthetics:

> All that while, construction played the part of architecture's subconscious, contained things which it prophesied and half-revealed long before they could become realities.[5]

The identification of 'construction' as the unconscious is important, he goes on to suggest that there is a movement in early twentieth-century architecture from back to front, whereby shapes and structures

usually concealed or placed at the unseen rear of buildings move gradually to the front as the mechanics of construction are revealed. Construction is figured as a body, which in modernist architecture is presented, stripped of its 'clothing' of ornament and superfluous decoration. There is a curious elision in Giedion's thinking in which he slides together the body and the unconscious as though they are one and the same, by erasing the third term from the middle of the unconscious/body/world equation. There is arguably a precedent for this in Freud's own work, which starts with the body in the investigation of hysteria and gradually turns to the attempt to read the unconscious almost as though the body does not exist. For both it seems, the body has become vitreous, glass-like, its dreams visible through its transparent skin. If we refocus Giedion's implied triptych to retrieve the third term it is possible to begin to unpick the work that is done by glass in modern architecture. As the construction is revealed it enters the realm of articulation, of representation. Glass mediates the dreams that are construction in a double fashion, revealing the interior to the exterior, but also enabling the reverse; likewise it protects the unconscious from the observer and the observer from the unconscious. In its aesthetic discipline it resembles Freud's description of the dream-work which reveals the unconscious through strategies of articulation designed to stand between the self and its presence in the world.

If the building is the body, what then is the place of the human body? Although the comparison of the human body with the architectural reaches back as far as classical theorists such as Vitruvius, modernists make the comparison to the exclusion of the human; by the twentieth century the simile becomes a metaphor in which the human is submerged, vanished. This action proceeds, I would suggest, from the desire to banish a specific body – the female – from the field of vision. In the shift of signification, as the building becomes body, the human body comes to represent superfluity, excess, and the female body is the locus of such plethoric surplus. Architectural Modernism itself is founded on the rejection of excess and on a corresponding basic opposition of masculine and feminine principles as comprehended by its founding fathers. The modern is implicitly masculine in its regard for order and simplicity, and explicitly opposed

to the feminine which is seen as enslaved to trivia, novelty for its own sake, and to superfluous decoration. 'Fashion', always identified with women, is a constant adversary for early modernist theorists. Adolf Loos' most famous essay 'Ornament and Crime' (1908) sets up women's fashion and female love of ornament as the direct enemy of modernism and makes it obvious that this feminine principle must be destroyed in order for the modern to succeed. The perception of the female body as excessive is displaced on to the accoutrements of femininity in order that both may be exiled. The simultaneous revelation and disciplining of the dreams of the building through the medium of glass can equally be seen as the revelation and disciplining to the point of disappearance of the troublesome female body in the built environment. The excessive nature of glass itself is enlisted by the dominant culture to neutralize the excessive feminine.

Some modernists appear to celebrate the ecstatic nature of glass; Bruno Taut who, with his colleague Paul Scheerbart, and like Le Corbusier and Walter Gropius, produced numerous designs for glass buildings, wrote in 1919:

> Hurray, three times hurray for our kingdom without force! Hurray for the transparent, the clear! Hurray for purity! Hurray for crystal! Hurray and hurray again for the fluid, the graceful, the angular, the sparkling, the flashing, the light – hurray for everlasting architecture![6]

They believed that the transformation of the environment through glass would transform the nature of human existence by eliminating secrecy and privacy, but what already seems to be implicit in Taut's rhapsodic celebration is a version of the Foucauldian exercise of disciplinary power. 'The kingdom without force' is a contradictory phrase which appears to describe a place without conflict, yet it is a kingdom, a hierarchical state that manages to maintain its hierarchy without aggression, but through the deployment of a more subtle arrangement of power, precisely Foucault's panoptic regime where the possibility of being seen produces self-imposed discipline. Modernist glass architecture promises to abolish the darkness and secrecy of the Victorian domestic interior, but in doing so it also elim-

inates the space of woman. The 'separate spheres' notion of masculine and feminine culture has been read both as oppressive and liberating to women, but the glass-walled house offers no sphere at all. If the house is the site of women's labour, glass opens up that scene, simultaneously emphasizing and obliterating her labour. The modernist interior emphasizes the clean, the light and the ordered, which are highly labour intensive to maintain, but this order is naturalized, as though it had always existed. The house becomes indeed as Le Corbusier described it, a machine for living in, but it is man who lives in the machine, woman becomes part of it, a cyborg housewife, comparable with the domestic machinery of the newly invented kitchen appliances.

The mechanization of the working classes explored in *Metropolis* (1927) is similar; the ideal of the glazed factory or workplace makes a curiosity of the worker, he is made visible only as part of the machine, the troubling bodies of women and workers are disciplined by being both visible and negligible at the same time. There is a neat illustration of the conjunction of mechanization, modernism and glass in a performance piece from 1929, called *Glass Dance*. This was a 'mechanical ballet', based on the Bauhaus' notion of the relationship of human and machine and performed by Carla Grosch in a skirt of glass rods, with her head in a glass globe and carrying glass spheres. The elaborate attire was designed to constrict movement while still allowing the (female) body to be visible, drawing attention to its tiny repetitive actions and emphasizing its mechanistic character. If the female body can be assimilated as machine, the feminine principle can also be expelled from the glass house. The admission of light displaces the contents of the space, the sparsely furnished, light-filled arena without internal walls paradoxically leaves no place for women, they can have, in the words of Virginia Woolf, no room of their own, with the effect of moving the woman out of the domestic space into the public. She is expelled through the glass wall of the home into the burgeoning consumer environment of public space, into another relationship mediated now through the plate glass windows of shops, where both the female body and luxury goods are displayed in a confusion of the relationship between consumer and consumed. The expressed male modernist desire to eradicate the fascination with fashion and novel-

ty actually conceals the means of placing of women in even closer proximity to it, identifying them still further with commodification.

The desire to produce transparency is present not only in architecture, and implicitly in psychoanalysis, but also in medicine. As the Crystal Palace led the technology that made modernist buildings possible, so too did other items from the Great Exhibition feed the fascination with making solid bodies transparent. The microscope and the camera as observers of the body are joined by X-rays in 1895 which allow the opportunity to see through flesh that is still alive. The science of the dissection of the body and the art of modelling its interior are old, but they too are made anew by glass. In 1930, four years after the completion of Gropius' Bauhaus with its huge curving glass wall, a 'man of glass' was presented with great popular success at the Dresden museum. As Carol Boyer remarks, 'this was not the image of a dissected cadaver, bloody and decomposing, but a purified model, a perfectly replicated body, a transparent citizen for the glass city.'[7] In 1990 Martin Roth discovered that three 'men of glass' still existed, they were restored and formed the centrepiece of an exhibition in Dresden, on the site of their original showing. In replicating the first exhibition, the contemporary curators drew attention to the role of the body and its display in the rise of the Fascist state, suggesting that the man of glass came to represent a pure form, a mute body devoid of an inner self and thus completely manipulable.

THE GLASS BODY

> And how could I deny that these hands and this body belong to me, unless perhaps I were to assimilate myself to those insane persons . . . who imagine . . . that they have a body of glass. (Rene Descartes, *Meditations*)

As a child I had a transparent woman, a kind of inverted double of Barbie, but where Barbie apparently had no organs at all, my crystalline woman had organs to spare. She came with two removable sets, one consisting of the usual contents of the internal anatomy and the other of the compressed and displaced organs of pregnancy, including a full-term – and not transparent – foetus. She was called The Visible Woman, but she was in fact, invisible. Barbie is a woman re-

duced to gender, empty inside and unmarked outside by secondary sexual characteristics such as nipples or pubic hair, she is a cipher for a social notion of femininity. The Visible Woman was reduced to sex, defined by organs and reproductive capacity. Like the glass man and unlike the wax Venuses of earlier anatomical modelling she was clean and purified, her invisibility under the eye of science removing the undescribable excess of femininity and leaving a neatly ordered set of functions in its place. She was presented as an efficient machine, again erasing her 'labour', as the baby was 'born' by removing the panel of the abdomen. In this she illustrates Carol Stabile's arguments on foetal photography and anti-abortion campaigns based on the rights of the unborn child. 'Fetal personhood' writes Stabile, 'depends upon the invisibility of female bodies and the reduction of women to passive reproductive machines.'[8] As the body of the Visible Woman is glass, so the artificial (glass) eye of the camera makes the human woman transparent, a passive mediating shell. To return to Armstrong's notion of transitivity, the eye hurries past the glass body and the triangulation of woman/baby/world is reduced to a simple binary – baby/world – vanishing the difficult third term.

These vitreous citizens are a tangible illustration of Foucault's description of the condition of the modern body. As he outlines in *Discipline and Punish* (1977), the fleshly body of the pre-modern period, subject to punishment and display, is gradually supplanted by the modern body which, divested of its previous signifying potential, has become residual dead matter containing only the potential to be described, organized and disciplined. The glass man completes the erasure of the flesh, as Boyer notes, he was free from smells, putrefaction and organic messiness, reduced only to disciplinary functions. Writing on Foucault, John O'Neill suggests that:

> modern man will have an affinity for the languages of the body. He will be driven to excavate the body's dreams, its pathologies and its death, to enter the body's spaces . . . It was only by treating himself as morbid and as insane that modern man could create the two human sciences – medicine and psychology – that have individualized him.[9]

So for Descartes the denial of corporeality, thinking oneself made of glass, was insanity, and for Foucault only through embracing insanity, seeing inside oneself, comes the possibility of realizing the condition of the modern body. Perhaps it is the framing of the body as sick and mad that has led beyond Foucault's modernity to the postmodern, when in the quest to reassert or deny its materiality the modern body is confronted by its artificial counterparts, the presence of replicated animate bodies, mechanical or pseudo organic, and the possibility of finally going beyond the flesh, of becoming cyborg.

Or perhaps the posthuman body is not 'beyond' after all, and the cybernetic organism is another version of the nexus of flesh and information that occupies Foucault. As Donna Haraway observes, 'Foucault's biopolitics is a flaccid premonition of cyborg politics.'[10] Where he identifies a displacement of the meaning of the body from its organic surface to the paper of its record as a case history, we can see in certain cyborg formations the realignment of the two, where information is transferred back to the body's surface. In a recent newspaper article[11] we are informed of the latest technological employment of glass – fibre optic clothing for the military and for the catwalk. Instead of simply producing radiance it transmits and receives information, digitally converted to light. The opening of the article echoes Giedion's response to the Crystal Palace, 'the strange but glorious world of optical fabrics', 'impossibly slender threads'; we are again in the world of dreams, but what now are these dreams? This is of an artificial skin, no longer at the distance of the edge of the building, but on the body itself. For the soldier it will replace the skin's own sensors, able to detect temperature changes, chemical attack and laser sighting and to resist bullets. This is the improved masculine body, protected and invulnerable, while in the article the 'fashion victim', implicitly female, is offered only the perfectly radiant dress. But whose skin is this? At the anxious boundary of the body the distinctions between interior and exterior are blurred and the second skin of glass further disturbs any sense of the contained and separate self. As Haraway comments of the cyborg, 'it is not clear who makes and who is made in the relation between human and machine.'[12] Her description of the cyborg as 'ether, quintessence' and people as 'nowhere near so fluid, being both material and opaque'[13]

begs the comparison between her conception of a cyborg identity and the condition of glass, and raises the possibility of reconstituting the machine, or at least the conception of relations between human and machine, through refusal of 'an anti-science metaphysics'. Is there here a way here of retrieving glass from the kinds of uses of domination we have seen, of resisting the attempt to control the mediating effects of glass, in order to embrace its transitivity, its reflections of partial identities and its contradictory state?

THINKING THROUGH GLASS

> Glass is a thing in disguise . . . a joyous and paradoxical thing, as good a material as any to build a life from.
> (Peter Carey, *Oscar and Lucinda*)

It could be argued that glass is the most postmodern of materials; descriptions of it seem to suggest many of the ideas beloved of post-structuralists: it is 'structureless'[14] an 'amorphous substance'; non-linear because 'its molecules have no regularity in their arrangement'[15] it is constantly 'in process', no longer completely liquid, but never quite solid; it belies the surface/depth distinction of the binary world view because it has no depth, it is all surface. It cannot be broken down, analysis promises to make sense of it, but what is delivered is more complexity. Analysis thinks it will deliver presence, but it cannot, because the pieces are too full of traces, full of the traces of the past and anticipations of the future. This is not to suggest, however, that glass represents the vertiginous collapse of the possibility of meaning that some post-structuralist thinkers offer. Isobel Armstrong's reading of glass is based partly on Gillian Rose's contestation of postmodernism through the notion of the broken middle, which suggests that although the middle, that which is between one condition and another, is always broken, 'the result is not a sickening destabilizing of the centre, a state of perpetual flux'[16] but a means of confronting complexity. In the reading of the modern building and the Visible Woman it is possible to see how the dominant uses of glass and conceptions of transparency have endeavoured to elude the middle without confronting its complexities, to pass to an apparently certain position, concealing the fact that, like glass itself,

any position already contains the flaws that mean it could be shattered at any moment. To recognize the 'in between' means to confront the possibility of that shattering, of the need to reconstitute a position, to keep moving. To think like glass means to remember its flaws, its transitive state and its temporary yet momentarily stable condition. To think like this is to counter Hughes' description of 'perfect or not there'. He, like the modernists of his subject matter, produces a simple opposition of there/not there which ignores the breakable middle.

Another similar model for a philosophy of glass might be extrapolated from Deleuze and Guattari's notion of nomad thought, based on their conceptions of what they call smooth and striated space. The smooth is the place of fluidity, fusion and boundlessness, while the striated is that of order, classification and categorization. Brian Massumi points out in his foreword to *A Thousand Plateaus* that:

> [nomad thought] does not repose on identity; it rides difference . . . Rather than analyzing the world into discrete components, reducing their manyness to the One of identity, and ordering them by rank, it sums up a set of disparate circumstances in a shattering blow. It synthesizes a multiplicity of elements without effacing their heterogeneity or hindering their potential for future rearranging.[17]

In this outline, with its quasi-scientific language he could almost be offering a description of the condition of glass, its shattering presence hinted at. Amongst the examples drawn from fields such as music and mathematics to illustrate nomad thought Deleuze and Guattari write of 'the technological model',[18] indicating the importance of understanding the products of human culture, of refusing, as Haraway puts it, 'a demonology of technology' in which 'nature' and its dangerous connotations for women are elevated and technology denigrated.' She continues:

> It is not just that science and technology are possible means of great human satisfaction, as well as a matrix

of complex dominations. Cyborg imagery can suggest a way out of the maze of dualisms in which we have explained our bodies and our tools to ourselves.[19]

Both these positions seem to reject the notion of infinite flux in which no grounded ethical stance can be taken, and both remain aware of the mobile and flexible nature of power which requires like means to confront it. For Deleuze and Guattari smoothness and striation are not constant states of opposition but linked conditions which are always moving across one another:

> What interests us in operations of striation and smoothing are precisely the passages or combinations: how the forces at work within space continually striate it, and how in the course of its striation it develops other forces and emits new smooth spaces . . . Of course, smooth spaces are not in themselves liberatory. But the struggle is changed or displaced in them, and life reconstitutes its stakes, confronts new obstacles, invents new paces, switches adversaries. Never believe that a smooth space will suffice to save us.[20]

If we conceive of glass as a smooth space that is constantly under striation, we can re-read the modern building and the Visible Woman to see the operation at work, as dominant culture attempts to impose lines of longitude and latitude on the transparent skin. Just as the smooth space will never suffice to save us, equally it will never suffice to oppress us, to retrieve it we must maintain the knowledge of the middle, the place of mediation, the vitreous. The temporary condition of glass reminds of the effects of striation and the need to realize the smooth space anew. It confronts the either/or of binary opposition and offers a space of reconsideration. To think about glass is also a means of rethinking our relations with material culture, to think of the body and its existence in the world. Most significantly perhaps, glass speaks of the contestation of the boundary, of inside and outside, self and other, conscious and unconscious, reveals them as imagined dualities and opens to question the ways in which we in-

habit our environment, and the ways in which that environment in-
habits us.

*Thanks to Mark, Dani and Leigh for their interest in transparent
trivia.*

CITY FUTURES
City visions, gender and future city structures

Marion Roberts

FUTURE OF CITIES – THE NEW CONSENSUS

The 'caring' nineties have seen the re-emergence of the 'vision thing' in urbanism and town planning. The city has become a hot topic, recognized in that most auguste of establishment institutions, the British Broadcasting Corporation. There seems to be a consensus emerging over what the form of our town centres, if not our cities should be. This chapter will examine four documents which have contributed to the articulation of that consensus, in the light of contemporary feminist concerns.

The four documents are the report[1] by the Urban Villages Group, *Urban Villages: a concept for creating mixed-use urban developments on a sustainable scale*, the consultancy URBED's report to the former Department of the Environment on the *Vitality and Viability of Town Centres*,[2] Elkin and McLaren's prescription for a 'green' city[3], the book *Reviving the City* and Bianchini and Landry's report for the think-tank Demos on the topic of its title: *The Creative City*.[4] Each of these reports has either had an impact on the previous government's policies, or contains proposals which are being taken up by the new Labour administration.

I will argue that each of the documents has much to contribute to such policy changes. There are limitations, though, in the premises and outlook of each contribution which do not meet the full potential for innovation. I will also make the argument that there is a strong thread of nostalgia running through these current visions of the future, a yearning for a past which has irrevocably gone. Instead, I suggest that urban designers, planners and academics should look more closely at contemporary social relations and rather than decrying

217

them, seek to understand them. Only then will the future reflect the needs and aspirations of the present.

FEMINIST CRITICISM OF CONTEMPORARY CITIES

Berman points out that Jane Jacobs' *Death and Life of Great American Cities* which was first published in 1961 gave us 'the first fully articulated women's view of the city'[5] since the work of such feminist philanthropists of the nineteenth century as Henrietta Barnett and Olivia Hill. Jacobs' trenchant criticisms of modernism with its bleak mono-functional zones of buildings and soulless stretches of open space inspired future generations of community activists. Her prescriptions for lively, vital mixed density areas, with a mix of commerce, shops and dwellings, providing 'eyes on the street' or twenty four hour surveillance, were not included in official policy documents.

It was not until the 1980s, with the emergence of feminist criticisms of town planning, that these issues came to the fore again in the UK.[6] The zoning of land into single uses was criticized because it prioritised male employment over female employment,[7,8] and in segregating areas of housing in which women with children were 'trapped' by poor transport, created pools of low-paid female employment. Mono-functional zoning also resulted in a diminution of use of town centres when the shops and offices shut, again resulting in an under use by women and some men concerned for their personal safety.[9]

Further criticisms were levelled at the dominance of highway engineers and road policy within the urban system. The predominance given to private car transport dispossessed those women who neither possessed a driving licence nor had access to a car,[10] created unfriendly and unsafe underpasses and turned formerly lively streets into windswept, polluted autoroutes. Cuts in public expenditure led to an under-investment in public transport; many surveys have shown that a significant proportion of women are too frightened to use public transport at night.

At the same time that these trends became a concern to the town planning profession in the late Francis Tibbalds' famous encapsulation 'private affluence and public squalor',[11] feminist geographers

were questioning the usefulness of the dichotomy public/private. Patriarchy, after all operates throughout the spheres of home and work and women operate in both.[12] Furthermore, as Valentine[13] has pointed out, analyses of male aggression in public places have always met with a need to comment on male aggression within the domestic sphere.

Feminist debate has been moving away from a wholesale condemnation of contemporary urban form towards an evaluation of the multi-faceted dimensions of spatial experience. Wilson has argued that male town planning has been driven by a desire to control the sexual licence of women and has therefore failed to celebrate the chaos and vitality of urban life.[14] Bowlby reports her own ambivalence towards out-of-town shopping, enjoying the security and spectacle it offers but simultaneously condemning the resultant decline in local shops.[15] Professional bodies have taken up the issues and the Royal Town Planning Institute[16] recently compiled an advice note, which amongst other issues advocates more woman-friendly town centres.

CITY VISIONS

It was against this background that the four documents, outlined previously, were produced. The first, Elkin and McLaren's *Reviving the City* (1991), was produced by Friends of the Earth in association with the Policy Studies Institute, to demonstrate how principles of sustainability might be put into practice. This has now been further developed into a series of model policies for adoption by planning authorities in their local and strategic plans.[17] The second, *Urban Villages* by T. Aldous (1992), was produced by Business in the Community with the support of both the European Union and HRH Prince of Wales, to influence British government policy. This has now been achieved, with mention of 'urban villages' in the revised draft of Planning Policy Guidance Note 1.[18] The consultancy, URBED's Report *Vitality and Viability of Town Centres* is based on a research study by independent consultants and University College London and has been published by the Department of the Environment as a good practice guide. Two Planning Policy Guidance notes,[19] which are planning advice notes produced by central government for local government, have been influenced by the report. Finally *The Creative City*

(1995), by Charles Landry and Franco Bianchini is a report published jointly by the cultural research consultants Comedia and the left-of-centre think-tank Demos.

All of these documents superficially show a surprising degree of consensus in their recommendations. All propose mixed-use development, celebrate the importance of the local environment and demand more investment in the public realm; clearly answer contemporary feminist concerns.

The City Revived

Each document makes these recommendations from a different ideological viewpoint. *Reviving the City* has a straightforward stance in that it argues that the benefits of mixed development must be fostered, that improved public transport and a higher quality public realm lie not only in energy conservation but in the increase of equity. Women, they argue, are deprived in contemporary urban environments, particularly single parents in inner city areas. Lively, 'jostling' mixed development centres and sub-centres, would provide employment opportunities, shopping and entertainment, thus making 'the town centre an efficient means of fitting in the demands of paid work, domestic work and family care'.

Elkin and McLaren are gender conscious, yet there are interesting contradictions in their stance which unconsciously emerge in their espousal of a 'green approach'. For example, they have a proposal to put green spaces next to footpaths and cycle ways, which, by providing quiet unlit spaces with places to hide, may unwittingly create the pre-conditions for attacks on women. Moreover, they point out that in order to create a compact city, space standards should be restricted or reduced for housing and offices. While this may make sense in reducing energy consumption and land use, it nevertheless contradicts the desires expressed by women's groups in the past.[20] For example,surveys of women's groups in the 1940s, found an almost unanimous desire for higher space standards.[21]

The Village Voice

The *Urban Villages* proposal seeks control rather than equity. The introduction by Trevor Osborne, Chair of the property company

Speyhawk, expresses concern about 'the breakdown of community spirit and growth of social unrest' which he perceives as afflicting parts of towns and cities. The *Urban Villages* vision proposes to reassert the principle of community through the creation of mixed development quarters or villages, with between 3000–5000 people on approximately 100 acres (40 hectares) of land. Each 'village' would contain a 1:1 ratio between people and jobs and a basic level of services, that is shops, primary schools and other civic facilities.

Whilst this may seem idyllic, and indeed the lavish illustrations depicting (mainly) medieval towns, are indeed very attractive, urban villages have some oppressive overtones. Their essential quality is to be small enough so that everybody can know each other and to share a 'working basis of common experience and common assumptions which give strength to community'.

It seems strange that at the point when almost all commentators are agreed that only in exceptional circumstances do communities based on geography exist,[22] a further attempt should be made to engineer them. This, coupled with the aim of reducing social unrest and the insistence that the 'village' should be in the ownership of one individual or institution, carries an underlying suggestion that socially excluded or marginal groups may not be welcome.

Further concerns arise with the treatment of transport and employment. The arrangement of such a village, the authors argue, would mean that the majority of journeys could be on foot and would take about ten minutes. For the able-bodied, this is evidently empowering. While they recognize that the 'village' will not be able to meet all employment needs and therefore some reciprocal commuting will have to take place, the authors are forced to admit that the size of the 'village' would not be sufficient to support an improved mass transit system, except possibly in the form of improvements to a bus system. The relatively low densities of urban villages, which are of a suburban level (30–50 ppa), also make it unlikely that an adequate range of services and employment could be provided. As McDowell commented about post-war neighbourhood units (to which urban villages bear an uncanny resemblance), at one level the close proximity to facilities might be benevolently interpreted as reducing travel time for women with children, or less benevolently, as reducing choice.[23]

The report compounded its gender blindness by advocating 'alleys, snickets and ginnels', or labyrinthine passageways. These may be picturesque in townscape terms, but Boys has pointed out that dangers they pose for the more vulnerable in terms of sexual harassment and physical assault.[24] This point was reinforced in the design of the model urban village of Poundbury, when the community policeman, obviously more well-versed than the developers, condemned the alleys' design on the grounds of their lack of safety.

Vital and Viable Town Centres

Vitality and Viability of Town Centres: Meeting the Challenge, is more firmly rooted in reality and allows for a greater recognition of diversity and social difference. It also positively encourages higher densities and a greater critical mass of people in order to increase pedestrian flow and to make public transport more viable and town centres feel safer.

The report recognizes concerns raised by different groups of women about personal safety and mobility. The argument is made that measures which enable mothers with young children and disabled people in wheelchairs to move about more freely will benefit everyone. Public transport is supported and numerous recommendations made for improving it.

Unsurprisingly, given that this report was funded and written for central government, it is less radical than *Reviving the City*. Commercial arguments take precedence over arguments for social justice; women appear as shoppers, thereby supporting the local economy and as potential victims of crime with just two interesting exceptions.

The first exception appears as a delightful case study: the Millgate shopping centre in Bury has discontinued the use of male security guards who were seen as hostile by some users. Instead they have been replaced by 'mall ladies' who give helpful and friendly information. The Millgate Centre think that the use of mall ladies emphasizes the secure nature of the centre, which is also given prominence through crime prevention initiatives and 'women's weeks'.

The second exception provides the only example in all three reports where the nature of masculinity, or at least masculine behav-

iour, is challenged. Both Coventry and Bath are mentioned as having introduced more user friendly town centres by banning the outdoor consumption of alcohol, except in pavement cafes and pubs. While on the one hand this might be represented as a restriction on individual freedom, drunkenness in public places tends not only to be threatening, but also associated with male behaviour and male violence.[25]

Cultural Revitalisation

The Creative City adopts a critical stance towards the commercialism of *Vitality and Viability Town Centres* and instead argues for revitalisation based on the release of human creativity. The thrust of the report is that there are under-used resources within each town and city: for example there is the potential of human beings to form associations, to engage in cultural and innovative activities and then there are the resources of places themselves, in terms of under-used buildings, roads that can be turned into parks and places for which new uses, new meanings, new life can be found.

The Creative City stresses the importance of reviving and intensifying the public realm, both through physical means such as re-shaping the city, introducing new green areas, pedestrianization, introducing new uses into existing buildings and sites and through urban managerial initiatives, such as reviving and creating festivals and events, shifting time zones for activities, encouraging public–private projects and youth initiatives and promoting direct democracy, possibly through new technology. The image given is that of lively, bustling places with a great deal of social interaction and small-scale economic activity.

The report is gender conscious to the extent that it draws on suggestions to make town centres more woman-friendly. The example of the Ruhr in Germany is cited, where women-only parking bays are provided to encourage women to go out at night. Dortmund also has a sign and a closed circuit TV system surveying a women-only car parking area near the exit of a multi-storey car park. The report advocates other measures such as changing and extending shop opening times to permit more flexible time-budgeting between home and work and to liven up the 'dead' hours between conventional shop closing times and theatres and restaurants opening. Interestingly,

while the report makes specific mention of youth programmes and programmes for the elderly, such as the University of the Third Age, there is no separate analysis of women's groups or of women's specific input into urban life.

Although it is difficult to assess the impact of the report by itself, the promotion of 'cultural revitalization' through the medium of research reports, consultancy, conferences and events has had a significant impact on local urban policy and appears to have influenced the British government's decision to fund the arts, sports and heritage through the National Lottery. This is not to suggest that current policy reflects the entirety of the report's recommendations, for *The Creative City* emphasizes the rigidity of contemporary philosophies and management. It also, in particular, criticises current regeneration initiatives in Britain for being ineffective in terms of the outputs of public–private partnerships and too retail and security-orientated in terms of town-centre management.

It would seem therefore that the thrust of recent government advice is to address feminist criticism. Whilst urban villages have been incorporated into policy on design guidance, the intention of creating safer places through increasing diversity, multi-functions, mixed development, with improved public transport and an enhanced public realm for sitting and walking has become the consensus. None of this can be quarrelled with: rather these recommendations are to be applauded. The question remains, are they enough?

A GENDER AWARE CITY

Postmodern thinking has emphasized the need to consider 'the public' as a diverse set of different groups, made up of individuals whose identities are constructed from significant indicators such as their gender, sexual orientation, class or ethnic origin. The problem for artists, visionaries and planners, is that not only do they have to consider the effects of their works on each of these groups within the public, but also that some groups define themselves almost in opposition to the others.[26] The certainties of a universal stance on the part of the author and a clear 'reception' on the part of the 'reader' or 'consumer' are denied.

The overwhelming impression from reading each of these reports is that of a masculine voice. Aldous exemplifies this to a painful extreme. In a convoluted sentence which prefaces an entire section where the 'promoter' or developer of an urban village is referred to as 'he' and the reader is reminded that 'when we say "he" it implies neither the singular nor the masculine gender'.

Landry and Bianchini introduce an interesting distinction between 'masculine' solutions such as physical redevelopment and a 'feminine' approach which concentrates on 'soft infrastructure, ambience or collaboration'. This gender stereotyping is not unattractive in terms of feminist criticisms of 1960s modernist development which has been regarded as corresponding to exclusive masculine notions of rationality,[27] but runs the danger of perpetuating stereotypes in which women are somehow seen as set apart from major infrastructure projects.

This criticism of a masculine viewpoint refers not to the authors of the reports, as, for example, the steering committee which advised Aldous included Catherine Graham-Harrison, who is a past director of the charitable organization, the Paul Hamlyn Foundation, but to their underlying suppositions. I have suggested that strong ideological differences exist between the four reports, yet each adopts a 'universal' masculine viewpoint,[28] lacking detailed examination of gender relations.

Can public space ever be 'gender neutral'? Marion Roberts

Although it is gratifying that Jane Jacobs' ideas on mixed use, security and safety have finally been taken up, a quarter of a century after they were first written, the time gap leaves some areas of doubt. Jacobs drew her ideas from participant observation of her own patch, Greenwich Village in New York, in the 1950s and 1960s. The world

has moved on since then and her ideas were formed at a time when the 'second wave' of feminism was in its infancy and racial violence had not impacted on American cities.[29]

It is a sad and uncomfortable fact that it is not known whether mixed development, increased surveillance and pedestrian density do lead to an absolute diminution in crime. Whereas safety in residential areas has been the subject of much recent study, crime in town and city centres is less well-researched. Trench, Oc and Tiesdell,[30] in their review of the Home Office's Safer Cities programme, refuse to enter into a discussion of crime statistics. Rather they make the point that if the measures they advocate make women (and men) feel safer, then that will have accomplished a great deal. Petterson offers some evidence from University of Westminster studies of a sample of the residents of centrally located mixed-use developments which suggests that the majority of such residents express a lesser degree of fear of crime than their counterparts on single-use housing estates. Interestingly, she notes that women still feel less safe about being out alone after dark and have a greater fear than men of sexual assault.[31]

Valentine, writing about lesbian experience of the city, comments on differences between the geography of anti-lesbian attacks and assaults on gay men, pointing out that attacks against lesbians are not only antagonistic towards gay identities but:

> reflect the fact that, although men are freely able to use and occupy public space alone or with other men without fear of sexual harassment, women who do so without male companions are open to comments about their appearance or to sexual overtures from men.[32]

In 'Women's Fear and the Design of Public Space' she concluded that the social relations within a space and men's dominance of a space were more important influences on women's fear than was design.[33] Recognition of gay and heterosexual women and men's differential experience of public space implies a deeper response to the construction and definition of gender identities.

For example, the Draft European Charter for Women in the City recommends that men have to do something to prevent violence

against women. Among the measures they suggest are mobilizing communities and educational institutions, setting up 'reflection groups', which should include transport providers as well as users, producing material for the media and establishing a European-wide information exchange on local initiatives.[34] Such a proposal suggests a redefinition of masculinity and a concern for the construction of personal as well as city identity.

To elaborate further, the provision of high quality public space has rightly been given greater priority by the British government. Yet the assumption that we are all equal in terms of the use of public space is surely open to criticism. Public space, the street, the square, the plaza is, as Elkin and McLaren argue, a place for chance encounters, informal meetings, loose associations. It is a place for parade, for spectacle, to see and be seen. Feminist literary critics and art historians have delineated the depth of difference between a construction of femininity and masculinity in the act of seeing and being seen. To assume an ungendered response to the urban spectacle is questionable, to say the least. Readings from cultural studies and in particular the work of Barthes, suggest that the reading of a text, in this case, a public space, is not formed by the intention of the provider – rather it is formed through an interplay between the provider and the reader, or in this case, the user. This observation returns us to the notion that the audience for public space is composed of different genders, classes and ethnicities, who each might have different perceptions of it. Architects have (mostly) learned this hard lesson from the response to the International Style of the 1960s, on the part of the general public who thought award-winning buildings were 'ugly' and prison-like; it would be a shame to re-live this experience with the design of public space.[35]

BACK TO THE FUTURE

A further point of interest is that all four 'visions' expressed in these reports are nostalgic. Each looks back to the pre-industrial city and attempts to revive its 'best' qualities. This nostalgia leads, in the first three instances, to a strangely sanitized view of urban life, which becomes purified of disturbing elements. Diversity and vitality are being designed as products; it is as though the aesthetic effects de-

sired in the mall have been brought into the street. As a *Time Out* critic once commented on the Greater London Council's rehabilitation of Covent Garden Market, it is wonderfully done but all too tickety-boo.

The illustrations in *Urban Villages* present sumptuous images of peaceful market towns. Elkin and McLaren, prefer the urban street of the Victorian era, three and four storey terraces, each dwelling with a front door onto the street. Whilst *Vitality and Viability of Town Centres* embraces the inner city shopping centre, its whole thrust is in opposition to out-of-town development which includes not only the Do It Yourself warehouse, but also the multiplex cinema and the theme park, hyperspaces of the future.

Of the reports, only *The Creative City* refers to either academic debates in urban geography or in architecture about the nature and form of the post-modern City.[36] It is implied in the others that the three dimensional spatial effects of the globalization of capital and the fragmentation of contemporary culture can be accommodated, primarily, in timeworn forms.

Public space is also about conviviality
Marion Roberts

This is not to insist that the chaos, social exclusion and dislocation in contemporary cities is somehow acceptable. Rather it is to suggest that the best quality of urban living is about opportunity, at a number of levels, social, political and economic. Wilson suggests this in

her discussion of the attraction for women of the disorder of cities, the possibilities for transgressing boundaries, for breaking codes.[37] To provide for such opportunities may, on occasion, be visually unappealing or shocking, but that is part of the real vitality of city life.

The types of opportunities which cities offer range from the economic possibilities of an enlarged labour market to the more transcendental pre-conditions for forming a cultural or political avant-garde. In certain instances this may have an electrifying effect on the body politic itself. For example Walker is currently carrying out a study of the meeting places and milieu of the suffragettes, noting the geographical proximity of the early protagonists of the feminist movement to a small area of London's West End.[38] Since middle-class women at this time had little opportunity to organize other than in face to face meetings within the norms of social propriety, but could easily make associations within the semi-public spaces of their drawing rooms, this quality of physical proximity and social practice was important to the genesis of the suffrage movement.

The Creative City recognizes and expands on these observations. The report points out the need for cities to have chaotic and spontaneous aspects, but suggests that these should exist in balance with some degree of regulation and order, as in the Camden Lock area of London, for example.

Yet, despite its forward thinking, *The Creative City*'s vision of modern life seems strangely cautious. Although note is taken of the potential of using new technology for creating direct democracy in locales, the examples and imagery given in the last section of the report, 'Who is Being Creative and Where' have an element of nostalgia. The nostalgia here is not for a more stable, more secure past, but suggests more the image of a stage set on speed, a Shakespearian production with a full cast of charismatic local leaders, bustling townsfolk heavily engaged in local activities and the odd eccentric, artist, seer or visionary providing local colour and inspiration. The conflicts and ugliness of urban life are resolved by 'creativity'.

The report, nevertheless has much to recommend it. Its trenchant criticisms of instrumental rationality, its recognition of the impor-

tance of the 'soft' aspects of cities and city life[39] and its proposals for revitalisation are all valuable. Its disappointing feature is its silence on the issue of city structure and, in common with the other three 'visions', on the future of developments on the peripheries of cities and urban areas.

OUT ON THE EDGE – THE MARGINS, GENDER AND TECHNOLOGY

It may be that the centres of towns and cities are changing in their character and that a new vibrant life is emerging at the 'edges'. Joel Garreau in his book *Edge Cities* has argued that the growth of these phenomena in the United States is closely connected to the feminisation of the workforce.[40] As women enter the waged labour force in increasing numbers, decentralized offices, workplaces and retailing outlets on the edges of towns and cities not only provide them with employment (albeit often low-paid), but their very proximity to residential areas enables women to juggle their time-budgets in managing their waged work, housework and child-care. This is not to suggest a doomsday scenario in which the centres of towns and cities are emptying, but rather to suggest that two trends are apparent in contemporary urban fabrics: a decentralization from the core and a metropolitan revival in city and town centres.[41]

The decentralization of workplaces and retailing is dependent on the relatively 'old technologies' of the internal combustion engine and the telephone. More recent technological developments in the field of telecommunications offer workers increased detachment from the confines of place, with such possibilities as out-sourcing work to another country, home working with connections to a central office by modem and fax, teleshopping and other electronically delivered private and public services. Graham and Marvin have reviewed the potential of these new developments and the most probable scenarios for their adoption. They suggest that far from leading to a new form of completely decentralized city structure, it seems most probable that the core activities in the centres of towns and cities will remain, that existing rings of suburbs will also persist, but that nodes, possibly even emergent 'edge cities' and sub-centres will develop within suburban areas with growth beyond, into the margins of metropolitan regions.

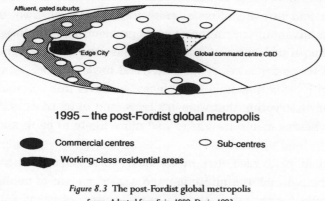

Diagram of Future City: source Graham, S. and Marvin, S. (1996)[45]

1995 – the post-Fordist global metropolis

⬤ Commercial centres ⬭ Sub-centres

⬛ Working-class residential areas

Figure 8.3 **The post-Fordist global metropolis**
Source: Adapted from Soja, 1989; Davis, 1992

Diagram of Future City Structure. University of Westminster Urban Design Unit

Feminists have drawn attention to the problems for women with low incomes in surviving in the inner city in this type of city structure, pointing out how they may be trapped into areas of exploitative employment and poor services because of their lack of mobility.[43] There are alternative aspects to the issue of gender relations and city structure, however. Time-budget surveys of household travel patterns[44] have revealed the complicated routines which many households employ to cope with the varied and often conflicting demands of employment, housework and shopping, childcare and leisure activities.

It may be, for women in dual earner households, that to live in the suburbs and to use and/or be employed in 'edge of town' developments is advantageous, in that it eases problems and conflicts in time budgeting, travel and activities as well as providing a higher standard of living for lower costs. The trend towards more women driving, with 58%[45] now holding licences, supports this speculation, as does the observation that women's trips tend to be short and across town, whereas men's are longer and more likely to be in and out of town.[46]

It might be argued that in an ideal world, motorised transport would be reduced to a minimum and a good system of public transport would concentrate activities in the centres of towns and cities, leading to the 'compact city structure' of pre-industrial urban settlements. The reality is that there is a conflict between the desires of many households to live with suburban amenities such as gardens and easy access to open space and the type of densities required to sustain efficient mass-transit systems. Furthermore shopping patterns have irrevocably changed, with an absolute decline in the number of small shops, growth in the numbers of multiples or chain stores and the provision of food supermarkets reaching saturation point.[47, 48]

Three of the four planning visions, reviewed earlier in this chapter, offered visions of revitalized town centres which developed their sustainability, cultural diversity and attractiveness to consumers. This is not to suggest that such efforts are wasted or should not be pursued. The speculation of this last section has been to suggest that to concentrate on town centres and on revivifying public space is only to tackle part of the problem and that it is tackling it in a gender specific manner. It is possible to envisage a different type of scenario, where not only are inner and central areas provided with densification, better management and cultural diversity but a similar set of creative solutions is applied to the periphery.

New technologies offer a chance of making better use of transport and communication systems such that the image of a privatized, suburban existence may be obsolete. Advanced telematics could ensure efficient use of transport systems, so that passengers are given accurate estimates of waiting times and use of suburban systems

increases. Use of advanced technologies such as electrically operated buses and cars could both reduce pollution and costs within a limited range from urban sub-centres. More sophisticated building programmes involving greater use of soundproofing and an adroit provision of terraces and roof gardens could permit higher density development around 'nascent' edge cities and suburban nodes. If planning regulations were to be adjusted at these points of development, then the possibility of the type of social and cultural facilities normally associated with central cities might be allowed to develop.

The division between public and private might become usefully blurred with the advent of the digital revolution in TV and information systems. In the same way that the telephone extends 'networks' of family, friendships and interest groups to flourish across physical boundaries, so might this facility be extended with increased use of the Internet and local TV and radio services. The benefit to women could be significant in that their access to a range of life enhancing activities would be increased, particularly if a complementary increase in quality and safety were also pursued with regard to transport.

Initiatives on the continent of Europe have placed an importance on the suburbs. Part of the strategy for the revitalization of Barcelona in its provisions of urban squares was the ambition to monumentalize the city, rather than to prioritize key areas.[49] An interesting feature of Roland Castro's 'Banlieues '89' programme in France was the ambition to revivify the suburbs so that both suburbs and centres would be 'travelling at the same speed'.[50]

The suggestions made here are speculative and further research is required. If the assertion is accurate that changes in women's household and employment activities and the extension of the technologies of the car and the phone into women's lives are significant factors in the growth of peripheral areas, then this has implications for an attitude to the future of such developments. The argument that follows is that not only should visions for the 'new' city be extended across both sexes and genders but that it should include the entirety of the city itself.

CONCLUSIONS

Contemporary visions for the city seek to accommodate women's emergence into the public sphere through an emphasis on mixed development, cultural animation, natural surveillance and the provision of high quality public spaces. Whilst this vision is to be applauded, advice emanating from the European Commission on re-education in gender socialization should also be heeded.

It has also been argued that the current nostalgia for pre-industrial forms of the city should be resisted as a single strategy for city planning and design. New forms of development, such as peripheral developments, have emerged partly as a response to changes in social relations such as the feminization of the workforce. Rather than decrying their existence, planners and urban designers should seek to understand further the social relations which form their rationale. Their physical and social conditions should also be enhanced in a creative manner. Only in this way can visions become a shared reality.

A shorter version of this paper originally appeared in Planning Practice and Research *Vol 12 No 2, May 1997, pp. 109–118. We would like to thank the editors and publishers for their permission to reproduce it here.*

CONTRIBUTORS

STEVIE BEZENCENET teaches in the School of Communication, Design and Media at the University of Westminster. She is currently course director of a new postgraduate programme in 'Design and Media Arts' and is researching into practice-based methods of doctoral research. She has published widely on issues of photographic history and criticism, but has recently turned to a visual practice. Her last photographic work was seen at the National Museum of Photography, Film and Television, Bradford (1995) as part of the group exhibition 'Viewfindings', a women's show concerned with issues of landscape, territory and gender. Stevie is a member of the 'Cutting Edge' editorial group.

JOS BOYS teaches Architecture and Urban Studies at De Montfort University, Milton Keynes. She was a founder member of Matrix, a feminist architectural and research practice, in the early 1980s and has also worked for the Women's Design Service, a London-based consultancy. She recently set up an undergraduate architecture programme at De Montfort which is based on the extensive use of electronic media and is currently completing a Ph.d. entitled 'Concrete Visions? Architecture, Society and the production of Meaning'. Jos is a member of the 'Cutting Edge' editorial group.

JANICE CHEDDIE is a writer, curator, film producer and part-time lecturer in cultural studies. Educated at Goldsmiths College University Of London and University Of Sunderland where she gained a Ph.D.in Cultural Studies (1996). Film projects include *Go West Young Man* (1996) and *The Nation's Finest* (1990), both directed by Keith Piper for Channel 4 and the Arts Council Of England and *Who Needs A Heart* (1989) directed by John Akomfrah. She is a founder member of Displaced Data, an organization of artists and writers of colour working with digital technology (http://www.artec.org/displacedata). She was also was the curator of Displaced Data's 'Translocations', Photographers Gallery, London, Spring 1997. In 1995 Janice was a consultant programmer for 'Forty Acres and A Microchip: Digital Diaspora', a conference on cultural diversity and new media at the Institute of Contemporary Arts, London, produced by iniVA and Digital Diaspora. Janice Cheddie lives and works in London.

HELEN COXALL is a museum language consultant and lecturer. Her consultancy work involves her in writing and advising on new exhibition text for galleries and museums; running staff training workshops and publishing in the field of museum language. She also teaches applied language and communication in the School of Communication, Design and Media, University of Westminster, and is a visiting lecturer on the Museum Studies MA, Leicester University and the English Studies BA, Oxford Brookes University. Helen is a member of the 'Cutting Edge' editorial group.

KATY DEEPWELL is an art critic and President of AICA, British Section (1997–2000).
She is editor of .*paradoxa*, an on-line feminist art journal (http://web.ukonline.co.uk/members/n.paradoxa/index.htm). Her publications include: (ed.) *New Feminist Art Criticism: Critical Strategies* (MUP 1995); (ed.) *Art Criticism and Africa* (Saffron 1997) and (ed.) *Women Artists and Modernism* (MUP 1998).

DANIELLE EUBANK is a specialist in the design of interactive multimedia. She first became interested in interactivity while an undergraduate student in visual communication at the University of California, Los Angeles (UCLA). Later she contributed to the Voyager Company's ground-breaking work on interactive products for the consumer market and designed multimedia titles for Microsoft. While earning a Master of Fine Arts in interface design at UCLA, she devoted three years to the investigation of how protest art, involving social issues, can utilize interactive media for the Internet. Danielle draws on her background as an artist and designer to explore the creative opportunities arising in the new media. She is currently with the British Broadcasting Corporation researching the application of digital technology to new media entertainment and information services.

PHILIPPA GOODALL is currently Director of Photography and New Media at Watershed Media Centre, Bristol. From the late 1970s she has been actively engaged in critical photographic practice, design issues and feminist cultural theory and politics through exhibition of her work, curation of others', teaching and writing. Her experience includes running a design collective, a community photography project, a regional agency to support independent photography, producing and publishing a newsletter/journal, arts consultancy, exhibition programming, training provision, and contributing to policy debates with higher education institutions, local authorities and arts funders. Philippa is a member of the 'Cutting Edge' editorial group.

JACKIE HATFIELD is an artist using film, digital image, sound and performance. She makes expanded moving image installation and single screen work. After completing a Postgraduate Diploma in Electronic Imaging at

Duncan of Jordanstone College of Art, she went to the University of Westminster to develop her research into the relationships between audience and art work, developing installations with moving images, random access delivery systems and multimedia authoring. This forms her current area of Ph.D. research. She lectures in video, theory and practice at the University of Westminster. Jackie is a member of the 'Cutting Edge' editorial group.

ROSIE HIGGINS, ESTELLA RUSHAIJA and ANGELA MEDHURST all work commercially in various capacities with new media companies as well as teaching new media skills within further and higher education. They are also regularly involved, as speakers and exhibitors, in digital media events under the collective title 'technowhores'.

RITA KEEGAN was born in New York where she attended the High School of Art and Design. She then went to the San Fransisco Art Institute in California. Rita came to Britain in the late 1970s. She has exhibited both nationally and internationally. Her work explores the issues of identity and representation and she works across a broad range of media and techniques including computer generated images and video. She is currently lecturing at Goldsmiths College.

SARAH KEMBER is a lecturer in New Technologies of Communication, at Goldsmiths College, University of London. She has contributed to a number of books including *Future Natural*, George Robertson et al (ed.), Routledge 1996 and *The Photographic Image in Digital Culture*, Martin Lister (ed.), Routledge 1995. She co-edited 'Technoscience', *New Formations*, 1996 with Jody Berland and her book entitled *Virtual Anxiety, Photography, New Technologies and Subjectivity*, will be published by Manchester University Press in 1998.

ERICA MATLOW has an MA from the Institute of Education in the Sociology of Education and has worked for many years as a practising graphic designer before moving into education. She is Principal Lecturer in Design at the University of Westminster, for nine years teaching on the Graphic Information Design BA (Hons). Her Ph.D. work is in the area of visual communication and cultural studies and is focused on the impact that the new technologies have had on graphic design education. She is the coordinator for 'Cutting Edge' the Women's Research group and a member of the 'Cutting Edge' editorial group.

UMA PATEL has a degree in Sociology and MSc in Software Engineering. She worked for eight years in Education before moving into a research career in HCI (Human Computer Interactions). Since 1991 she has worked on a number of research projects and has experience of requirements analysis, prototyping, usability engineering, and graphical user interface design. Her Ph.D. work is

in the area of usability and utility of 3D interfaces. Recently she has been involved in developing and evaluating software for Web based collaboration, and modelling the work of virtual teams.

GAIL PEARCE is an artist whose work crosses between film, animation and digital processes. Recently she has made an interactive television drama for cable and is currently working on a digital art commission. She teaches on film, animation and new media courses. Gail is a member of the 'Cutting Edge' editorial group.

JANE PROPHET is a British artist working with video and digital media. After graduating from Sheffield Hallam University in 1987, where she studied Fine Art, she went on to complete an MA in Electronic Graphics at Coventry University. Her interest in digital systems and artists' use of computer imaging became the focus of a Ph.D. at Warwick University. These concerns are evident in recent projects, in particular *Swarm*, *TechnoSphere* and *The Heart of the Cyborg*, which are accessed via the World Wide Web and focus on this medium's potential for enabling audience interaction. Jane is a member of the 'Cutting Edge' editorial group.

MARION ROBERTS is an architect with professional experience in the field of community architecture and housing. Her interest in feminism led to her doing a Ph.D. in the topic, which culminated in the publication of *Living in a Man-Made World: Gender Assumptions in Modern Housing Design* (Routledge 1991). Since then she has taken up a Senior Lectureship in Urban Design at the University of Westminster. Her research interests have moved to include public art, on which she publishes articles in academic journals. She is currently editing a two-volume introduction to urban design (Longman, forthcoming) and is pursuing research into gender divisions and city structure. Marion is a member of the 'Cutting Edge' editorial group.

ALEX WARWICK is a Lecturer in English Literary and Cultural Studies at the University of Westminster. She has written on diverse subjects, including vampires, images of the apocalypse and the body, dress and critical theory. Her current work is on the cultural history of substances and textures. Alex is a member of the 'Cutting Edge' editorial group.

NICKY WEST is an artist based in London and Associate Senior Lecturer at the University of Northumbria of Newcastle, England. She has lectured and exhibited widely, including in New York, Japan, Eastern Europe and Finland. She is co-editor of *Inventing Ourselves, Lesbian Lives* (Routledge, 1989).

ALEXA WRIGHT is an artist working with installation and digitally manipulated photography to investigate the effects of technology on perceptions of

self. She has frequently collaborated with medical practitioners, and in 1997 was commissioned by the Wellcome Trust to work with neurologists to visualize phantom limbs. Her recent video installations contrast visual and physical realities to explore the power of sight and the perceived oppositional relationship between mind (self) and body. Alexa has exhibited in solo and group shows in North America and Europe, and is currently 0.5 Senior Lecturer in photography at the University of Humberside.

REFERENCES

SECTION 1 DESIGNING BODIES

PARTIAL BODIES
Re-establishing boundaries, medical and virtual

1 Michel Merleau Ponty, *The Phenomenology of Perception*, London: Routledge, 1962 p.102
2 From an interview with M. F. Langevin, counsellor for transplant patients, Montreal, November 1994
3 Craig Murray 'Technologies of embodiment: wielding the scalpel in virtual reality'. Paper presented at *CIBER@RT '96*, Valencia, Spain p.14
4 Simon Penny 'Virtual reality as the completion of the enlightenment project' in Gretchen Bender & Timothy Druckery (eds.) *Culture on the Brink: Ideologies and Technology*, Seattle: Bay Press, 1994 p.243
5 Jennifer Gonzalez 'Envisioning cyborg bodies' in *The Cyborg Handbook* ed. C. Hables Gray, New York & London: Routledge 1995 p.270
6 As described in a letter from Dr J. Kew, Neurologist at Princess Royal Hospital, Telford, Dec 1996
7 Ronald Melzack 'Phantom limbs and the concept of a neuromatrix' in *TINS* Vol. 13, No 3, UK 1990 p.88
8 Simon Penny in Ars Electronica Information: Quotes at *http://www.aec.at/meme/symp/contrib/biopenny.html*

NITS AND NRTS
Medical Science and the Frankenstein Factor

1. Sarah Franklin, 'Postmodern procreation', *Science As Culture*, 3, 4, 17, p.536
2. Paula A. Treichler, 'Feminism, medicine and the meaning of childbirth' in Mary Jacobus, Sally Shuttleworth and Evelyn Fox Keller (eds) *Body/Politics: Women and the Discourses of Science*, London: Routledge 1990
3. *Equinox*, Channel 4 1994
4. Mary Shelley, *Frankenstein*, Diane Johnson (ed.) London: Bantam Books 1981, p.vii
5. Ibid., p.ix
6. Ibid., p.xxvii
7. Ibid., p.x
8. For example, James Hogg *The Private Memoirs and Confessions of A Justified Sinner* and Robert Louis Stevenson *The Strange Case of Dr Jekyll and Mr Hyde* where splitting and projection lead to the creation of the double or alter ego. Oscar Wilde's *The Picture of Dorian Gray* is another case in point.
9. Johnson, op. cit., p.xvi
10. Ibid., p.xvii
11. Ibid., p.131
12. Ibid., p.xii
13. Ibid., p.115
14. Rosi Braidotti, *Nomadic Subjects: Embodiment and Sexual Difference in Contemporary Feminist Theory*, New York: Columbia University Press 1994, p.78
15. Ibid.
16. Ibid., p.79
17. Ibid., p.80
18. Ibid., p.81
19. Ibid., p.81
20. Ibid., p.82

21. Ibid.
22. Ibid., p.78
23. Ibid., p.94
24. Ibid., p.77
25. Martha Rosler, 'Image simulations, computer manipulations: some considerations, digital dialogues: photography in the age of cyberspace', *Ten.8*, 2, p.59
26. Barbara Maria Stafford, *Body Criticism*, Massachussets: MIT Press, 1991 p.471
27. Ibid.
28. Ibid., p.467
29. Jacobus et al, op. cit., p.2
30. Ibid., p.3
31. Ibid.
32. Mary Ann Doane, 'Technophilia: technology, representation and the feminine, in Jacobus et al., p.170
33. Franklin, op. cit., p.541
34. *Camera Obscura* 29 (1992) p.180
35. Ibid., p.194
36. Ibid., p.195
37. *Camera Obscura* 28, 29 (1992)
38. Ibid., p.6
39. Jacobus et al, op. cit., p.144
40. Braidotti, op. cit., p.90
41. Doane in Jacobus et al, op. cit., p.175
42. Ibid., p.175
43. Braidotti op. cit., p.84
44. Ibid., p.90
45. Ibid.
46. NLM HperDoc/The Visible Human Fact Sheet/ April 1993
47. Ibid.
48. Ibid.
49. Jeffrey Kluger 'Rest in pieces', *Discover*, October 1993
50. But due to media interest, 'Adam' has been revealed as Joseph Jernigan who was executed by lethal injection for the crime of murder in Texas, 1993. 'Eve', as yet unnamed, died of a heart attack at the age of 57.
51. Kluger, op. cit.
52. Ibid.
53. NLM HyperDoc
54. Allan Sekula, 'The body and the archive' in Richard Bolton (ed.) *The Contest of Meaning: Critical Histories of Photography*, Massachussets: MIT Press, p.358
55. NLM HyperDoc
56. Sekula, op. cit.
57. Ibid.
58. Ibid.
59. Ibid.
60. *The Economist* March 5 1994
61. Author interview with Dr. Ackerman, 9 September 1994
62. Richard. C. Lewontin 'The dream of the human genome' in Gretchen Bender and Timothy Druckrey (eds) *Culture on the Brink: Ideologies of Technology*, Seattle: Bay Press 1994, p.107
63. Ibid., p.111
64. I am thinking of Andrew Ross' work on Social Darwinism in North America (see *The Chicago Gangster Theory of Life*), Kevin Kelly's new biology of machines (*Out of Control*) and the critical analysis of Darwinian theories of art and technology by, for

example, Tiziana Terranova and Simon Perry in *New Formations, Technoscience.*
65. Lewontin, op. cit., p.108
66. Ibid, p.109
67. Donna Haraway, *Simians, Cyborgs and Women*, London: Free Association Books, 1991
68. Mary Shelley, *Frankenstein*, p.3
69. Ibid., p.23
70. Ibid., p.24
71. Ibid., p.37
72. Ibid., p.39
73. Ibid., p.42
74. Ibid., p.84
75. Ibid., p.200
76. Ibid., p.115

IMAG(IN)ING THE CYBORG
1. Jane Prophet, *The Imaginary Internal Organs of a Cyborg*, CD-ROM, 1998. Website: *http:www.ucl.ac.uk/slade/cyborg/index.html*, Email: jane@cairn.demon.co.uk
2. Christine Battersby, 'Her body/her boundaries: gender and the metaphysics of containment', in *Journal of Philosophy and the Visual Arts: The Body*, The Academy Group, London, 1993. pp.30–39
3. Ibid p.38
4. Sarah Kember, unpublished notes which accompanied her seminar given at *Wired Women: Virtual Worlds/Real Lives*, a conference at University of Portsmouth 8th March 1997.
5. Rosemary Betterton, *An Intimate Distance: Women, Artists and the Body*, London Routledge, 1996
6. Donna Haraway, 'A Manifesto for Cyborgs: technology and socialist feminism in the 1980s', in Linda J. Nicholson (ed.) *Feminism/Postmodernism*, London Routledge, 1990 p.190–233
7. Michael Baxandall, *Painting and Experience in Fifteenth Century Italy*, Oxford: Clarendon, 1972.
8. The Shorter Oxford English Dictionary defines a chimera as either a grotesque monster in archaeological or painting etrms, or figuratively as a wild fancy or unfounded conception. *The Shorter Oxford English Dictionary* Volume 1, A. Markworthy. Oxford: Clarendon Press: 1991. p.325
9. Les Levidow and Kevin Robins, *Cyborg Worlds: the military information society*, London: Free Association Books, 1989

IMAGING THE UNSEEABLE
1. http://www.nlm.nih.gov/research/visiblb/visible_human.html
2. Combined to reconstruct 3D objects.
http/www.rad.upenn.edu/rundle/InteractiveKnee.html
3. At the University of Colorado Health Services Center – Center for Human Simulation. http://www.uchsc.edu/sm/chs/about.html http://www.uchsc.edu/sm/chs/

THE BODY AND THE MACHINE
1. Donna Haraway, 'A Manifesto for Cyborgs: science, technology, and socialist feminism in the 1980s', in Linda J. Nicholson (ed.), *Feminism/Postmodernism*, London: Routledge 1990, p. 223
2. Simone de Beauvoir quoted in Judith Butler, *Gender Trouble*, London: Routledge, 1990, p. 8
3. Ibid.
4. Marjorie Garber, *Vested Interests*, London: Routledge 1992, p.16

5. Francette Pacteau, 'The impossible referent: representations of the androgyne' in Victor Burgin, Cora Kaplan, James Donald (eds), *Formations of Fantasy*, London: Methuen, 1986

6. Chantal Nadeau, 'Girls on a wired screen: Cavani's cinema and lesbian s/m', in Elizabeth Grosz and Elspeth Probyn (eds), *Sexy Bodies: The Strange Carnalities of Feminism*, London: Routledge, 1995, p. 212.

7. Nietzsche quoted in Melissa Jane Hardie, ' 'I embrace the difference': Elizabeth Taylor and the closet', in Elizabeth Grosz and Elspeth Probyn op. cit., p. 160

8. Jaron Lanier, quoted by Kevin Robins, 'Cyberspace and the world we live in', in Jon Dovey (ed.), *Fractal Dreams*, London: Lawrence and Wishart, 1996, p.7.

9. Donna Haraway: 'A Manifesto for Cyborgs: technology, and socialist feminism in the 1980s' in *Symians, Cyborgs, and Women: The Reinvention of Nature*, London: Free Association Press, London, 1991 p148

SECTION 2 TERRITORIES OF INFORMATION

'DIGITAL SAMPLING'
Ideas suggested by some women's art practices from Europe, Australia, Canada, and America.

1. Frederike Pezold Pezoldo, *Art for the 21st Century: Design of a Counterworld Edition*, Cantz, 1995. p.98

2. e.g. Jean Baudrillard 'The precession of simulacra' Brian Wallis (ed.) *Art After Modernism: Rethinking Representation*, New York, NMOCA: Godine,1984. pp.253–282

3. for a feminist critique see E.Ann Kaplan 'Feminism/Oedipus/Postmodernism: the case of MTV' in E. A. Kaplan (ed.) *Postmodernism and Its Discontents: Theories, Practices* London, New York, 1988. pp.30–44.

4. Frederike Pezold Pezoldo: *Art for the 21st Century*, p.10.

5. Kass Banning 'The mummification of Mommy: Joyce Wieland as the AGO's living Other' Jessica Bradley & Lesley Johnstone (ed.) *Sightlines: Reading Contemporary Canadian Art* Canada: Artextes Editions,1994. p.153.

6. Carol A. Stabile, *Feminism and the Technological Fix*, Manchester: Manchester University Press, 1994. pp.5–7

7. Ibid.

8. Martha Rosler 'Lookers,buyers, dealers & makers: thoughts on audience' Brian Wallis (ed.) *Art After Modernism: Rethinking Representation*, New York, NMOCA: Godine, 1984. pp.311–340

9. PARC (The Xerox Palo Alto Research Centre) runs a programme called PAIR to team artists and scientists, Palo Alto nr. San Francisco see: Dot Tuer 'From xerox parc to the kitchen table: playing the artistic stakes in cyberspace' *BorderLines*, Canada. No.37 pp.15–20. MIT is a University with a well-established research centre and publishing house which has run many programmes for scientists and artists collaborations in Boston, ZKM is Zentrum für Kunst und Medientechnologie Karlsruhe, Germany. These represent three different prominent projects but there are many others.

10. For different forms of cultural analysis: see Constance Penley & Andrew Ross (ed.) *Technoculture*, Minneapolis: Minneapolis University Press,1991, and Gretchen Bender & Timothy Druckrey (eds) *Culture on the Brink: Ideologies of Technology*, Seattle: Bay Press, 1994.

11. see Arlene Raven 'Womanhouse' & N. Broude & M. Garrard 'Conversations with Judy Chicago & Miriam Schapiro' in Norma Broude & M. Garrard,/*The Power of Feminist Art*, New York: Harry Abrams, 1994. pp.48–86

12. Donna Haraway *Simians, Cyborgs and Women: the Reinvention of Nature*, London: Routledge, 1991.; Nelly Oudshoorn *Beyond the Natural Body: an Archeology of Sex*

Hormones, London: Routledge,1994. ; N. Katherine Hayles 'Virtual Bodies & Flickering Bodies' October No.66 Fall 1993 pp.69–91; Elizabeth Grosz *Volatile Bodies: Towards a Corporeal Feminism*, Bloomington & Indianapolis: Indiana University Press, 1994; or Evelyn Fox Keller *Reflections on Gender & Science*, New Haven: Yale University Press, 1985.

13. Kathleen Woodward 'From virtual cyborgs to biological time bombs: technocriticism & the material body' in Gretchen Bender & Timothy Druckrey (eds) *Culture on the Brink*, Seattle: Bay Press, 1994., p.47 & 48.

14. Ibid, p.50

15. Baudrillard op. cit., p.256

16. Clement Greenberg 'Modernist painting' (1960) in C. Harrison & P. Wood (eds) *Art in Theory*, 1900–1990, Oxford: Blackwell, 1992. p.754–760

17. see Simon Penny 'Virtual reality as the completion of the enlightenment project' Gretchen Bender & Timothy Druckrey (eds) *Culture on the Brink* 1994. Barbara Maria Stafford *Good Looking: Essays on the Virtue of Images*, Boston: MIT,1996.

18. Janet Wolff, *The Social Production of Art*, Basingstoke: Macmillan,1981: see also Michel Foucault 'What is an author?' in P. Rabinow (ed.) *The Foucault Reader*, Harmondsworth: Penguin, 1984 pp.101–120 or C. Battersby *Gender & Genius*, London: Women's Press, 1989.

19. see Barbara Maria Stafford, *Body Criticism*, Boston, MIT, 1994.

20. Theresa de Lauretis 'Technologies of gender' in *Technologies of Gender*, Basingstoke, Macmillan, 1987. pp.1–27

21. Ibid., p.17–19

22. Ibid., p.6–9

23. J. Barry & S. Flitterman, 'Textual strategies: the politics of art making' in J. Frueh, A. Raven & C. Langer (eds) *Feminist Art Criticism*, New York: Harper Collins, 1988 pp.87–98 & in H. Robinson *Visibly Female*, London: Camden Press, 1987 pp.106–118 and for a counter-argument, Angela Partington in same volume p.228–250.

24. Pauline Barrie 'The art machine' *WASL Journal*, Dec 1987/Jan 1988 pp.8–9 & Part 2 Feb/March 1988 pp.16–17: R. Brauer & Rosen *Making Their Mark: Women Artists Move into the Mainstream*, 1970–1985 New York: Abbeville, 1988; 'The status of Canadian women in the arts', *Matriart: A Canadian Feminist Arts Journal*, Vol 5 no.1 1994.

25. J.Russ *How to Suppress Women's Writing*, London: Women's Press, 1983, Linda Nochlin 'Why have there been no great women artists' in *Women, Art & Power* London: Thames & Hudson, 1989.

26. Dot Tuer 'Perspectives of the body in Canadian video art' *C Magazine*, Canada,Winter 1993 p.30 see also Vera Frenkel *From the Transit Bar*, exhibition catalogue, Canada, Toronto, Power Plant, 1994–1995;

27. Kim Sawchuk 'Biological, not determinist: Nell Tenhaaf's technological mutations' *Parachute*, Canada. 75 July–September 1994 pp.10–17

28. Margaret Benyon 'On the second decade of holography & my recent holograms' *Leonardo* Vol.15.No.2.pp.89–95 1982. & M. Benyon with John Webster 'Pulsed holography as art' *Leonardo* Vol 19 no.3 1986 pp.185–191.

29. 'Ars Electronica' an annual conference in Linz since the 1980s and 'ISEA' (The International Society of Electronic Arts) now based in Montreal which holds annual conferences around the world are two of the largest art and technology events where artwork is showcased. A copy of the 'VNS Matrix Bitch Mutant Manifesto' can be found on: *http://www.gold.ac.uk/difference/vns.html*

30. Proposals for' All New Gen' can be found on the internet: *http://www.gold.ac.uk/difference/ang.html*

31. Gashgirl's internet address is *http://sysx.apana.org.au/artists/vns/gashgirl/*

32. *Mistaken Identities*

33. C. Tamblyn *She Loves It, She Loves It Not: Women and Technology*, an interactive CD-Rom *Leonardo* Vol.28 No.2 1995 pp.99–104
34. e.g. Griselda Pollock & Rosika Parker, *Old Mistresses: Women, Art & Ideology* London: RKP, 1981; N. Broude & M. Garrard *The Expanding Discourse*, New York: Icon/Harper Collins, 1990 and many others.
35. Jill Scott *The body remembers*, Australia: Australian Centre for Contemporary Art, exhibition 1996, catalogue *Mesh#10*, 1996.
36. Margaret Morse 'What do cyborgs eat? Oral logic in an information society' in Gretchen Bender & Timothy Druckrey (eds) *Culture on the Brink*, Seattle: Bay Press, 1994. pp.157–189
37. Ibid p.160.
38. Ibid p.163
39. see Parveen Adams *The Emptiness of the Image: Psychoanalysis and Sexual Differences* London: Routledge, 1996. pp.141–159 & n.4 p.165.
40. N.Burson in Jean Clair *Identity and Alterity: Figures of the Body*, 1895–1995 Venice Biennale exhibition catalogue, 1995. pp.462–465
41. Donna Haraway 'The Cyborg Manifesto' quoted in Cynthia J. Fuchs 'Death is Irrelevant', *Cyborgs, Reproduction, and the Future of Male Hysteria*' in Chris Gray *The Cyborg Handbook*, London & New York: Routledge, 1995. p.286.
42. Morse op. cit., p.185
43. Ibid., p.159
44. Jane Prophet, *Imaginary Organs of a Cyborg*, CD-Rom, Umbrella, 1997
45. Kim Sawchuk 'Biological, not determinist: Nell Tenhaaf's technological mutations' *Parachute* 75 July–September 1994 p.15
46. Helen Chadwick *Stilled Lives* exhibition catalogue, Edinburgh, Portfolio Gallery,1996; Denmark, Odense: Kunsthallen Brandts Klaedefabrik,1997.
47. Pipilotti Rist *I'm Not the Girl Who Misses Much* touring exhibition catalogue, St Gallen, Kunstmuseum; Graz; Neuen Galerie am Landesmuseum; Hamburg, Kunstverein, 1994, selection shown also London: Chisenhale Gallery, 1996.
48. Vera Frenkel 'Body Missing' internet site *http://www.yorku.ca/BodyMissing/intro.html*
49. L. Hershman 'Touch sensitivity and other forms of subversion: interactive artwork' *Leonardo* Vol. 26 No.5 (1993) pp.435. see also Lynn Hershman, *Bunt Ujarzmionych Cial: Captured Bodies of Resistance* exhibition catalogue, Poland: Warsaw Centre for Contemporary Art, Ujadowski Castle, 1996.

ESCAPE FROM THE FLATLANDS
The impact of new technologies on graphic design education

1. Edward R. Tufte, *Envisioning Information*, Connecticut: Graphics Press 1990
2. Steven Heller, 'Masters of the Universe: Yale University School of Art Graphic Design Program', *Upper and Lower Case*, Vol 22. Number 4. 1996. p.10
3. AIGA *Journal of Graphic Design* Vol 13 No 1 1995, American Institute of Graphic Arts, NY
4. Cynthia Cockburn, 'The Circuit of Technology, Gender, Identity and Power' in *Consuming Technologies*, Roger Silverstone and Eric Hirsch (eds) London: Routledge 1992
5 Sherry Turkle *The Second Self*, New York: Simon and Schuster, 1984
6. Francis Grundy, *Women and Computing*, Intellect Books, 1996
7. Cockburn, op. cit.
8. Roger Silverstone and Eric Hirsch (eds), *Consuming Technologies*, London: Routledge 1992
9. Ellen Lupton and J. Abbott Miller (eds) *Design, Writing, Research*, New York: Princeton Architectural Press, 1996

10 Peter K. Lunt and Sonia M. Livingstone, *Mass Consumption and Personal Identity*, Milton Keynes: Open University Press

11. Marvin Minsky, *The Society of Mind*, London: Heinemann 1987

12. Ellen Lupton and J. Abbott Miller, (eds), *The ABC of the Bauhaus and Design Theory*, London: Thames and Hudson, 1993

13. Heller, op. cit.

14. Florian Brody, 'Interaction design, state of the art and future developments: an argument for information design, in William Velthoven and Jorinde Seijdal, (eds.), *Multimedia Graphics*, Mainz, Germany: Verlag Hermann Schmidt, 1996

15. Bob Cotton and Richard Oliver, *Understanding Hypermedia*, London: Phaidon Press, 1993

16. Signe Hoffos, 'Multimedia and the interactive display in museums, exhibitions and libraries', *Museum Journal*, Feb 1993.

17. Richard A. Lanham., *The Electronic Word*, London: The University of Chicago Press, 1993

18. Gunther Kress and Theo van Leeuwen, *Reading Images*, London: Routledge, 1996

19. Katherine McCoy and Michael McCoy, 'Design: the interpretation of the millennium,' *Upper and Lower Case*, Vol 22. Number 4. 1996. p.4

20. Tim Benton, 'Multi media and multimedia: some possible options for the history of art and design'. *Journal of Design History* Vol 9. Number 3. 1996 p.213

21. Victor Margolin, 'Design history or design studies: subject matter and methods', *Design Issues, History, Theory, Criticism*. Vol 11. Number 1. 1995. p.13

22. Neil Postman, *Technopoly*, New York: Vintage Books, 1993

23. Sherry Turkle, *Life on the Screen*, New York: Simon and Schuster, 1995

24. Ibid.

25. Postman, op. cit.

TECHNOWHORES

1. *www.wmin.ac.uk/media/technowhores*

2. Somehow what are essentially 1s and 0s are being invested with an inherent power by the salesmen, producers and admen – a look back over our shoulders to the school of technological determinism?

3. The disembodied nature of the subject on the Internet and the common practice of subverting real-life gender roles on-line has led to debate of the Internet as a culture that is beyond gender. Where it is imposible to verify the 'truth' of a gendered presentation with material evidence or possible to leave one's gender undefined, it is argued, difference along the line of gender becomes meaningless. This argument can be extended to other differentiating axes that constitute identity such as race, age and disability.

4. This is a reference to MOOs in particular as an example of on-line activity. However, while most people's Internet access is still via a 28.8 modem and an overloaded ISP or university server, the delivery images and sound on this medium is problematic and slow and many users choose to surf viewing text only.

5. Donna Haraway, *Simians, Cyborgs and Women*, London: Free Association Books, 1991, p.150

6. Istvan Csisery-Ronay, 'The SF of theory: Baudrillard and Haraway' in *Science Fiction Studies'* Vol.18 No.3 (1991, p.387), cited in Bukatman (1993, p.323)

7. Foundations for female identity that are based upon an inversion of the hierarchical nature/culture dichotomy of modernist Enlightenment epistemology fail to challenge the separation of women from the realm of the technological. For example, eco-feminists assert that women are indeed closer to nature than men, and that masculine values, with the parallel desires to dominate nature and women, have been expressed through technology. An entrenched opposition to modern technologies is based upon

an essentialist construction of gender as the primary structuring social device, including the structuring of technology. Their reassertion of a dichotomous basis for female identity leads them to advocate a withdrawl from the technological in an emphasis on 'feminine' values, rather than a challenge to the values that structure 'technology' and, indeed, 'nature' as historically dominant and politcally useful mythologies through modernist scientific and philosophical discourse.

8. Haraway op. cit., pp.180–181
9. Gilles Deleuze and Felix Guattari: *On the Line*, translated by John Johnston, New York: Semiotext(e) 1993 pp.11–15
10. Rosi Braidotti, *Nomadic Subjects: Embodiment and Sexual Difference in Contemporary Feminist Theory*, New York: Columbia University Press,1994, p.180
11. see @Help
12. Braidotti, op. cit., p.180
13. Braidotti's use of 'feminist' affirms this as a political, willful process. It also acknowledges a non-exclusionary community of women based on a common difference along one of the multiple axes of identity, the outcome of the radical materialism of her figuration and and her emphasis on the embodied, and therefore sexually differentiated subject.
14. Haraway: op. cit., p.149
15. 'Intermediate technology' is the adaption of sophisticated technologies for use in developing countries using local materials and methods of manufacture in order to reduce overheads, increase self-sufficiency and minimize environmental damage. It is also a term used to insult 'inelegant' solutions in the production of digital work. It is used here to suggest the pragmatic and strategic use of computer technology to beneficial ends – by no means a dominant mode of practice.

RE-PRESENTING MARGINALIZED GROUPS IN MUSEUMS
The computer's 'second nature'?

1. Colin Beardon and Suzette Worden, 'The virtual curator: multimedia technologies and the roles of museum', in Edward Barrett and Marie Redmond. (eds) *Contextual Media*: *Multimedia and Interpretation*, Cambridge, Mass; MIT 1995, pp.65–6.
2. SHIC Working Party, *Social History and Industrial Classification*, Museum Documentation Association, 1993.
3. Helen Knibb, 'Present but not visible: searching for women's history in museum collections,' Dublin T. et al (eds), *Gender and History*, Oxford: Blackwell, 1994, p.354
4. Gaby Porter, 'Putting your house in order', Robert Lumley (ed) *The Museum Time Machine*, London: Comedia/Routledge, 1988, p.114
5. Gaby Porter, *Studies in Gender and Representation in British History Museums*, Ph.D Thesis, Leicester University, 1994, p.9
6. Helen Clark and Sandra Marwick, 'The people's story: moving on', *Social History Curators Group (SHCG) Journal*, 19, 1992, p.59
7. Christine Johnson, 'Extending SHIC to popular culture', *Journal of SHCG*, 16, 1989, p.17
8. Linda Hutcheon, *The Politics of Post Modernism*, London: Methuen 1989, p.74
9. Ibid, p.75
10. Catherine.Belsey, *Critical Practice*, London: Methuen 1980, p.44
11. Alan Morton, 'Tomorrow's yesterdays: science museums and the future', Robert Lumley, (ed), *The Museum Time Machine*, London: Comedia/Routledge, 1988, p.142
12. Michel Foucault. *Language Counter Memory Practice*, D. F. Bouchard and S. Simon (eds) and tr. Ithaca: Cornell U.P. 1977, p.142
13. Madan Sarup, *Post Structuralism and Post Modernism.*, Brighton: Harvester Wheatsheaf, 1993, p.59
14. Roger Silverstone, 'The medium is the museum', *Museums and The Public*

Understanding of Science, The Science Museum, London, 1992, p.35

15. GENREG: 'A simple and flexible system for object registration at the National Museum of Denmark.' Lene Rold, paper given at the *Archives and Museum Informatics conference on Hypermedia and Interactivity in Museums* San Diego, ICHIM'95, MCN'95, 1995.

16. Sarah Hyde. *Women and Men*, Whitworth Art Gallery, Exhibition Catalogue, Dec '91–Aug '92, Feb, 1992, p.1.

17. Ibid.

18. Griselda Pollock and Roszika Parker, *Old Mistresses: Women Art and Ideology*, London: Routledge, 1981.

19. Marie Redmond and Niall Sweeney. 'Multimedia production: non-linear storytelling using digital technologies,' Edward Barrett and Marie Redmond (eds) *Contextual Media: Multimedia and Interpretation* Cambridge, Mass; MIT, 1995, p.90

20. Roland Barthes, 'The death of the author', (1968) in David Graddol. and Oliver Boyd-Barrett, Oliver (eds), *Media Texts, Authors and Readers*, Milton Keynes: Open University Press, 1994. In which Barthes refutes structuralist beliefs in the writer having autonomous control over the meaning of a text. He proposes that it is readers who make their own meanings – thus there could be many different interpretations.

21. John Fiske, *Television Culture*, London: Methuen 1987, p.305 in Ulrike Meinhof, 'DoubleTalk in News Broadcasts', *Media Texts, Authors and Readers*, David Graddol and Oliver Boyd-Barrett, (eds) Milton Keynes Open University Press, 1994, p.213.

22. Silverstone, op. cit., p.35

WHAT HAVE SCIENCE, DESIGN AND TECHNOLOGY GOT TO DO WITH GENDER
A conversation between Uma Patel and Erica Matlow

Because this is a transcript of our conversation we have not detailed any particular references in the text. We are therefore listing some appropriate books that could help you to continue talking.

Edward Barrett and Marie Redmond, *Contextual Media: Multimedia and Interpretation*, Cambridge, Mass; MIT Press, 1995.

Colin Beardon and Diane Whitehouse, (eds), *Computers and Society*, Exeter: Intellect Books, 1996.

F. P. Brooks *The Mythical Man-Month: Essays on Software Engineering*. Reading Massachusetts: Addison-Wesley. 1975.

John M. Carroll (ed), *Designing Interactions:Psychology at the Human Interface*, Cambridge: Cambridge University Press, 1991.

A. Cole, T. Conlon, S. Jackson, and D. Welch, 'Information Technology and Gender Problems and Proposals', *Gender and Education*, 1994.

Barbara Ehrenreich and Deirdre English *For Her Own Good: 150 years of the experts' advice to women*. London: Pluto Press, 1979.

K. A. Frenkel *Women & Computing*. Communications of the ACM 33 (11) 34-46, 1990

Francis Grundy, *Women and Computers.*, Oxford: Intellect Books 1993.

Sandra Harding, *Whose Science? Whose Knowledge? Thinking for Women's Lives*, Ithaca: Illinois, Cornell University Press, 1991.

Dale Spender, *Nattering on the Net, Women, Power and Cyberspace*, Melbourne: Spinifex Press, 1995.

Uma Patel:– I work at the Centre for HCI Design, School of Informatics, City University and would like to thank my colleagues for many stimulating exchanges which have influenced my thinking. The opinions expressed in this conversations are entirely my own.
6 July 1997

ni66666666666666666666

FROM SLAVESHIP TO MOTHERSHIP & BEYOND
Thoughts on a digital diaspora

1. Mark Dery, Black To The Future: Interviews with Samuel R. Delany, Greg Tate and Tricia Rose, *Flame Wars: The Discourse Of Cyberculture*, New York: Duke University Press, 1994, p.188.
2. I am using the term Black Arts to describe work by artists of African, Asian and Caribbean descent. As such I have capitalized the term 'Black' to define a political positioning rather than a term which refers to peoples of African descent only.
3. Keith Piper, Notes on the development and use of a digital diaspora' 1993, Displaced Data web site *http://www.artec.org.uk/displacedata/* 1997. (No Page Numbers) Displaced Data (Janice Cheddie, Keith Piper, Derek Richards.)
4. Ibid.
5. Henri Lefebvre, *The Social Production Of Space*, Oxford: Blackwell, 1996, p.12.
6. David Harvey, *The Condition Of Postmodernity*, Blackwell, Oxford, 1989, p.219.
7. Ibid p.44.
8. Paul Gilroy, *There Ain't No Black In The Union Jack: The cultural politics of race and nation*, London: Hutchinson, 1987.
9. Michael Benedikt, Introduction, *First Steps In Cyberspace* Michael Benedikt, (ed.) Cambridge Massachusetts MIT 1994, p.2.
10. Mark Poster, *Postmodern Virtualities, Cyberspace/Cyberbodies/Cyberpunk*, London: Sage Publications, 1995, p.90.
11. These aspects of Black music in the diaspora are discussed at length in Paul Gilroy's *There Ain't No Black In the Union Jack*
12. I am thinking here of the essentialist claims of Ron Eglash's 'African Influences in cybernetics', Chris Hables Gray (ed.), *Cyborg Handbook*, London: Routledge, 1995, pp.17–28, and Sadie Plant, 'The future looms: weaving women and cybernetics', *Cyberspace/Cyberbodies/Cyberpunk*, London: Sage Publications, 1995, pp.45–65.
13. See Keith Piper's CD-ROM *Relocating The Remains*, iniVa/Keith Piper, London 1997.
14. Margot Lovejoy, *Postmodern Currents: Art & Artists in the Age of Electronic Media*, New Jersey: Prentice Hall, 1997 (2nd Edition). p.248–250. This is also discussed in relationship to feminism in Nina Lykke and Rosi Braidotti (ed.), *Between Monsters, Goddesses and Cyborgs: Feminist Confrontations with Science, Medicine and Cyberspace*, London: Zed Books, 1996.
15. See Ron Eglash 'African influences in cybernetics', Chris Hables Gray (ed.), *Cyborg Handbook*, London: Routledge, 1995, pp.17–28
16. Plant, op. cit., pp.45–65.
17. Keith Piper, 'Separate spaces: A personal perspective on black art and the new technologies', *Variant*, Summer 1993, Issue No.14, Glasgow, p.11
18. Piper op. cit.
19. Cited in Displaced Data's proposal document for 'Translocations' multi media exhibition, Photographers Gallery, London, England, 7th March – 26th April 1997. Displaced Data (Janice Cheddie, Keith Piper, Derek Richards). Rita Kegan in interview with author 25th October 1996.
20. Gilroy, op. cit., p.215
21. Events such as Marc Boothe's Digital Diaspora, the first being the *'Digital Slam: Call & Response* at the Institute of Contemporary Arts, (ICA), London, April 1995, linking up London and New York. Other Digital Diaspora events and the New York based CafÇ Los Negroes continue to operate under this premise.
22. This concept of re-connection also underpins the daily postings of Internet based Gravity Links. A list which goes under the banner of "Mapping cyberspace in full colour." This list is devoted to highlighting web sites of interest to people of colour with a focus primarily on peoples of African descent (though this should read African-American).An example of a posting from ===

Gravity-Links Timer Digest: Tues., Dec. 17, 1996
Vol. 1.77
Contents:
 01. Web — Afro-centric Debate Resource Homepage, The ()
 02. Web — AFRO Events Calendar, The ()
 03. Web — Blurred Racial Lines ()
 04. Web — Microstate Network, The ()
 05. Web — Afro-centric Internet Library, The ()
 06. Web — Maps of Africa ()
 07. Web — Video Vault, CNN ()
 08. Web — Legislative Indexing Vocabulary (LIV) ()
 09. Web — Coalition Against Slavery In Mauritania And Sudan, Inc. (()
 10. Tip — Netscape [Multiple Users on the same machine] ()

23. A fact reinforced by the presence of white and black artists of South Asian descent at these events.
24. The Cedar Centre is just one mile geographically but many miles economically from the smart shops of Canary Wharf. There was real excitement at the prospect of being given access to the Internet. Its global links could, it claimed, help the broad mix of ethnic groups keep in touch with developments back home. But the excitement faded as staff and volunteers wrestled with slow and cumbersome software finding little information on the Net of direct use. *The Guardian*, 30, October 1996. p.23
25. This issue is discussed at length in Dery: *Black to The Future*, 1994, op.cit
26. 'Virtual skin: articulating race in cyberspace', Mary Anne Moser, Douglas Macleod (eds.), *Immersed In Technology: Art and Virtual Environments*, Cambridge: MIT Press, 1996. pp.29–49.
27. A common thread within uses of technology has been these acts of cultural translation. 'Just as important, but less apparent, is the complex process by which western technoculture, even the most propagandistic and militaristic, is always be re-read and re-interpreted in ways that make sense of local cultures and go against the grain and the intentions of Western producers and sponsors. 'Introduction, Constance Penley and Andrew Ross (ed.), *Technoculture*, Minnesota: University Of Minnesota Press, 1991, p.xi
28. A sampler is a piece of technological equipment, which converts a section of music (either pre-recorded or from a musical instrument) a sample, into electronic data, this data can then played/operated via computer or synthesiser .
29. Tricia Rose, *Black Noise: Rap Music and Black Culture in Contemporary America*, Weslyn University Press, 1994, p.73
30. Ibid. p.73
31. Though writer and cultural critic Kwodo Eshun argues in Black Audio's '*Mothership Connection*', 1995, that Black techno music is not made for the dance hall or the stage but rather for the studio.
32. This is discussed in Gilroy, *There Ain't No Black In the Union Jack*
33. Keith Piper, *Caught Like a Nigger In Cyberspace*, published on Displaced Data's web site as part of *Translocations*, an exhibition curated by Displaced Data at The Photographers Gallery, London, England, 7th March–26th April 1997. http://www.artec.org.uk/displacedata/
34. Ibid.
35. See Janice Cheddie 'Transcoding the journey', catalogue essay *From Light*: Phaophanit & Piper, 1995, curated by Eddie Chambers, published by Eddie Chambers, Bristol, England.
36. This discussed by Jean Fisher, 'The syncretic turn: cross-cultural practices in the age of multiculturalism', *New Histories*, catalogue, ICA, Boston, 1996, p.33.
37. 'Speculative fiction that treats African-American themes and addresses African-American concerns in the contexts of twentieth century technoculture – and, more

generally, African-American signification that appropriates images of technology and prosthetically enhanced future – might, for want of a better term, be called Afro-Futurism'. Dery, op. cit., p.180.

38. Gilroy, op. cit., p.4
39. *http://www.obsolete.com/thereal/*
40. This critique is also partly informed by my mother, Joan Cheddie's experience of making the journey from the Caribbean to England three times by ship. Within all these journeys she was a single mother looking after small children. Her narratives tell of how hostile an environment a ship is to a woman with children.
41. Octavia Butler *Parable of the Sower*, London: Women's Press, 1990.
42. As Kobena Mercer points out in the African diaspora there is an 'intrinsic hybridity of the New World societies where race-mixing is, in a sense the norm rather than the exception.' *Self Evident*, exhibition catalogue, Ikon Gallery, Birmingham, 1995, p.15.
43. Gabriel Teshome H., 'Thoughts on nomadic aesthetics and the black independent cinema: traces of a journey, Mbye B. Cham & Claire Andrade-Watkins (eds.), *Blackframes: Critical Perspectives on Black Independent Cinema*, Cambridge Massachusetts, MIT, p.70.
44. Ibid. p.70.
45. Ibid. p.75.

SECTION 3 SPATIAL PERCEPTIONS

A REFLECTION ON 'MIRROR, MIRROR'
1. Karen Coyle, 'How hard can it be' in *Wired Women*, Lynn Cherny and Elizabeth R.Weise, (eds), London: Seal Press, 1996 p.42

POSITIONS IN THE LANDSCAPE?
Gender, space and the 'nature' of virtual reality
1. See, for example Gillian Rose, Feminism and Geography Cambridge: Polity Press, 1993 and Edward Soja, *Postmodern Geographies* London and New York: Verso, 1989.
2. Errol Lawrence, 'Just plain common sense: the "roots" of racism', Centre for Contemporary Cultural Studies, *The Empire Strikes back. Race and racism in 70s Britain*, London: Hutchinson, 1982, pp.47–94
3. David Harvey, *The Condition of Postmodernity*, Oxford: Basil Blackwell, 1989, Fredric Jameson, *Postmodernism or, the Cultural Logic of Late Capitalism*, London and New York, 1991
4. Doreen Massey, *Space, Place and Gender* Cambridge: Polity Press, 1994, p.162
5. Summarized in Edward Soja and Barbara Hooper, 'The space that difference makes: some notes on the geographical margins of the new cultural politics', Michael Keith and Steve Pile (eds) *Place and the Politics of Identity*, London and New York: Routledge, 1993
6. De Lauretis quoted Gillian Rose, *Feminism and Geography*, Cambridge: Polity Press 1993, p.140
7. David Tomas, 'Old rituals for new space: rites de passage and William Gibson's cultural model of cyberspace', Michael Benedikt (ed) *Cyberspace: first steps* Cambridge and London: MIT Press, 1994
8. Rose op. cit.
9. Doreen Massey, 'Masculinity, dualisms and high technology', Nancy Duncan (ed) *BodySpace: destabiliziing geographies of gender and sexuality*, London and New York: Routledge, 1996, p.112
10. Sheila Rowbotham, *Woman's Consciousness, Man's World*, London: Pelican, 1973, p.35
11. John Berger, *Ways of Seeing*, London: Writers and Readers, 1972

12. Gill Valentine, '(Re)negotiating the "hetrosexual street" ', Nancy Duncan(ed) *BodySpace: destabiliziing geographies of gender and sexuality*, London and New York: Routledge, 1996, p.146

13. Ibid, p.149

14. It should be noted that the latter position (in viewing both material and virtual space) uncomfortably brings together two potentially opposing stances – those who fear that conventional gender identities may get confused, and feminists with concerns about how women are made to feel unsafe in space defined by masculine assumptions

15. Dale Spender, *Nattering on the Net: Women, Power and Cyberspace*, Melbourne: Spinifex Press, 1995

16. Dale Spender, *Man Made Language*, London; Routledge and Kegan Paul, 1980

17. Ibid

18. William J. Mitchell, *City of Bits: Space, Place and the Infobahn*, Cambridge and London: MIT Press 1995, p.38

19. Neal Stephenson *The Diamond Age or a Young Lady's Illustrated Primer*, Harmonsworth: Penguin, 1996

20. George Lakoff interviewed by Iain A. Boal, 'Body, brain and communication' James Brook and Iain A. Boal, *Resisting the Virtual Life: The Culture and Politics of Information*, San Francisco: City Lights, 1995, pp.115–130

21. Laura Miller, 'Women and children first: gender and the settling of the electronic frontier, James Brook and Iain A. Boal, *Resisting the Virtual Life: The Culture and Politics of Information*, San Francisco: City Lights, 1995, p.52

22. Cynthia Cockburn, *Brothers: Male Dominance and Technological Change*, London, Pluto Press, 1983 and Doreen Massey, 'Masculinity, dualisms and high technology', Nancy Duncan(ed) *BodySpace: destabiliziing geographies of gender and sexuality* London and New York: Routledge, 1996, pp.109–126

23. Ibid.

24. Michael Benedikt (ed), *Cyberspace: first steps*, Cambridge and London: MIT Press. p.6

25. Elizabeth Grosz, *Space, Time and Perversion*, London and New York: Routledge, 1995, p.122–124

26. Beatrix Campbell *Goliath: Britain's Dangerous Places*, London: Methuen, 1993

27. Spender op. cit.

28 Jos Boys, 'Concrete Visions? Architectural knowledge and the production and consumption of buildings' (University of Reading, unpublished Phd, forthcoming)

29. Jos Boys 'Dealing with the difference', Sophie Bowlby (ed) 'Women and the Designed Environment' special issue *Built Environment* Volume 16, no. 4 1990 pp.249–256. It should be noted that such a combination – where concepts linking space and gender were explicitly connected to changes in the form of some 20th century cities (via both free-market and regulatory mechanisms) was historically and geographically specific. What's more, it produced contradictions for men and women, because of differences between the model of 'proper' gender relations imposed spatially and the actual lived out experiences of different groups of men and women during this period (particularly in the enormous shift of married women into the paid workforce in Britain and North America in the post-war period).

30. For example, Elizabeth Wilson, *The Sphinx in the City*, London: Virago, 1991, Marshall Berman, *All That is Solid Melts into Air* London: Verso, 1982

31. Donna Haraway *Simians, Cyborgs and Women; the reinvention of nature*, London: Routledge, 1991, Soja and Hooper: 'The space that difference makes: some notes on the geographical margins of the new cultural politics'

32. Grosz: *Space, Time and Perversion*

33. Kathleen Kirby is analyzing Fredric Jameson *Postmodernism or, the Cultural Logic of Late Capitalism* London and New York, 1991

34. Kathleen Kirkby, 'Re-mapping subjectivity', Nancy Duncan (ed) *BodySpace:*

destabiliziing geographies of gender and sexuality, London and New York: Routledge, 1996, p.52

BODIES OF GLASS: THE ARCHITEXTURE OF FEMININITY

1. Isobel Armstrong, 'Transparency: towards a poetics of glass in the nineteenth century' in Francis Spufford and Jenny Uglow (eds) *Cultural Babbage:Technology, Time and Invention*, London, Faber and Faber, 1996, p.125. I would like to record my debt to Isobel Armstrong, whose work in her essay was the inspiration for mine.
2. Ibid, p.131.
3. Michel Foucault, 'Of other spaces', *Diacritics* 16. No.1 (Spring 1986), p.24.
4. Robert Hughes, *The Shock of the New*, London: Thames and Hudson 1991, p.178.
5. Siegfried Giedion, Space, *Time and Architecture: The Growth of a New Tradition*, Cambridge, Massachusetts: Harvard University Press, 1941, p.23.
6. Hughes op. cit., p.178.
7. M. Christine Boyer, Cybercities, New York: Princeton Architectural Press 1996, p.100.
8. Carol Stabile, *Feminism and the Technological Fix*, Manchester: Manchester University Press, 1994, p.71.
9. John O'Neill, 'Foucault's optics' in Chris Jenks (ed.), *Visual Culture*, London: Routledge, 1995, p.192.
10. Donna Haraway, *Simians, Cyborgs and Women*, London: Free Association Books, 1991, p.150.
11. Anjana Ahuja, 'Dressing for glimmer', *The Times*, November 18 1996
12. Haraway op. cit., p.177.
13. Ibid p.153.
14. Raymond McGrath and A. C. Frost, *Glass in Architecture and Decoration*, London: The Architectural Press, 1961, p.425.
15. Grolier Electronic Publishing, 1995.
16. Armstrong, op. cit., p.132.
17. Gilles Deleuze and Felix Guattari, *A Thousand Plateaus*, trans. Brian Massumi, Minneapolis: University of Minnesota Press, 1987, pp.xii-xiii.
18. Ibid., p.475.
19. Haraway op. cit., p.181.
20. Deleuze and Guattari op. cit., p.500.

CITY FUTURES
City visions, gender and future city structures

1. Tony Aldous, *Urban Villages London*, Urban Villages Group, 1992
2. URBED *Vitality and Viability of Town Centres: meeting the challenge* London: HMSO, 1994
3. T. Elkin and Duncan McLaren, *Reviving the City* London: Friends of the Earth with the Policy Studies Institute, 1991
4. Charles Landry and Franco Bianchini, *The Creative City* (Paper No 12) London: Demos and Comedia 1995
5. Marshall Berman, *All That Is Solid Melts Into Air*, London: Verso, 1983 p.322
6. Clara Greed, *Woman and Planning* London: Routledge, 1994
7. Doreen Massey, *Spatial Divisions of Labour: Social Structures and the Geography of Production* London: 1984
8. Sophy Bowlby, (et al) 'The geography of gender' in R. Peet and Nigel Thrift, *New Models in Geography* London: Unwin Hyman 1989
9. Ken Worpole, *Towns for People* Milton Keynes: Open University Press, 1992
10. Laurie Pickup, 'Women's travel requirements: employment, with domestic constraints' in Margaret Grieco, Laurie Pickup and R. Whipp *Gender Transport and Employment: the Impact of Travel Constraints* Aldershot: Gower, 1989

11. Francis Tibbalds, *Making People Friendly Towns* Harlow: Longmans, 1991
12. Suzanne Mackenzie, 'Women in the city' in R. Peet and Nigel Thrift, *New Models in Geography* London: Unwin Hyman
13. Gill Valentine,'The geography of women's fear' *Area* (21) 4, pp.385–389
14. Elizabeth Wilson, *The Sphinx in the City*, London: Virago, 1991
15. WDS (Womens' Design Service) 1992 *Planning London*. Women and Development Plans London: Womens' Design Service
16. Royal Town Planning Institute 1989 *Planning for Choice and Opportunity* Women and Planning, Working Party 1
17. Friends of the Earth 1994 *Planning for the Planet: Sustainable Development Policies for Local and Strategic Plans*: London, Friends of the Earth
18. Department of the Environment 1997 Planning Policy Guidance Note 1: *General Policy and Principles* London: HMSO
19. Department of the Environment 1996 Planning Policy Guidance Note 6: *Town Centres and Retail Developments* London HMSO and Department of the Environment 1994 Planning Policy Guidance Note 13: *Transport* London: HMSO
20. See for example Barbara MacFarlane, 'Homes fit for Heroines: housing in the twenties' in Matrix (eds) *Making Space: Women and the Man-Made Environment* London: Pluto, 1984
21. Marion Roberts, *Living in a Man-Made World: Gender Assumptions in Modern Housing Design*, London: Routledge, 1991
22. Doreen Massey, 'Flexible sexism' in Doreen Massey, 1994 *Space. Place and Gender* Cambridge: Polity Press, Ray 1995 'Friendly Society' *New Statesman* 10 March 1995, pp.20–22 1991
23. Linda McDowell, City and home: urban housing and the sexual division of space in M.Evans and C. Ungerson. *Sexual Divisions: Patterns and Processes* London: Tavistock, 1984
24. Jos Boys, 'Making out: the place of women outside the home' in Matrix(eds) *Making Space: women in the man-made environment* London: Pluto, 1984
25. Tuck 1989 cited in Ken Worpole, 1992
26. Mike Featherstone, *Consumer Culture and Postmodernism* London: Sage, 1991
27. Jos Boys, 'Neutral gazes and knowable objects' in Katerina Ruedi, Sarah Wigglesworth and Duncan McCorquodale, *Desiring Practices: Architecture. Gender and the Interdisciplinary*, London: Black Dog Publishing, 1996
28. Linda Bondi and M. Domosh, 'Other figures in other places: on feminism, postmodernism and geography' *Environment and Planning D. Society and Space* 1992 (10)pp.199–213
29. Berman op. cit.
30. Berman op. cit.
31. Geraldine Petterson, 'crime and mixed use development' in Coupland Andy (ed.) *Reclaiming the City: Mixed Use Development* London: E & FN Spon 1996
32. Gill Valentine 1993 '(Hetero)sexing space: lesbian perceptions and experiences of everyday spaces, *Environment and Planning D.Society and Space* (11), pp.395–413, p.409
33. Gill Valentine, 'Women's fear and the design of public space' *Built Environment* (1990)(16)4, pp.288–303
34. European Communities Equal Opportunities Unit 1994 *Proposition for a European Charter For Women In The City*, Brussels DGIV Equal Opportunities Unit European Concession
35. Jane Darke, 'Architects and user requirements in public sector housing: Architects assumptions about the user' *Environment and Planning B. Planning and Design 11*, 1984 398–404
36. See for example David Harvey, *The Condition of PostModernity* Oxford: Basil Blackwell, 1989 Doreen Massey, Space. Place and Gender Cambridge, Polity, 1994 or

Jon Bird, (et al) *Mapping the Future: local cultures. global change* London: Routledge, 1993

37. Wilson op. cit.

38. Lynne Walker, 'Well-spaced women: spaces of the women's movement in Victorian London' in Ian Borden, Joe Kerr, Alicia Pisaro and Jane Rendell, (eds) *Strangely Familiar: narratives of architecture in the city* London: Routledge, 1996

39. Jonathan Raban, *Soft City*, London, 1988 Harvill sets out avision of the 'soft' side of urban life.

40. Jo Garreau *Edge Cities*: New York: Doubleday, 1992

41. Marion Roberts, Tony Lloyd-Jones, Bill Erickson and Stephen Nice 'The city as a multi-layered complex of simple units' *Urban Utopias: New Tools for the Renaissance of the City in Europe Proceedings: European Conference November 1995 Berlin* European Commission DGXII & TVFF Berlin, 1996

42. Stephen Graham and Simon Marvin *Telecommunications and the City: electronic spaces. urban places* London: Routledge, 1996

43. Sue Cavanagh 'Women and the built environment' in Clara Greed and Marion Roberts *Introducing Urban Design: Interventions and Use* Harlow: Longman, 1997

44. Peter Jones, 'Household organisation and travel behaviour' in Grieco,Margaret, Pickup, Laurie & Whipp, R. (eds) *Gender, Transport and Employment* Aldershot: Avebury, 1989

45. Department of Transport(1996) *National Travel Survey* 1993/5 HMSO: London

46. Rosalie Hill, 'Women and transport' in Booth, Chris, Darke, Jane, & Yeandle, Susan *Changing Places: women's lives in the city* London, Paul Chapman, 1996

47. Dory Reeves, 'Women shopping' in Booth, C, Darke, J., & Yeandle, S. *Changing Places: women's lives in the city*.London: Paul Chapman, 1996

48. Mike Batty, 'The retail revolution' Editorial: *Environment and Planning B*, 1997 (29)pp.1–2

49. Oriol Bohigas, 'Strategic Metastasis' in Hortet, Lluis & Adria, Miquel Barcelona: *Sculptures and Spaces* (1982–1986) Barcelona: Adjuntament de Barcelona and Joan Miro Foundation, 1987

50. Roland Castro, 'Civilisation Urbaine ou Barbarie Paris, Plon 5' A version of this paper was given at the 'Women, Time, Space' Conference organised by the Women's Centre, University of Lancaster, March 1994

Watch – Sylvia Belanger

Love Con 1 1995 – Nicky West

Celestial 1997 – Nicky West

Performing Daily 1994 – Nicky West – Installation photograph by Terry Dennet

Mistaken Identities – Christine Tamblyn 1996

'Hands' 1996 – Images from Video Installation – Rita Keegan

'Trophies of Empire', Self Portrait 1992 – Images from Video Installation – Rita Keegan

'Time Machine' 1995 – Images from Video Installation – Rita Keegan

Love Pump – Jane Prophet

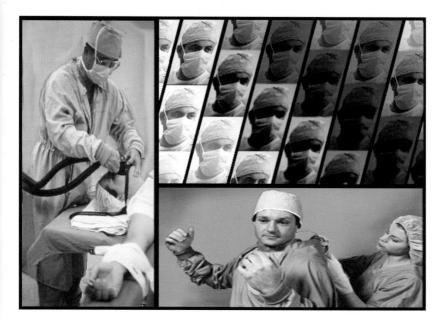

Exit – Jane Prophet

Mask – Jane Prophet

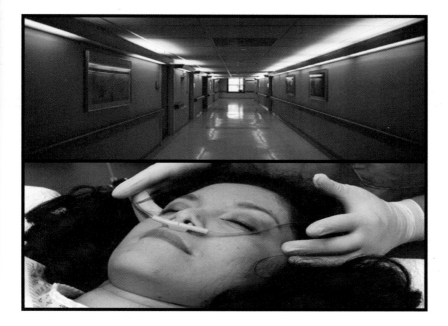

These images are part of a series resulting from a collaboration with Neurologist Dr John Kew and Neuropsychologist Dr Peter Halligan, sponsored by the Wellcome Trust, London in 1997. Alexa Wright worked with eight amputees to investigate and visualize the specific nature of the phantoms they experience. The resulting work uses the genre of portraiture to expand upon previous investigations of the relationship between body and self; in this series of images the subjective reality of each individual is portrayed within the context of their daily lives. Both the authenticity of the photographic image and the authenticity of body image are questioned: which is the 'true' body; that which we see or that which is experienced?

Stills from Installation *Scar* – Jackie Hatfield

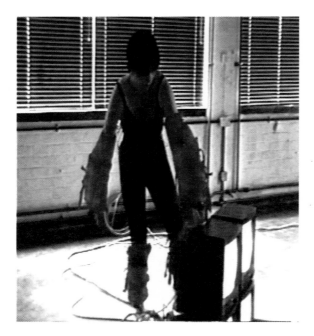

Stills from 'Camera Suit' Performances – Jackie Hatfield

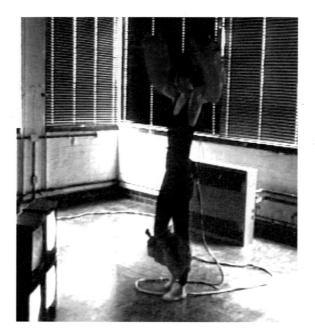

Stills from *Walk in the Glens Wearing a Camera Suit and Tartan Boots* – Jackie Hatfield

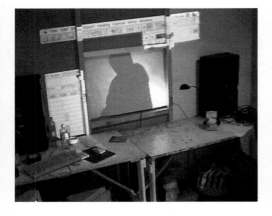

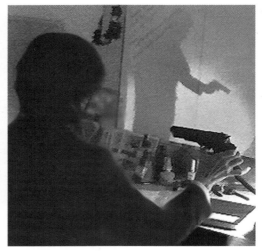

Mirror, Mirror: behind the mirror, what makes it work – Gail Pearce

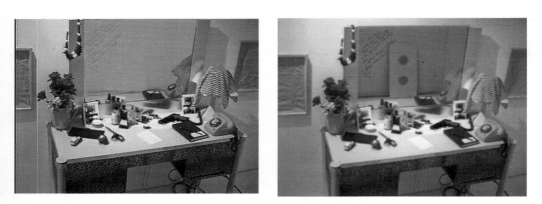

Mirror, Mirror: interactive dressing table installation – Gail Pearce